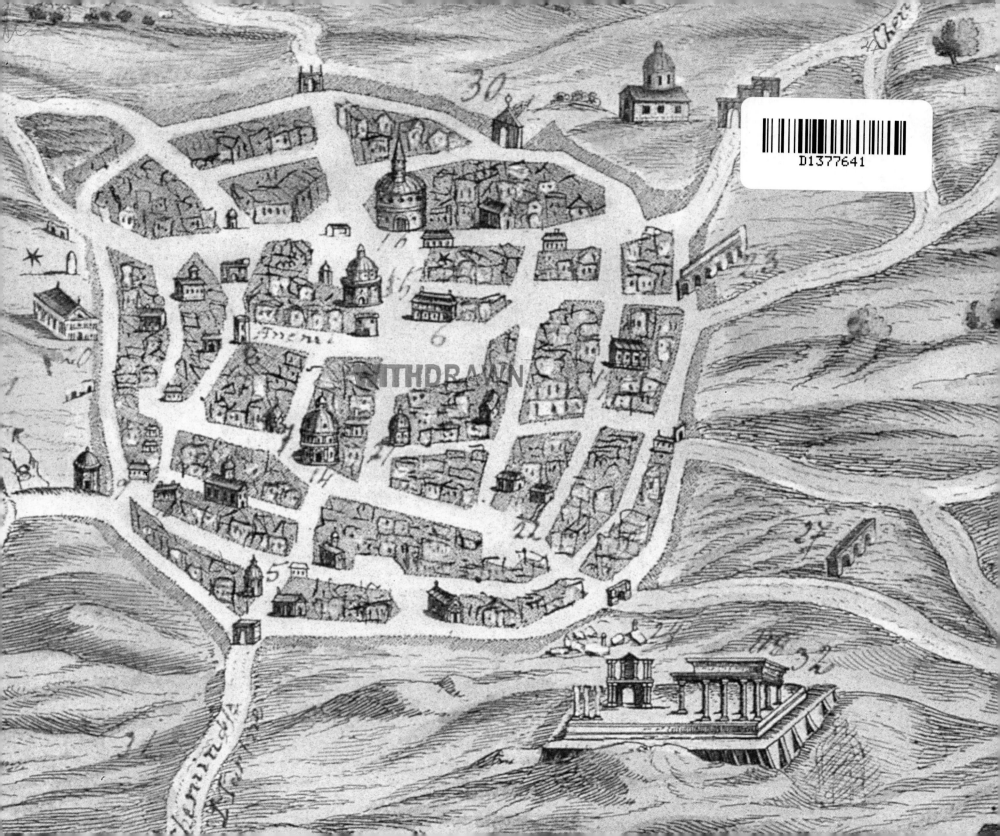

A Luminous Land

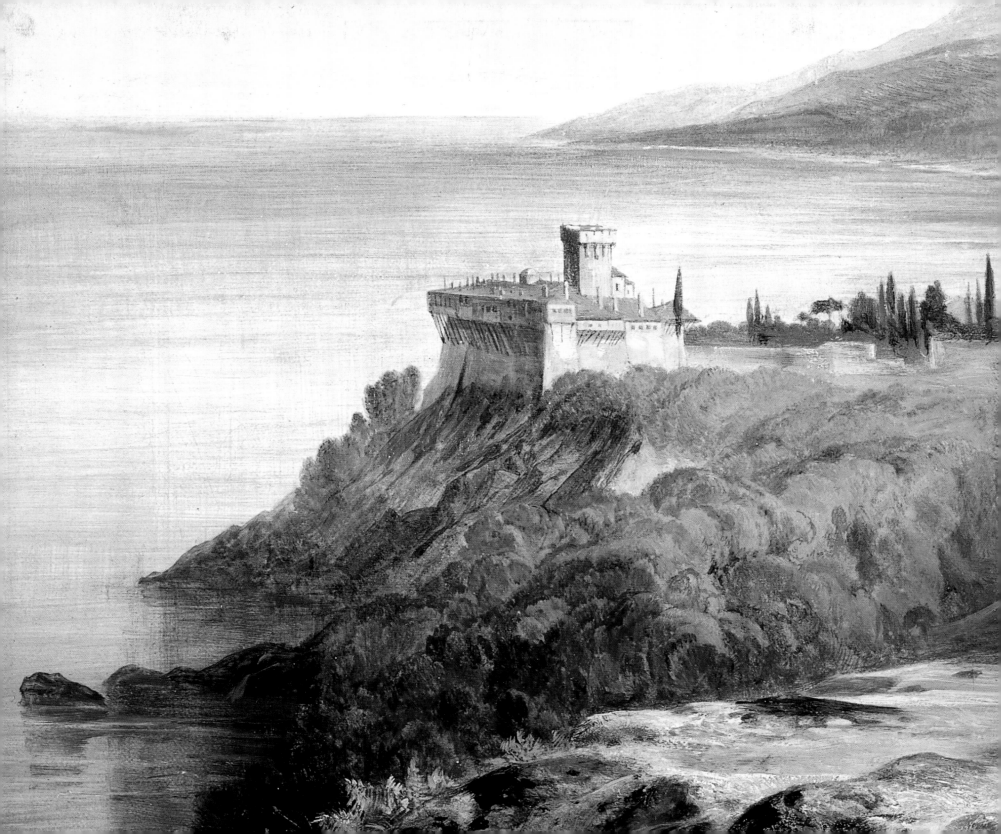

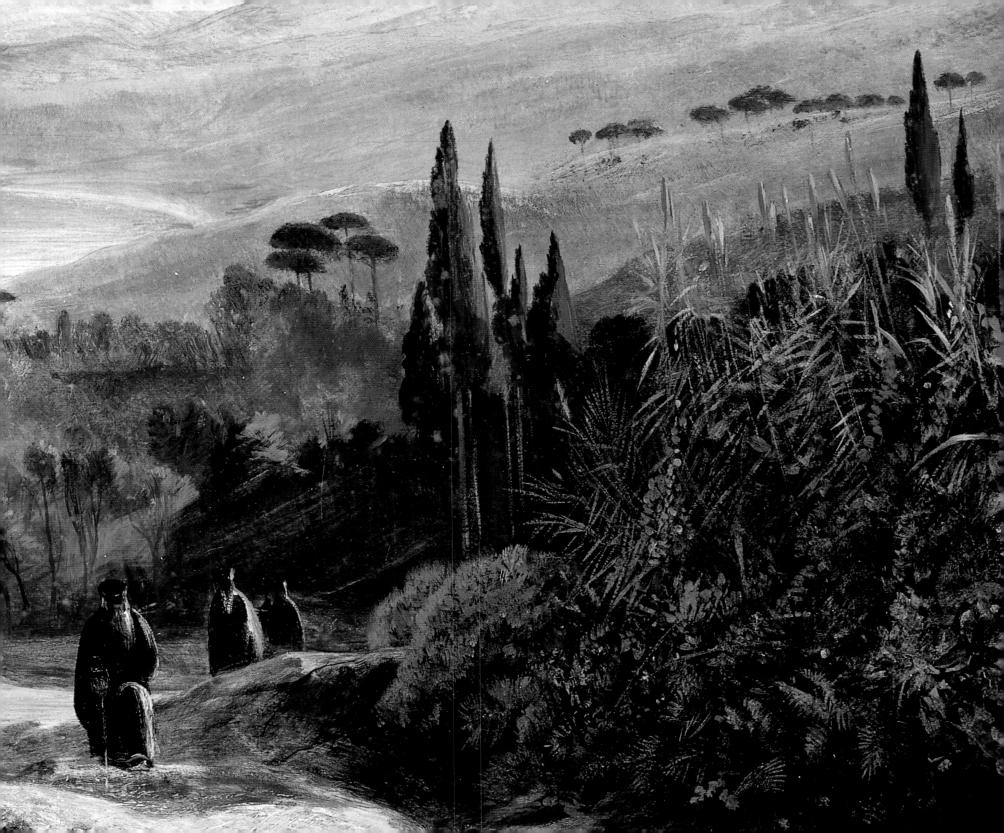

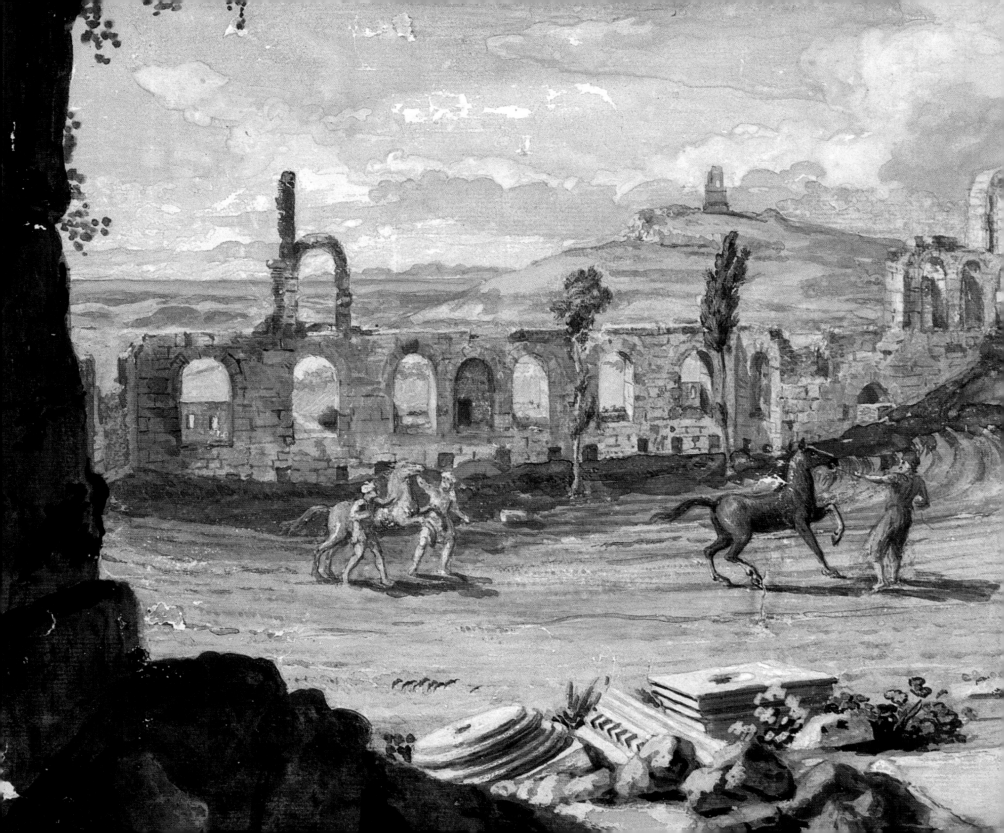

A Luminous Land

ARTISTS DISCOVER GREECE

Richard Stoneman

The J. Paul Getty Museum, Los Angeles

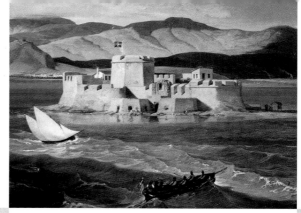

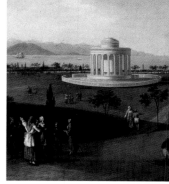

Christopher Hudson, *Publisher*
Mark Greenberg, *Managing Editor*

Tobi Levenberg Kaplan, *Manuscript Editor*
Benedicte Gilman, *Editorial Coordinator*
Elizabeth Burke Kahn, *Production Coordinator*
Pamela Patrusky Mass, *Designer*
David Fuller, *Cartographer*
Theresa Velázquez, *Typographer*
Printed by CS Graphics, Singapore
Color Separations by Professional Graphics,
Rockford, Illinois

Library of Congress Cataloging-in-Publication Data

Stoneman, Richard
 A luminous land: artists discover Greece/Richard Stoneman.
 p. cm.
 Includes bibliographical references and index.
 ISBN 0-89236-467-X
 1. Greece–In art. 2. Greece–Description and travel. I. Title.
N8214.5.G8S76 1998
758'.7495—dc21 97-31228
 CIP

© 1998 The J. Paul Getty Museum
1200 Getty Center Drive, Suite 1000
Los Angeles, California 90049-1687

PRECEDING THE TITLE PAGE:
Edward Lear, *Mt. Athos and the Monastery of Stavroniketes*
(detail of FIGURE 85).

TITLE PAGE:
James Stuart, *View with the Monument of Philopappos
in the Distance & the Artist Sketching in the Foreground*
(detail of FIGURE 11).

To All My Friends in Greece

Acknowledgment is due to the following for permission
to reproduce copyrighted text material: From *Mani:
Travels in the Southern Peloponnese*, by Patrick Leigh Fermor.
© 1958. Reprinted by permission of John Murray, Ltd.,
London. From *The Memoirs of General Makriyannis,
1797–1864*, edited and translated by H. A. Lidderdale.
© 1966. Reprinted by permission of Oxford University
Press, Oxford. From *Edward Lear: The Cretan Journal*,
edited by Rowena Fowler, © 1984; and from *Edward Lear:
The Corfu Years*, edited by Philip Sherrard, © 1988.
Reprinted by permission of Denise Harvey, Greece. From
Edward Lear: Selected Letters, edited by Vivien Noakes.
© 1988. Reprinted by permission of Vivien Noakes, London.

Contents

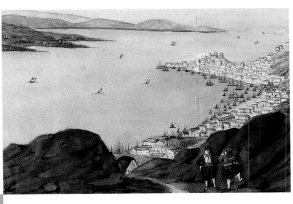

Chronological Table

3000–1200 B.C.	Bronze Age	356–323	Alexander the Great	1204	Crusaders sack Constantinople
2000–1450	Minoan Palace Culture in Crete	323–146	Hellenistic period	1204–1453	Frankish rule in Greece
1600–1200	Mycenaean rule in Greece	146	Roman sack of Corinth	1204–1669	Venetian rule in Crete, Corone,
1450–1200	Mycenaean rule in Crete	86	Roman sack of Athens		Methone, and Euboea
1200–800	Dark Ages	31	Augustus becomes first	1386	Venice acquires Corfu
800–700	Orientalizing period		Roman emperor	1388	Venice acquires Nauplia
750–650	Greek colonization in Mediterranean			1453	Constantinople sacked
	and Black Seas	About A.D. 150	Pausanias travels in Greece		by Ottoman Turks
630–480	Archaic period	324	Constantinople (founded by	1453–1821	Ottoman rule in Greece
490–479	Persian Wars against Greece		Constantine) becomes capital	1463–1540	Venetian rule in parts of Peloponnese
478–323	Greek Classical period		of Roman Empire	1489	Cyprus annexed by Venice
431–404	Peloponnesian War	324–1453	Byzantine Empire		
		393	Olympic Games suppressed		
			by Theodosius		
		529	Philosophy schools of Athens closed		
			by Justinian		

1540	Turks take Monemvasia and Nauplia	1799	Ionian Islands become "Septinsular Republic"	1844	Constitution proclaimed
1566	Turks take Naxos and Cyclades			1862	Otho expelled
1571	Battle of Lepanto	1800–1807	Russian rule in Ionian Islands	1864	Accession of George I
1645–1669	Venetians at war with Turks in Crete; Turks take Crete	1803–1815	Napoleonic Wars	1881	Turks cede Thessaly and Arta to Greece
		1814–1864	British rule in Ionian Islands		
1684–1687	Venetians take Peloponnese from Turks	1821–1827	Greek War of Independence	1913	Greece annexes Crete
		1822	Death of Ali Pasha of Ioannina	1914	Greece annexes Chios and Mytilene
1687	Venetians briefly take Athens; Parthenon damaged by explosion	1824	Death of Lord Byron	1914–1918	World War I
		1827	Capodistria becomes president of Greece (April)	1939–1945	World War II
1715	Turks drive Venetians out of Ionian Islands		Battle of Navarino (October)	1941–1945	Axis rule in Greece
				1945–1949	Greek Civil War
1716	Venice surrenders Peloponnese to Turks	1831	Capodistria assassinated (October)	1967–1974	Dictatorship of the Colonels
		1832	Otto (Otho) selected as king of Greece	1974–present	Democratic rule in Greece
		1834	Accession of Otho		

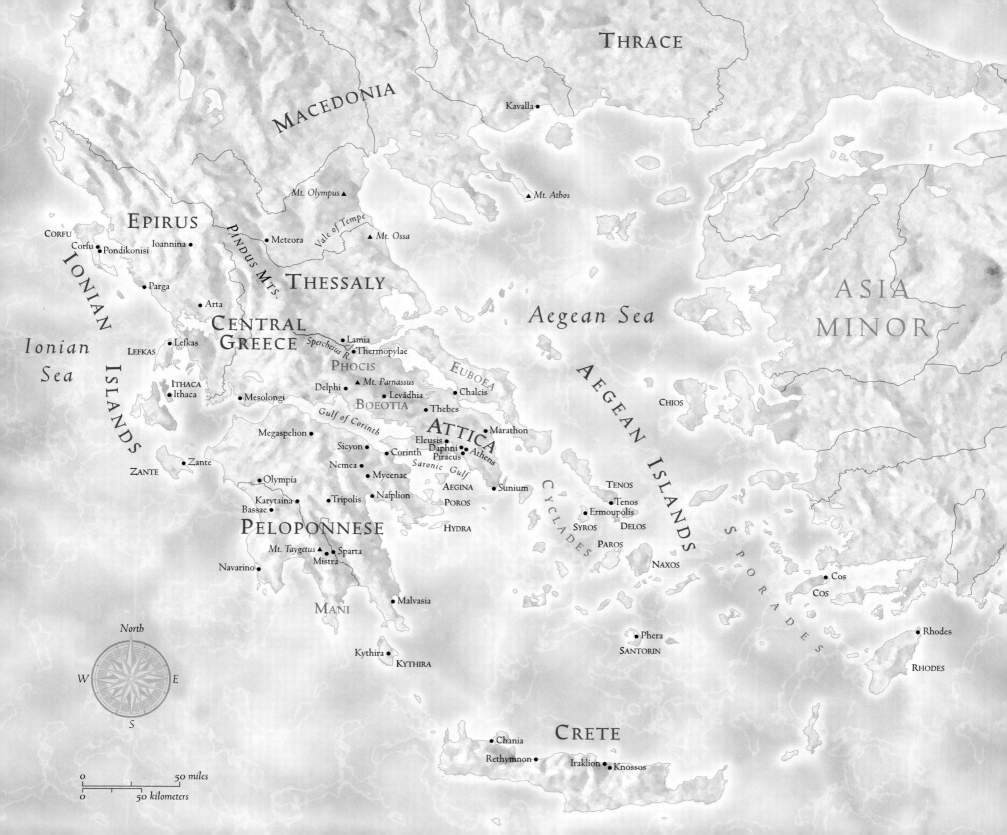

THRACE

MACEDONIA

Kavalla •

▲ Mt. Olympus ▲

▲ Mt. Athos

EPIRUS

CORFU •
Corfu • Pondikonisi
Ioannina •

PINDUS MTS.

Meteora •

Vale of Tempe

▲ Mt. Ossa

Parga •

THESSALY

ASIA
MINOR

Arta •

IONIAN
ISLANDS

CENTRAL
GREECE

Aegean Sea

Ionian
Sea

Spercheius R. • Lamia
• Thermopylae

LEFKAS Lefkas •

PHOCIS

EUBOEA

ITHACA •
Ithaca •

Delphi • ▲ Mt. Parnassus
• Levádhia

• Chalcis

CHIOS

Mesolongi •

BOEOTIA

• Thebes

AEGEAN ISLANDS

Gulf of Corinth

ATTICA

Megaspelion •

• Marathon

Eleusis • Daphni
Sicyon • • • Athens
• Corinth Piraeus

Nemea • Saronic Gulf

TENOS

• Tenos

Zante •

Mycenae •

• Ermoupolis
SYROS

Olympia •

• Nafplion

AEGINA • Sunium

CYCLADES

DELOS

ZANTE

Karytaina •
Bassae •

• Tripolis

POROS

PAROS

PELOPONNESE

HYDRA

NAXOS

Mt. Taygetus ▲ • Sparta
Mistra •

SPORADES

Navarino •

• Cos
COS

MANI

• Malvasia

• Phera
SANTORIN

• Rhodes

Kythira •
• KYTHIRA

RHODES

North

W E

S

CRETE

• Chania
Rethymnon • Iraklion • • Knossos

0 50 miles

0 50 kilometers

TOPOGRAPHY AND THE PICTURESQUE

SEEING GREECE

Even in the present generation, classical scholars have been heard to boast that they have never sullied their understanding of the classics by a visit to the country where the works they study were created. The admission is the more extraordinary at a time when Greece has become one of the easiest of countries to visit, and one of the most popular holiday destinations in the world. But it seemed odd to John Ruskin, over a hundred years ago:

I have not loved the arts of Greece as others have; yet I love them, and her, so much that it is to me simply a standing marvel how scholars can endure . . . to have only the names of her hills and rivers upon their lips, and never one line of conception of them in their minds' sight. Which of us knows what the valley of Sparta is like . . .? which of us, except in mere airy syllabling of names, knows aught of "sandy Ladon's lilied banks, or old Lycaeus, or Cyllene hoar?" (Lectures on Art, p. 103.)

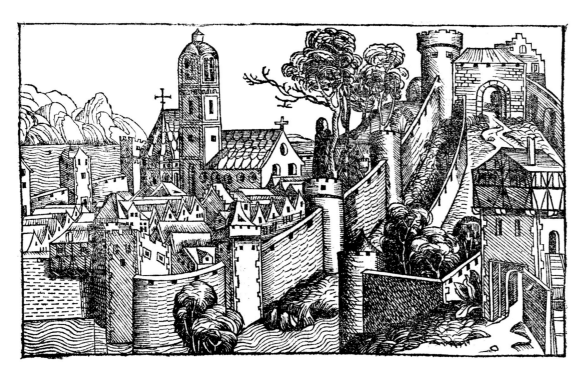

Michael Wolgemuth (German, 1434–1519)
View of Setines [Athens]
Woodcut, 14 x 22 cm (5½ x 8⅝ in.)
From Hartmann Schedel, *Liber Chronicarum* (Nuremberg, 1493), p. 277;
Los Angeles, Getty Research Institute, Resource Collections

This, the first representation of Athens ever published in a Western book, is a purely imaginary view; in fact, the same woodcut serves to represent several other cities as well in the same work. The more accurate work of Cyriac of Ancona, even had it been known to Schedel or his printer, would have been irrelevant to their purposes.

The desire to see Greece—in the most banal sense—inspired lovers of Greek civilization to undertake a journey to the place, even as early as the fifteenth century. The two earliest Western travelers to Greece to take an interest in its antiquities, Cristoforo Buondelmonti and Cyriac of Ancona, both regarded Greece's classical past as the focus of their interest; and both made visual records of what they saw, which—at least in the case of Cyriac—have been of exceptional value to later scholars; but how did they actually *see*?

The question is worth posing because, although there are many depictions of Greece—of its antiquities, its landscape, and its towns—from the Middle Ages onwards, there is perhaps no history of painting of Greece until the middle of the eighteenth century. The eye earlier visitors cast upon the country was essentially different from the gaze of a traveler from the last couple of centuries.

Greece, though it was an entity in the history books, was after the Ottoman conquest no more than a geographical expression as far as Westerners were concerned. In the Middle Ages its ports served as stages on the pilgrimage route to the Holy Land. Few travelers did more than note stray legends as they sailed by. When they published accounts of their travels, they included illustrations of Greek places that had no special privileged status vis-a-vis the other towns portrayed. The town vistas in authors like the fifteenth-century German lawyer Bernhard von Breydenbach were a kind of aide-memoire: as many topographical details as possible were included, so that the illustration took on the quality of a map or guide, almost a pictorial map, rather than a "view." And though topographical detail was important in the record of a pilgrimage like von

Breydenbach's, it was not always important to authors of other kinds of books: Hartmann Schedel in his *Liber Chronicarum* (*Nuremberg Chronicle*), which was published in 1493, found it quite satisfactory to use the same woodcut to represent several cities, Athens included (FIGURE 1). *Seeing* was not central to their perception.

In the seventeenth century, even an artist in the elevated sense, and one steeped in the classics, like the French painter Nicolas Poussin, felt no need to portray a true image of the city of Athens—either as it appeared in his own time or as it had been at the time of his subject—in his two paintings of the body of Phocion carried out of Athens. A conventional, and conventionally splendid, assemblage of classical buildings (mainly in the Roman style) was enough for his purpose. Poussin did not want to *see* Greece.

Such observations should not be taken to belittle the achievement of those painters who did visit Greece and record what they saw. Jacques Carrey is a prominent exception to the rule. In 1674, he traveled with the Marquis de Nointel on his embassy to Constantinople, which turned into a pompous peregrination around the great sites of Greece. Carrey is duly famed for the exact records he made of the Parthenon pediments in 1674, just a few years before their partial destruction by a Venetian shell in 1687, as well as for his large panoramic view of Athens itself (with the Marquis prominent in the foreground)—the earliest proper pictorial record of a Greek scene (FIGURE 6).

But the lesser importance attached to *seeing* explains not only the schematic quality of the first pictorial maps of Athens (by J. P. Babin, Jacob Spon, and George Wheler—all circa 1674) but also the sang-froid with which their contemporary Guillet de la Guilletière perpetrated his spurious travel account of the antiquities of Athens and, later, of Sparta. If it was impossible to know the exact topography of a city, then—rather than settle for the limited amount that was possible—Guillet would follow the advice of Aristotle in preferring as a plot what was probable even if impossible. Even in the eighteenth century, J. D. Le Roy had no compunc-

tion about rearranging the monuments of Athens in his engravings, though his purpose was more artistic: to make the compositions more harmonious, more picturesque. In the nineteenth century, J. M. Gandy still did the same (FIGURE 2).

Other ways of seeing than that of the classical scholar-tourist were of course also important in the sixteenth and seventeenth centuries. Mariners needed maps and charts in order to trade, so that the rise of the portolan chart (a sea-chart indicating ports and the bearings between them) had a significant impact on the perception of the eastern Mediterranean. Some merchants who spent the middle decades of the seventeenth century in the Levant took a real interest in the places they dwelt. The lively books of the seventeenth-century trader Bernard Randolph, for example, contain not only good stories and valuable information, but also interesting, detailed, and probably reliable depictions of certain Greek cities, such as Negroponte and Mistra (FIGURES 32, 42). The Venetian rulers of Greece in the sixteenth and seventeenth centuries made maps for military purposes in which gun emplacements and the position of battlements are the most prominent features. Again, the Venetian geographer Vincenzo Coronelli was able to raise this functional work to the status of a modest art form in his depictions of many of the maritime cities of Greece (for example, FIGURE 43).

The style was extended to the important atlases of the seventeenth century, which were frequently adorned with vignettes or larger depictions of the major cities a sailor would come to—no doubt at least partly with the purpose of assisting the traveler in recognizing the location of his landfall. Present-day taste sees these atlases, and their plates, as collectible art, but in their time they were art or technique in the service of another end.

The change in perception comes in the second half of the eighteenth century, and the first expedition, from 1751 to 1753, of the English club of aristocratic connoisseurs known as the Society of Dilettanti stands on the cusp of the change. The English architects James Stuart and

Nicholas Revett visited Athens on behalf of the Society with a view to creating a truly exact recording of the monuments, and with the further aim of enriching taste and influencing the arts of England. Having got the measurements of the Choragic Monument of Lysicrates, located in Athens, Stuart built a close replica in the park at Shugborough (which Sir William Chambers scorned as being about as artistic as a pewter tankard) and started a fashion. Lysicrates Monuments sprang up everywhere over the next fifty to a hundred years: in Perth, in Elgin, in Nashville, in Chicago, in Sydney. But Stuart was not just a draftsman; he was also an accomplished painter, and his paintings of Athens are the earliest in which the pleasure of seeing seems to converge with the duty of recording (FIGURES 11, 12).

The next expedition sponsored by the Society of Dilettanti was to Ionia, in modern Turkey, from 1754 to 1765. The participants this time included Richard Chandler and William Pars. Chandler's is one of the prosier travel accounts of Greece, but Pars has left a number of excellent watercolors, not only of scenes in Ionia but of Greece as well, in which he traveled more widely than Stuart and Revett, reaching past Sunium to Delphi (see FIGURES 33, 34). The pleasure of a pictorial composition is again to the fore.

The new style coincided with other developments in the arts and politics. The rise of the enthusiasm for "picturesque" scenery and the associated dominance of the "serpentine line" in art and landscape gardening led artists to look at buildings and landscape in a new way. In Comte de Choiseul-Gouffier's significantly named *Voyage pittoresque de la Grèce*, published in 1782, the artistic aim blended with a new awareness of Greece as an enslaved country under Turkish rule. Choiseul-Gouffier was ambassador at Constantinople from 1784 to 1792 and used his position to acquire antiquities, to travel widely in Greece, and to employ artists to prepare pictures of the scenes he visited. Most of the engravings in the *Voyage pittoresque* were based on the work of Jean-Baptiste Hilaire (FIGURE 90), some of whose original paintings also survive. The emphasis on the picturesque in the paintings is combined with a genuine sense of Greece's lack of liberty,

Joseph Michael Gandy (English, 1771–1843)
Imaginary Landscape with Neoclassical Buildings
Watercolor, 29.2 x 48.1 cm (11 1/2 x 16 1/2 in.)
Los Angeles, Getty Research Institute, Resource Collections

This Greek landscape by J. M. Gandy shows how far, even as late as the nineteenth century, artists were ready to go in portraying imaginary Greek buildings. Nicolas Poussin in the seventeenth century had painted Athenian scenes in which the buildings were based on Roman rather than Greek models; but he had never been to Greece. In the eighteenth century, J. D. Le Roy, who did visit Athens, simply moved buildings around in his paintings to "improve" their picturesque qualities.

In this painting, Gandy outdoes both these painters, and also his own reconstruction view of Sparta (Chapter III, FIGURE 47), in portraying a wholly imaginary landscape that brings together buildings of Greek, Roman, and even Egyptian inspiration. The palm trees and the turreted walls hint at a Nilotic landscape; the domes and arched bridges are of Roman inspiration; while pedimented temples of the Greek type form accents in the distant folds of the hills. The style seems to look forward to the fantastic history paintings of John Martin rather than back to Gandy's predecessors in Greece.

Many of Gandy's most elaborate architectural inventions derive from the period when he was working for Sir John Soane in London, after 1811. One of these represents an aerial cutaway view of Soane's Bank of England, in which the contemporary building is altered to the appearance of a classical ruin. This painting, by contrast, shows the landscape as it might be reconstituted through the idealising work of a classical architect. Gandy's work represents a stage in which the architect no longer seeks inspiration from the classical scene (as James Stuart and Nicholas Revett did), but rather attempts to impose on the bare Greek landscape his own architectural improvements.

expressed in the accompanying text and especially in the frontispiece, which portrays Greece as a woman in chains. Choiseul-Gouffier is one of the first authors to express the view that Greece should live up to the example of its heroic past and rise up to throw off the oppressor. This politicized view—however little it features in the choice of subjects for the actual engravings—is one that seems never to have occurred to the English travelers.

Now lovers of Greece began to bemoan the fact they had not visited Greece. Winckelmann wrote about Greek art as if he had seen it, though he never had, and longed to visit Olympia; Goethe found the Greek temples at Paestum in Italy a revelation, but Greece itself remained only a land of longing for him. At the same time more travelers began to go to Greece and Asia Minor—not just those on the various expeditions of the Society of Dilettanti, but major writers like Chateaubriand and Lamartine, as well as scholars like Edward Daniell Clarke and artists in search of a subject.

In part this was due to the closure, as a result of the Napoleonic Wars (fought from 1797 to 1814), of the traditional routes to Italy, where young aristocrats had been accustomed to make their Grand Tour as a conclusion of their education. The enthusiasm for a visit to Greece spread beyond the upper classes to include many who longed to see the scenes referred to in the classical texts they had studied at school. In addition, armchair travelers, inspired by the fashion for the picturesque, began to collect volumes of exotic scenes. William Henry Bartlett, after making a reputation with his numerous architectural views of English cities, made several visits to the Orient, including Greece, and produced more than a thousand views that were engraved and used as illustrations for several handsome folios by different editors. Thomas Allom and William Purser, though a little less productive, worked in the same way. Their work answered to a need among the public—a need which was exploited a little later by Hugh William Williams, whose *Select Views in Greece* was published in serial form in the late 1820s and, admittedly, had a rather smaller com-

pass than Bartlett's work. But there was an eagerness to see what the places looked like, whether one had been there or not.

Most travelers had had some training in watercolors, and even those who were not professional artists, like William Gell, produced satisfying work as a record of their travels (see FIGURE 82). They were helped in this, amateurs and professionals alike, by the device known as the camera obscura, an arrangement of lenses designed to throw an image of the scene before the artist onto a sheet of paper. By tracing around the image, the artist could reliably reproduce the angles and proportions of the original view. The Englishman Edward Dodwell (FIGURE 3) used this device to discourage unwelcome inquiries by the disdar (military governor) of the Acropolis. Dodwell had threatened to imprison the man in the box, along with the antiquities, if he did not stop pestering him. (For Dodwell's account, see my *Literary Companion to Travel in Greece*, pp. 141–42.)

A new movement in the artistic response to Greece began with the growing interest in the political condition of the country. In the early years of the nineteenth century one finds for the first time in the artistic record an interest in individuals, or at least in human types and their colorful costumes. While Charles Cockerell and Carl Haller von Hallerstein devoted their energies to the study of architecture and the depiction of ruins in landscapes, as well as some interesting reconstruction views of ancient buildings (for example, FIGURE 18)—again, a new departure—their traveling companion Otto Magnus von Stackelberg concentrated his efforts not on scenery but on costume portraits (see FIGURE 49). The beautiful hand-colored volumes of his *Costumes et usages des peuples de la Grèce moderne* (Costumes and customs of the peoples of modern Greece), published in the 1820s, bespeak a new response to those who were, after all, the travelers' hosts in the country. The sitters seemed to be the subject of a serious gaze, whereas in the depictions of the seventeenth century—in Tournefort, for example—they had appeared simply quaint. Many series of costume paintings were made and engraved at this time: a set particularly worth mention is the series of watercolors by the

otherwise unknown Georg Rumpf in the Gennadius Library in Athens. Such paintings appealed also to a taste for turquoiserie that had developed at home and was represented in the sprightly portraits of individual Greeks in costume by Richard Bonington and Nicolas Lancret. An interest in individuals in Greece is visible also in Louis Dupré and in Charles Lock Eastlake, whose sensitive depiction of Lord Byron's "Maid of Athens" (FIGURE 21) became a popular engraved print.

The detailed depiction of costume proved invaluable also to the history painters. When the War of Independence began, many painters, especially in France, responded with dramatic and often harrowing depictions of its events. Delacroix' *Scenes from the Chios Massacres* is the best known, but other painters, such as Ary Scheffer and J. Odevaere, practiced the same genre. Though they used correct detail, they did not even attempt to portray the Greek landscape with verisimilitude. The same emphasis characterized the work of the Bavarian genre painter Peter von Hess in his important series of paintings of scenes of the War of Independence. The buildings are accurately depicted, but they are a backdrop for the figures. The same is true of his two large formal paintings of King Otho arriving in Nafplion, then called Nauplia (FIGURE 51), and Athens. In these, every figure is a portrait.

In all these artists, even the landscape artists, one feels that style is dominant. Bartlett's views look much the same whether they are of Greece or Switzerland, Syria or Derbyshire, while of course the depictors of costume had little scope for atmosphere and the history painters had to paint history paintings. But perhaps even the picturesque eye still did not see the landscape in the way that we do. The English scholar Edward Daniell

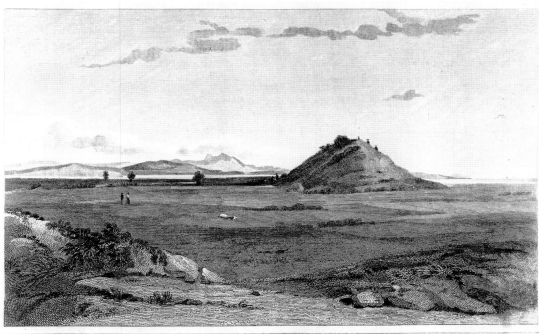

S. Pomardi del. London, Published June 1, 1819, by Rodwell & Martin, New Bond Street. Chas Heath sculpt.

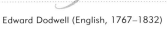

Edward Dodwell (English, 1767–1832)
Great Tumulus in the Plain of Marathon
Engraving, 10.2 x 16.5 cm (4 x 6 ½ in.)
From Edward Dodwell, *A Classical and Topographical Tour through Greece,
During the Years 1801, 1805, and 1806*, vol. 2 (London, 1819), facing p. 158;
Los Angeles, Getty Research Institute, Resource Collections

This is one of the engravings that illustrated Dodwell's two-volume work describing his travels in Greece. It depicts the plain of Marathon, located about 25 miles northeast of Athens, and in the distance the tumulus, or ancient grave, that covers the bones of the Athenians who died in the Battle of Marathon, fighting against the Persians for Greek freedom, in 490 B.C.

Clarke compared the healing sanctuary of Epidaurus with Cheltenham, the romantic charm of the Vale of Tempe with Matlock, and the plains of Thessaly with the Yorkshire Dales. Topographically, perhaps, they are not so unalike; yet the comparison strikes as quaint because it ignores the quality of the light.

THE DISCOVERY OF LIGHT

No modern visitor to Greece fails to remark on the extraordinary quality of the light, its crystalline nature, the way it dissolves distance, the way everything leaps forth in luminosity (this was true even of smog-polluted Athens when I first went there in the early 1970s). The ancient Greeks seem to have been aware of the light; they lived in it as their element. There are many words for *seeing* in ancient Greek, and in one faded metaphor "to see the light" means simply "to be alive." Euripides' Iphigeneia, about to become a sacrifice to the gods, complains simply, "It is sweet to see the light." Light is a symbol in Orthodox thought of mystic union with something higher. You cannot be in Greece and not be aware of light. The character of the light has never been better expressed than by that wonderful interpreter of the Greek scene, Patrick Leigh Fermor (*Mani*, pp. 286–87):

This light, of which I have talked so much, has many odd foibles and conjuring tricks. One of these is the lens-like function of the air. All the vapours that roam the Italian atmosphere and muffle the outlines of things are absent here. A huge magnifying glass burns up the veils of distance, making objects leagues away leap forward clearly as though they were within arm's length. . . . At this late afternoon hour, the hard-hearted mountains turn golden and lavender, the valleys become ground porphyry and powdered serpentine. . . . The light also performs several simultaneous and contradictory acts; it chisels and sharpens everything so that the most fluid curve can be broken up at once, by a shift of focus, into an infinity of angles; it acts like an X-ray, giving mineral and tree and masonry an air of transparence; and it sprinkles the smoothest and most vitreous surface

with a thin layer of pollen like the damask on a moth's wing. . . . The strangest phenomenon of all occurs with the shadows. What little there is at noon is grey and dead, and when the colors revive in the afternoon, they are a cool blue and archways are curving waterfalls. But in the late evening they outglare the solids that fling them, falling across white walls or grey stone courtyards or the dust of a pathway with an intensity like a magnesium flare, standing from the surfaces that register them in electric-blue and orange and sulphur-green shapes as separately as though they were in high relief or deep intaglio. The motionless trench dug by a tree-shadow or the shifting and instantaneous bird-shaped cavity that crosses a terrace looks far more real than the tree-trunk or the swooping bird which they echo; both of these the light, by comparison, has immaterialized.

The young English painter George Basevi defined some of the problems for a painter in a letter to his patron, the architect John Soane, of January 18, 1819:

To convey to you an idea of the colouring of Greece is impossible, it would be first necessary to shew the sun which glows in these climates. Lord Byron has done all that Poetry can do, but even he is very far behind; the dark blue sky, the deep blue sea are beyond the reach of art. I now value our artist Turner more than ever; without having even ever visited Italy, he has devined the effect of an Italian sun and borders on the Eastern. (Quoted from Arthur T. Bolton, *The Portrait of Sir John Soane, R. A.*, p. 277.)

The first painters to respond successfully to this quality of the Greek atmosphere and the landscape it bathes were the Bavarian artists who visited Greece in the first days of Bavarian rule after the Greek War of Independence. King Ludwig I of Bavaria wished to complement his series of Italian views in the Hofgarten at Munich with a similar Greek series, and dispatched Carl Rottmann with a commission for thirty-eight paintings (twenty-three were completed). Rottmann departed for Greece in March 1834 and traveled with a younger colleague and pupil, Ludwig Lange. Rottmann had been told by Peter von Hess, who had worked on official

paintings in Greece, that there was nothing to interest a landscape painter in Greece. (Hess perhaps felt as a German that a real landscape must have green meadows in it). Rottmann knew, even before he left, that Hess was wrong: "That is to me incomprehensible," he wrote in a letter of March 12, 1839, to Carl von Heideck, another painter, who was also the leader of a military expedition to Greece in 1826 to 1827, "... How I shall paint Blue in Greece! I will take a bladder full of cobalt, the biggest a Bavarian boar ever carried in his innards" (quoted from Erika Bierhaus-Rödiger, *Carl Rottman: 1797–1850*, p. 124).

 That bladder of cobalt is indeed the key to Rottmann's view of Greece. His previous experience in landscape painting had been in his native Bavaria and Switzerland; but his pictures change significantly when Greece is his subject. As so often, the watercolors convey the Greek scene better than the more formal oils he worked up later. In all, he made more than four hundred sketches, watercolors, and oil paintings of Greece, mainly of Peloponnesian sites (see Chapter III), plus some of Attica, Thebes, Chalcis, and the nearer Aegean Islands (plus Santorin). Lange covered the same ground and also recorded Delphi (FIGURE 4), Tenos, and other places. Lange also made a number of charming watercolor sketches of contemporary Greeks, a subject which interested Rottmann not at all. King Ludwig was pleased with the work of his artist; after he had visited Greece himself, he noted in his diary (October 18, 1838): "Rottmann is the painter for Greece. Greece and Rottmann were made for each other" (quoted from Erika Bierhaus-Rödiger, *Carl Rottman: 1797–1850*, p. 148).

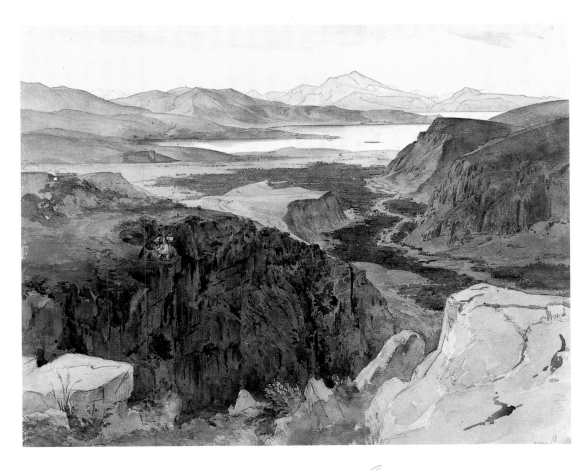

Ludwig Lange (Bavarian, 1806–1868)
Delphi
Watercolor over pencil, 42.2 x 52.8 cm (16⅝ x 20¾ in.)
Munich, Staatliche Graphische Sammlung, inv. 35872

Delphi, perhaps the most magnificent of all Greek sites and now the most visited after the Acropolis of Athens, appears surprisingly seldom in the pictorial record. Rottmann made a few sketches of Mt. Parnassus but drew nothing of Delphi; presumably he never went there. His pupil Lange provides a characteristically romantic representation of this incomparable landscape. From a lookout on the top of the Phaedriades rocks, the view sweeps down the valley of Crisa to Itea. It is plain that for Lange, as for his master Rottmann, it is the sweep of landscape and the light that falls on it that make the essence of a painting.

Yet Rottmann's vision had its limitations. As Lange remarked of him, Rottmann wanted to depict Greece as it had been two or three thousand years before. Contemporary Greeks scarcely ever appear in Rottmann's views, not even as accents or notes of scale, as they do in the work of eighteenth-century artists. Bavarian soldiers are occasionally included and ancient Greeks make their appearance in a view of the Sacred Way. Lange had a different approach, and one that can be seen as continuous with the work of the costume artists of the generation before the War of Independence.

German rule brought a numerous tribe of German artists to Greece, many of them now half-forgotten: Hildebrandt, Hübner, Frey, Wittmer, Koellnberger, Marc, Haubenschmid, Weiler. This German connection had an unexpected and important side effect for Greece. Although the Bavarian dynasty was extremely unpopular and came to an end in 1862, it had sprung out of intimate links already created between young Greeks and the Bavarian capital by the classical scholar and philhellene Friedrich Thiersch. Thiersch had established a connection with the Philomousos Etaireia in Greece that had resulted in bringing numbers of Greeks to study at the Hochschulen and the university in Bavaria. During 1831 and 1832 he was in Greece himself, and was so intimately involved in the peaceful establishment of the constitutionalist rule in Greece that he was on the point of being offered the regency. He maintained his links with Greece until his death in 1860. One result was that Munich was a natural destination for a bright young Greek. One of the first to make his mark was Nikolaos Gysis, a talented artist born on Tenos in 1842, ten years after Thiersch's visit. Gysis studied in Munich with Karl von Piloty and became director of the Munich Academy of Fine Arts. Gysis, one of the first important native painters of Greece, was also the first artist of the so-called Munich school of Greek painting.

Painting had been, in effect, a nonexistent art form in Greece before the revolution. The only piece of native art of that period is the series of paintings of major battles of the Greek War of Independence, carried out by Panagiotis Zográfos under the careful instructions of General Makriyannis: they are not topographical paintings, but attempts to convey the progress and setting of the battles, with successive events depicted in a single frame, and corresponding closely to the verbal records in Makriyannis's own memoirs (FIGURE 77).

Gysis's work represents a completely new departure. Predominantly a genre painter and portraitist, he practiced a wholly European style that can stand comparison with the best contemporary artists of Western Europe. He was not a landscape painter, but several of the younger Greeks who studied at the Munich academy after him were accomplished painters of landscape as well as of portraits, historical scenes, and other subjects. They include the history painter Theodoros Vryzakis as well as Polychronis Lembessis and Konstantinos Volanakis. The importance of these latter two, from our point of view, is that they devoted their talents to the depiction of Greek scenes, Volanakis specializing in maritime scenes and Lembessis producing some wonderful proto-Impressionist landscapes (see FIGURE 28, for example), both with and without ruins. The Italian-born Vikentios Lanza belongs to this period, although he was not trained in Germany, and the slightly later artists Aimilios Prosalentis (also an important portraitist) and the Corfu-born Angelos Giallinas worked in essentially the same tradition.

These Greek painters are much less well known in the West than the artists from Britain of the generation before them, who took advantage of the improved traveling conditions in Greece to make it a tourist destination with brush and palette in hand. The Scottish tourist James Skene, for example, a friend of Walter Scott, traveled in Greece in the Bavarian years (he was there from 1838 to 1845) and produced a remarkable series of paintings, mainly for his own enjoyment (FIGURES 40, 41, 71, 72, 83). The English author and artist Edward Lear, by contrast, made a business of painting. He traveled incessantly to feed the demand he had discovered, and perhaps in part created, for fine paintings of scenes of Greece and the Near East. His first visit to Greece was in 1848, and he

returned several times. In a letter of August 25–26, 1848, he wrote (presumably in ignorance of the German painters' work):

I cannot but think that Greece has been most imperfectly illustrated: the detached views of Athens &c . . . Wordsworth's popular vol. is all too much for effect & has not much character I think I recollect. Williams' Greece I cannot recall—. But the vast yet beautifully simply sweeping lines of the hills have hardly been represented I fancy—nor the primitive dry foregrounds of Elgin marble peasants &c. What do you think of a huge work (if I can do all Greece—) of the Morea and alltogether? But my main object in seeing Greece was improvement in sheer pure landscape—(hang Ruskin,)—& some of that I feel I have got already.

(*Edward Lear: Selected Letters*, ed. Vivien Noakes, p. 83.)

His portfolios of watercolors were produced to tempt patrons into ordering a fully worked-up oil; yet modern taste generally finds the watercolors far more artistically satisfying, more poetic and yet true to the luminous landscape of Greece.

In the twentieth century, landscape painting has lost much of its status as an artistic activity in the face of cubism, surrealism, abstract art, and their successors; landscape seems to be practiced more as a personal satisfaction and diversion than as a major artistic line. Nathaniel Hone is perhaps the last painter of Greece who has made it into the histories. Yet the quiet exercise of topographical art has always been in part a personal activity, as it was for those little-remembered artists whose work appears in, for example, the Ionian Islands chapter of this book (Chapter IV). Their accomplishments have stood the test of time, as have those of the major names from the four centuries from 1500 to 1900, whose vision took on new dimensions because of their experience of Greece. In portrayals of Greece—from the topographical maps to the luminous watercolors of Rottmann and Lear—one can trace a continuous growth of the urge to *see what was there* and to portray the scene for its own sake, as well as a constantly enhanced sense of the painter's major subject, light. While many painters have explored light in different contexts, the unique light of Greece has made for an artistic response that is likewise one of a kind. Painting of Greece is more than an offshoot of a remembered classical education: it is part of the history of painting itself.

ATHENS

The lanthorn [the Choragic Monument of Lysicrates] in Athens was built by Zenocles, the theatre by Pericles, the famous port Piraeus by Musicles, the Palladium by Phidias, the Pantheon [sic] by Callicrates: but these brave monuments are decayed all, and ruined long since, their builders' names alone flourish by mediation of writers.

The English philosopher Robert Burton's pessimistic assessment of the durability of man's creations (in *The Anatomy of Melancholy*, originally published in 1621; part. 3, sect. 1, memb. 3) was not only false in detail, but also responsible for encouraging writers of later ages to envision ancient Athens more or less how they liked. Hartmann Schedel's illustrated encyclopedia *Liber Chronicarum* (Nuremberg, 1493) and Sebastian Münster's *Cosmographia* (Basel, 1541) both contain woodcuts depicting this important city of the world's history: both are completely imaginary (see FIGURE 1, for example). Even in the seventeenth century, after travelers and topographers had begun

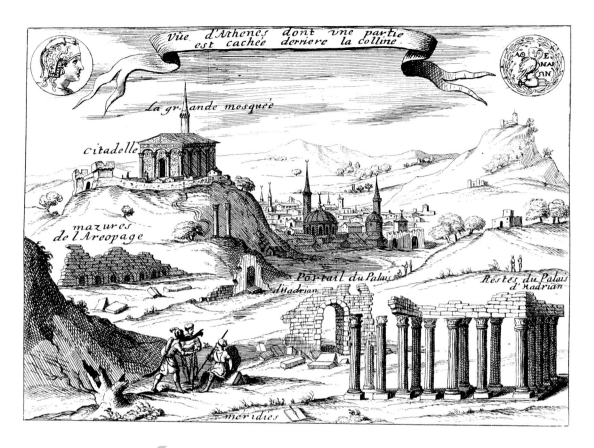

Vüe d'Athenes dont une partie est cachée derriere la colline.

la grande mosquée

citadelle

mazures de l'Areopage

Portail du Palais d'Hadrian

Restes du Palais d'Hadrian

meridies

5

J. P. Babin (French, d. 1699)
View of Athens
Engraving, 14 x 19.5 cm (5½ x 7⅝ in.)
From J. P. Babin, *Relation de l'état present de la ville d'Athènes*
(Lyon, 1674), facing p. 1; Los Angeles,
Getty Research Institute, Resource Collections

This view by J. P. Babin is the first published version of his plan, which was drawn upon by Jacob Spon for his work on the topography of Athens. Essentially a perspective view, it is a valuable record of the appearance of the village of Athens at the end of the Middle Ages. Spon was instrumental in the publication of Babin's work.

to send back reports of the city as it was, artists continued to produce paintings that contained completely imaginary depictions of the buildings and cityscape. Visitors to Greece in the Middle Ages and the Renaissance usually had other things on their minds than antiquities: commerce or pilgrimage were the common motives of Levantine travel.

The modern interest in recovering the appearance of the ancient buildings was first evinced in the Italian merchant and scholar, Ciriaco de' Pizzicolli, usually known as Cyriac of Ancona. In his visits to Greece in the 1430s and 1440s, he wrote journals of his search for antiquities and inscriptions, and drew much of what he saw. Unfortunately, many of Cyriac's manuscripts have been lost, and we are often reliant on copies by later hands. What does survive from his own hand makes clear that he was no expert draftsman, but his drawings of the Parthenon and the Philopappus Monument, for example, preserve important information about the monuments that have since suffered further damage.

The recovery of ancient Athens begins with the visit of Spon and Wheler in the 1640s. Jacob Spon, a passionate antiquary, was a doctor from Lyon who had made a study of the Roman antiquities of Provence and of numismatics. He set off for Greece in 1674, and in Rome fell in with George Wheler, a young English clergyman. Together they traveled to Athens, where they spent many months studying topography (although they were not allowed to visit the Acropolis, which was closed to non-Turks). Their work drew heavily on the studies done by the Capuchin friars housed in the buildings that incorporated the Choragic Monument of Lysicrates, or Lantern of Demosthenes (at that time used as a monk's cell). The Jesuit father J. P. Babin seems to have been the first to produce a topographical plan of Athens (FIGURE 5). Like those done by his contemporaries who worked in other parts of Greece, this depiction combines a perspective view with the

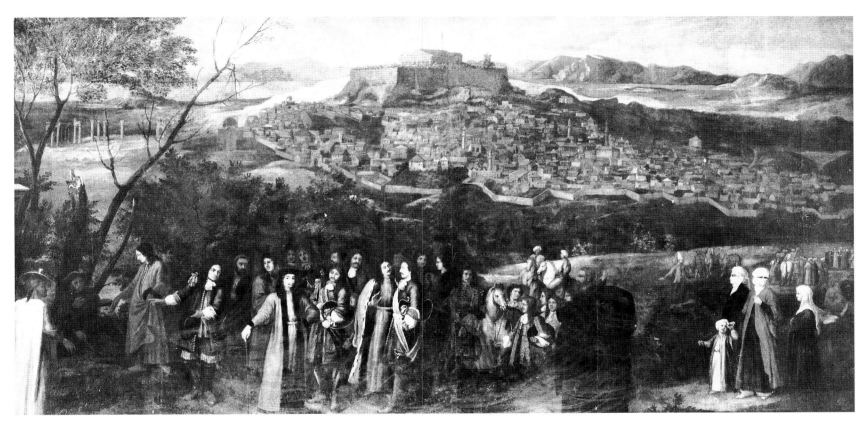

locations of as many features and buildings as possible. The style is followed in a number of deriva-tive maps of the seventeenth century (FIGURE 10, for example), including one drawn by Spon and another, largely derived from Spon's, that Wheler published in his book.

In 1674, while Spon and Wheler were in Athens, an important visit took place: that of the Marquis de Nointel. He had been sent by the French king to negotiate with the Sultan in Constantinople for the renewal of trading privileges between France and the Ottoman Empire. Nointel was less than successful in his mission, but he carried it out in great pomp and style, and devoted considerable time to collecting antiquities. It is to his taste for pageantry that we owe the large painting by Jacques Carrey, Nointel's artist, depicting the arrival of the Marquis in Athens (FIGURE 6). Unlike Spon and Wheler, Nointel was allowed to enter the Acropolis. Carrey made drawings of most of the Parthenon's pedimental figures as well as those of the frieze and metopes of

Jacques Carrey (Flemish, 1649–1726)
The Marquis de Nointel Visiting Athens in 1674
Oil on canvas, 272 x 520 cm (107 1/8 x 204 3/4 in.)
Musée de Chartres, France, inv. 4383
Photo: National Gallery and
Alexandros Soutzos Museum, Athens

This painting by the artist who almost certainly prepared the earliest known drawings of the Parthenon sculptures is a unique record of the appearance of Athens at the time of the Marquis de Nointel's visit in 1674. Although the emphasis is on the grandeur of the ambassador, the monuments and city walls are carefully depicted.

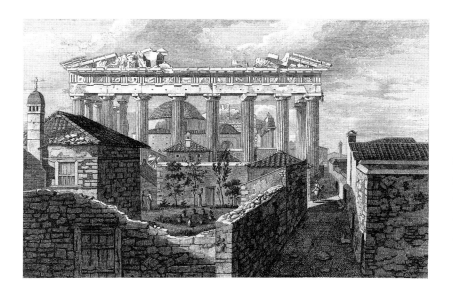

Nicholas Revett (English, 1720–1804)
The Parthenon
1787
Engraving
From James Stuart and Nicholas Revett,
Les antiquités d'Athènes, vol. 2 (Paris, 1808), pl. IV, fig. 1;
Los Angeles, Getty Research Institute, Resource Collections

Revett's is one of very few detailed views of the Parthenon drawn before Lord Elgin's agents removed its sculptures. It vividly shows how, with Greece under Ottoman rule, the Acropolis had been turned into a Turkish village: there is a mosque in the middle of the Parthenon and dwellings crowd all around it. It enables us to understand the problems that the painter and draftsman William Pars had when, as Chandler describes, he climbed to a high and windy spot to draw the frieze in 1765. "Several of the Turks murmured, and some threatened, because he overlooked their houses; obliging them to confine or remove the women, to prevent their being seen from that exalted station" (Richard Chandler, *Travels in Asia Minor and Greece*, vol. 2, pp. 55–56).

the Parthenon, which are an indispensable resource for the modern student of the Parthenon sculptures.

Further French interest in the antiquities of Athens was evinced by the publication in Paris in 1758 of the fine series of folio engravings by Julien David Le Roy, *Les ruines des plus beaux monuments de la Grèce* (The ruins of the most beautiful monuments in Greece), which portrayed most of the main sites in an intense and dramatic style. Some of the monuments were misidentified in their captions, and Le Roy was not above moving monuments about in his views to improve the composition. But these engravings were very influential in drawing the attention of the world to the fine buildings at Athens, the existence of which most had until then not suspected.

The formation in England of the Society of Dilettanti, probably in 1734, introduced the next epoch in the history of the depiction of Athens. The Society was founded as a dining club for aristocrats who had visited Italy, but it quickly acquired aspirations to influence contemporary taste. The growing Western European interest in the "Grecian style" was reflected in the Society of Dilettanti's decision to commission James Stuart and Nicholas Revett, two English architects who had met in Rome, to visit Greece and prepare a study of the monuments of Athens. The two were the first practicing artists to be elected to the Society. They departed in 1750, reached Piraeus in March 1751, and spent two years working in Athens, excavating, measuring, and meticulously documenting surviving examples of classical Greek architecture.

Their work, *The Antiquities of Athens Measured and Delineated*, was filled with carefully rendered engravings like the one of the Parthenon shown in FIGURE 7. It set new standards of accuracy in architectural drawing and greatly influenced the arts in England. Stuart, who was more than a mere draftsman, produced a number of paintings of the Athenian scene (for example, FIGURES 11, 12), sometimes including himself, suitably inconspicuous in Turkish robes, which represent the first real modern paintings to be made in Greece.

In the next generation, the English novelist and art connoisseur Thomas Hope, who had inherited a fortune from his father, made a long tour of Greece and Ionia (from 1788 to 1796) and produced not only a large number of important views of the nearer Aegean islands but also interesting studies of Athens.

By the turn of the nineteenth century, Athens was livening up as a tourist destination, still patronized mainly by Englishmen. It was in 1801 that the agents of Thomas Bruce, Seventh Earl of Elgin, arrived. Lord Elgin had been appointed British ambassador in Constantinople in 1799, and before ever visiting Athens had conceived the idea of acquiring some marbles (as British travelers had done before him) to adorn his new family home at Broomhall, near Dunfermline, Scotland. Elgin was motivated both by acquisitiveness and a desire for "the improvement of the arts in England." He engaged artists to draw and paint the antiquities as well as to make models and to take away "detached pieces if any are found," according to the wording of his firman, a permit issued by officials of the Ottoman Empire. This provision was broadly interpreted by Elgin's secretary, Philip Hunt, as including the demolition of major structures to secure "detached pieces," and, as Hunt reported to the House of Commons Select Committee in 1816, "This was the interpretation which the Voyvode [governor] of Athens was induced to allow it to bear." The story of Elgin's acquisition of the Parthenon frieze, pediments, and metopes has been often told (see especially William St. Clair, *Lord Elgin and the Marbles*), but should not blind us to the interesting work done by his artist, Giovanni Battista Lusieri. The almost photographic precision of his view of the Philopappus Monument (FIGURE 14) may explain why he was a very slow worker. He completed only two other drawings of Athens before his death in 1821. (There are two unfinished views of the Bay of Naples at Broomhall.) Lord Elgin's recompense to the people of Athens for the treasures he had removed was a stolid clock tower, erected near the Roman marketplace; it was demolished in the 1830s. The tower—but not the clock—is pictured in Ludwig Koellnberger's watercolor shown in FIGURE 13.

At the center of the life of foreigners in Athens at this period was the French consul, Louis Sebastien Fauvel, who had arrived there in 1780 and was not to leave until the revolution of 1821, in which Greeks fought for liberation from Turkish rule. For a while Fauvel was agent for the Comte de Choiseul-Gouffier, for whom he collected antiquities. Fauvel collected also on his own account; he also made drawings, maps, and a careful relief map of Athens in plaster of Paris. (These last were acquired by the Bibliothèque Nationale in Paris after his death, when the collection was broken up.) Fauvel was less important for his own achievement than as a focus for the visiting artists. It seemed everyone knew Fauvel: the amateur watercolorist William Gell and the English artist Edward Dodwell were entertained by him, and the French painter Louis Dupré, who visited Greece in 1819, created a memorable portrait of the melancholy Fauvel in the midst of his collection (FIGURE 15).

Modern perception of the early years of the nineteenth century in Greece is dominated by the figure of Lord Byron. The English Romantic poet arrived in Athens in autumn 1809, and

numbered among his acquaintances not only Fauvel and Lusieri but the poet William Haygarth and the Scottish novelist John Galt, as well as the architect Charles Cockerell, who, with a party of Danes and Germans, discovered the Temple of Aphaia on the island of Aegina. For part of his stay in Athens, Byron lodged in the Choragic Monument of Lysicrates (FIGURE 17), which had been converted into a cell as part of the Capuchin convent (FIGURE 16). He also lived with the Macri family, on Ermou Street, whose daughter Teresa he made famous in verse as the "Maid of Athens." Teresa was portrayed also by the painter Charles Lock Eastlake (FIGURE 21), who spent some three and a half months in Athens in the summer of 1818.

Byron met his end in 1824, succumbing to a fever after arriving to take up arms in the Greek War of Independence. The war, naturally enough, curtailed artistic visits to the country by outsiders for its duration. Art in this period is represented almost solely by the naive Greek painter Panagiotis Zográfos. The restoration of peace and an independent government in Greece came in 1829 with the appointment of Ionnis Antonios Capodistria as President of Greece. His assassination in Nauplia (modern Nafplion) on October 9, 1831, led to an interregnum, which was eventually brought to an end, after much discussion between the Western powers, when the young son of King Ludwig I of Bavaria, Otto, was chosen to become king of Greece. Otto arrived at Nauplia, his provisional capital, in February 1833, and was known to Greeks as King Otho.

The reign of Otho (to give him the Greek form of his name), though he became deeply unpopular and was eventually forced to abdicate, lasted nearly thirty years and had a dramatic impact on Greek archaeology and antiquities, as well as on the arts, including painting and architecture. Otho set out to turn into reality the classical vision of Greece beloved by his father, which had already made Munich into one of the great Neoclassical cities. In his reign Athens—now officially the capital of independent Greece—filled up with archaeologists, architects, and painters, mostly from Bavaria, though other Germans and a Dane or two made up the numbers. Foremost among the archaeologists was professor Ludwig Ross, from Berlin, who took in hand the restoration of the Acropolis. He was aided by the architect Leo von Klenze, who had already carried out many architectural commissions in Munich, and was to do more. Another architect, Gustav Eduard Schaubert, had befriended the Greek architect Stamatios Kleanthes in Berlin. They shared a house on the north slope of the Acropolis that later became the first university in Athens and is now the university museum. The most lasting achievement of Schaubert and Kleanthes was the restoration of the Nike Temple on the Acropolis, but their detailed city plan for the development of Athens was abandoned when they came into conflict with Klenze and resigned.

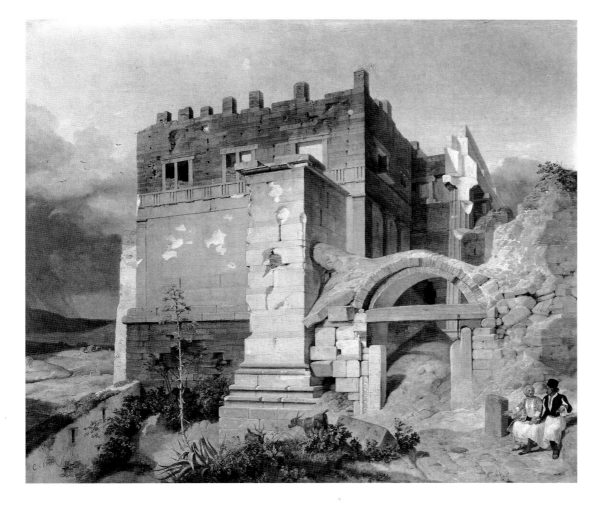

8

Freiherr Carl Wilhelm von Heideck (Bavarian, 1787–1861)
The Ascent to the Acropolis
1835
Oil on canvas, 72 x 87 cm (28 3/8 x 34 1/4 in.)
Munich, Bayerische Staatsgemäldesammlungen, inv. 9895;
on permanent loan to the Museum of the City of Athens

This painting is of interest because it shows the Frankish
palace still incorporated in the buildings of the Propylaea;
it was later demolished in the course of the excavations under-
taken by Ludwig Ross on this and other parts of the Acropolis.

Schaubert and Kleanthes had been pupils of the architect Karl Friedrich Schinkel, who in his turn provided a plan for the conversion of the whole of the Acropolis into a royal palace, with the existing buildings incorporated in it (FIGURE 23). Fortunately, this "renovation" was not carried out either, and the present palace was built instead in Syntagma Square, to the designs of Friedrich von Gärtner, another Bavarian and a long-standing rival of Klenze.

Later in Otho's reign the other great Neoclassical buildings of Athens were built: the Academy (1859–1885, by the Dane Theophilus Hansen), the University (1839–1889, by Hansen's brother Christian), and the National Library (1887–1891, by Theophilus Hansen).

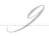

Prosper Marilhat (French, 1811–1847)
The Erechtheum, Athens
1841
Oil on canvas, 74.3 x 92.7 cm (29¼ x 36½ in.)
London, The Wallace Collection

Marilhat traveled in the East during the years 1831 to 1833 and was particularly noted for his African scenes, including many views of the Nile scenery. Architecture is more prominent in this painting of the Erechtheum, or Temple of Erechtheus, than in his Egyptian views, but it is subordinated to the overall aim of a picturesque composition of somewhat sultry atmosphere that shows rather more verdure than is present in reality.

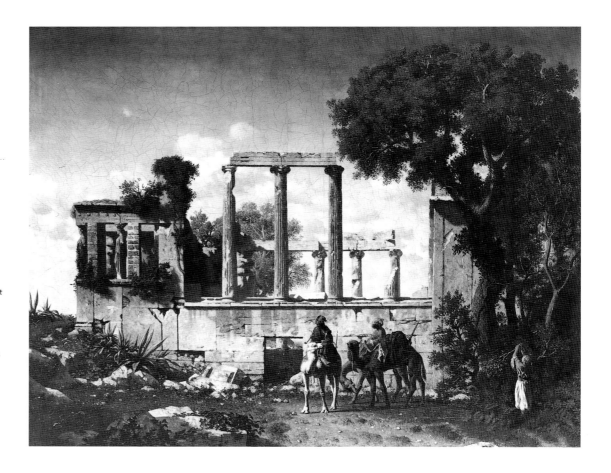

Of the painters, the most distinguished was Carl Rottmann, who had been commissioned by Ludwig I to prepare paintings for the Hofgarten in Munich and was in Greece from August 1834 to about September 1835. He was accompanied by his pupil Ludwig Lange, who, like Klenze (FIGURE 22), prepared a reconstruction view of the Acropolis, but from the east. The Danish painter Martinus Rørbye was also in Athens in 1836 and painted several views (FIGURE 26, for example).

For some time after the establishment of the kingdom, travel for Western Europeans continued to be unsafe on account of brigands, particularly in the Peloponnese. But in the same years, Greece began to catch on as a tourist destination. Visitors came with their brushes and paints, and those less handy with these implements were eager to acquire the paintings of skilled artists as souvenirs of their trip. Athens was just one of the many places that painters depicted, and painting in

Athens is now part of the history of painting in Greece in general. Relatively little-known topographical painters like Prosper Marilhat (FIGURE 9) and Lambert Weston (FIGURE 27) brought their talents to bear alongside artists more strongly identified with the Greek scene, such as Edward Lear and James Skene. The school of native painting, which owed its origins to the example of Nikolaos Gysis (see Introduction, p. 10), began to come into its own in the last third of the century and is represented here by the work of three painters for whom the new awareness of light is a dominant theme: Polychronis Lembessis (FIGURE 28), Iakovos Rizos (FIGURE 29), and Aimilios Prosalentis (FIGURE 30).

The painters of the second half of the nineteenth century offer no such individual vision of Athens as their predecessors, and the emphasis on the interplay of light and monument remains a major element in artistic views of Athens even up to the twentieth century. For example, Nathaniel Hone the younger's turn-of-the-century view of Athens (FIGURE 31), painted under the spell of the Impressionists, reflects his overriding interest in the effect of light. Among present-day travelers to Greece, the ancient ruins still monopolize the visitors' attention, while the fine but crumbling Neoclassical buildings of nineteenth-century Athens, and the little Byzantine churches, attract scant notice from the hordes of tourists bent on experiencing firsthand the glory that was Greece.

The following selection can offer only the merest sampling of the wealth of paintings of all aspects of Athens from four centuries. The holdings of the Benaki Museum and the Museum of the City of Athens on this subject would fill several volumes, to say nothing of paintings located elsewhere. I have tried to offer a representative selection and one that illustrates the development of Athens as a subject for painting. A concurrent theme is the changing fate of the buildings and monuments of Athens, of which the paintings are frequently the best and most vivid record.

ATHENES

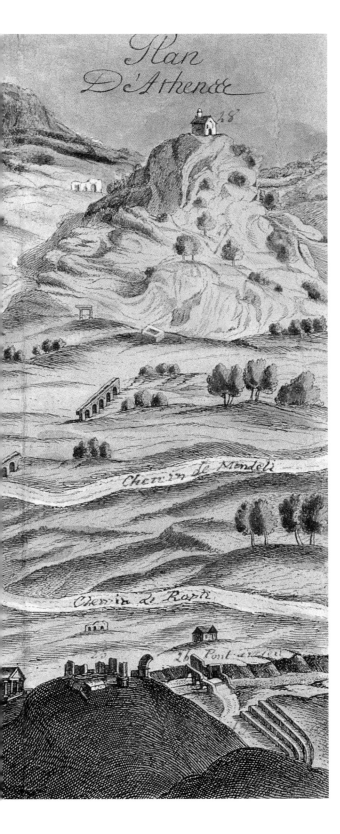

Anonymous
Plan of Athens
ca. 1700
Colored copper engraving,
20 x 39 cm (7 7/8 x 15 3/8 in.)
Athens, Benaki Museum, no. 22955

Closer to the style of a map than J. P. Babin's *View of Athens* (FIGURE 5), this engraving still exhibits features of the perspective view. It draws on the work of Spon as well as Babin to portray the topographical setting of Athens in its landscape. The main antiquities are clearly visible, including the Pnyx, the aqueduct of Hadrian, and the Temple on the Ilissus (the latter two since destroyed).

11

James Stuart (English, 1713–1788)

View with the Monument of Philopappos

in the Distance

& the Artist Sketching in the Foreground

Gouache on paper,

27 x 38.9 cm (10 ⅝ x 15 ¼ in.)

London, British Architectural Library,

Royal Institute of British Architects, inv. Y30/7

The engravings in Stuart and Revett's *Antiquities of Athens* included not only many measured drawings of monuments and details, but also engraved versions of the richly colored gouaches, like this one, that Stuart painted in Athens. Relatively few artists troubled to record the Odeion of Herodes Atticus at the northern foot of the Acropolis. In this view, Stuart, as often, includes himself, dressed in Turkish costume.

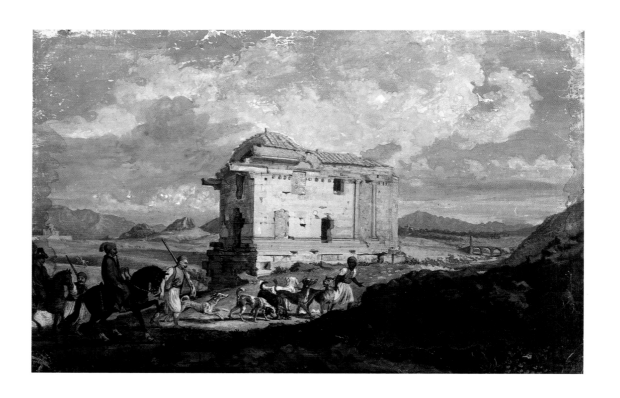

James Stuart (English, 1713–1788)
View of Ionic Temple on the River Ilissus, nr.
Athens, with a Hunting Party in the Foreground
Gouache on paper,
30.5 x 46.5 cm (12 x 18¼ in.)
London, British Architectural Library,
Royal Institute of British Architects, inv. Y30/2

This painting and its engraved version are a valuable record of a building that has since entirely vanished, except for a few stones projecting from the embankment of Arditou Street on its southern side. It was probably the Temple of Demeter in Agris (in the fields) designed by Callicrates, one of the architects who built the Parthenon.

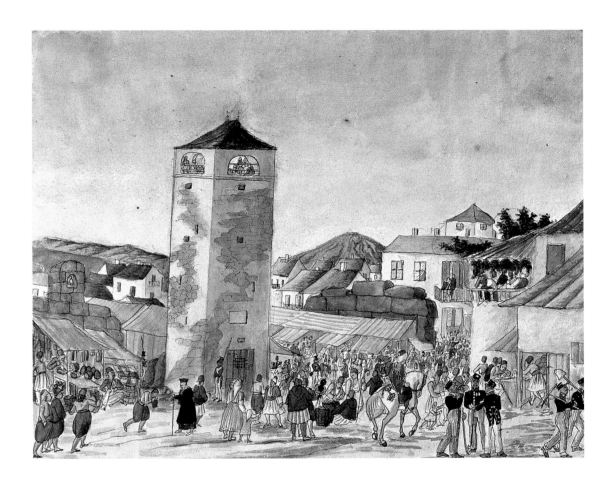

Ludwig Koellnberger (Bavarian, 1811–1892)
Lord Elgin's Tower in Athens
Watercolor, 15.7 x 19.8 cm (6⅛ x 7¾ in.)
Munich, Bayerisches Hauptstaatsarchiv,
Kriegsarchiv, BS III 21.II no. 24

Koellnberger's naive and cheerful—some-what amateurish—style captures the lively market scene dominated by the clock tower given by Lord Elgin to the people of Athens as recompense for his removal of the Parthenon marbles. The tower was demolished not long after this painting was made. Curiously, the clock is not shown in this painting, though Koellnberger's contemporary Adalbert Marc did include it in his rather different representation of the tower. Perhaps we shall never know quite what this august monument looked like.

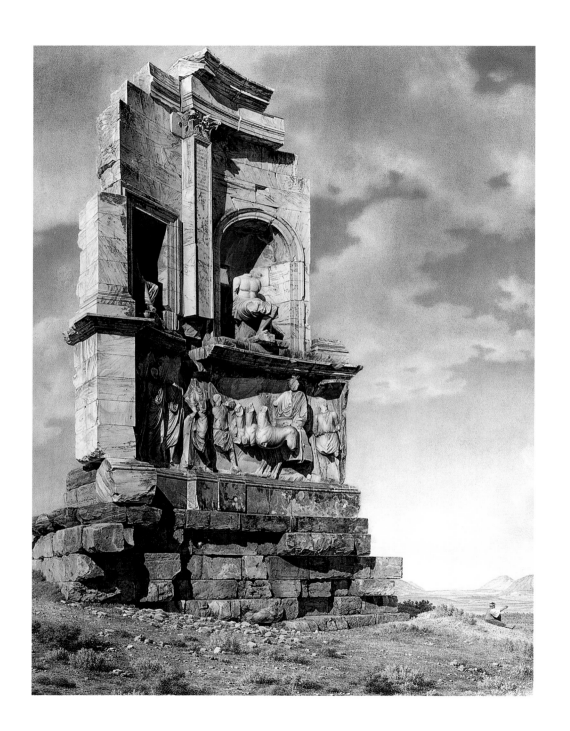

14

Giovanni Battista Lusieri (Italian, 1751–1821)

The Philopappus Monument

ca. 1800

Watercolor, 78.1 x 61 cm (31 x 24 in.)

Collection of the Earl of Elgin and Kincardine,

K.T., Broomhall, Scotland

When one first sets eyes on this painting, it is hard to believe that it is not a photograph. Lusieri's fabled slowness of achievement finds its explanation in his extraordinary attention to detail, which allows every thistle leaf to stand out individually. The colors of the stone, from the deep sandy red of the base to the texture of the marble, are represented with equal fidelity. No archaeologist could ever have asked for more from his illustrator, and it is a pity that so much of Lusieri's work was lost or never completed.

15

Louis Dupré (French, 1789–1837)

Louis Fauvel in His House

Overlooking the Acropolis

1819

Watercolor

Athens, Gennadius Library

Fauvel, the French consul in Athens, was a scholar and collector of antiquities as well as host to all the travelers, painters, poets, and topographers who passed through Athens in the early years of the nineteenth century. Dupré's watercolor portrays a solitary man, perhaps preoccupied with his studies and with the incomparable setting in which he had to work.

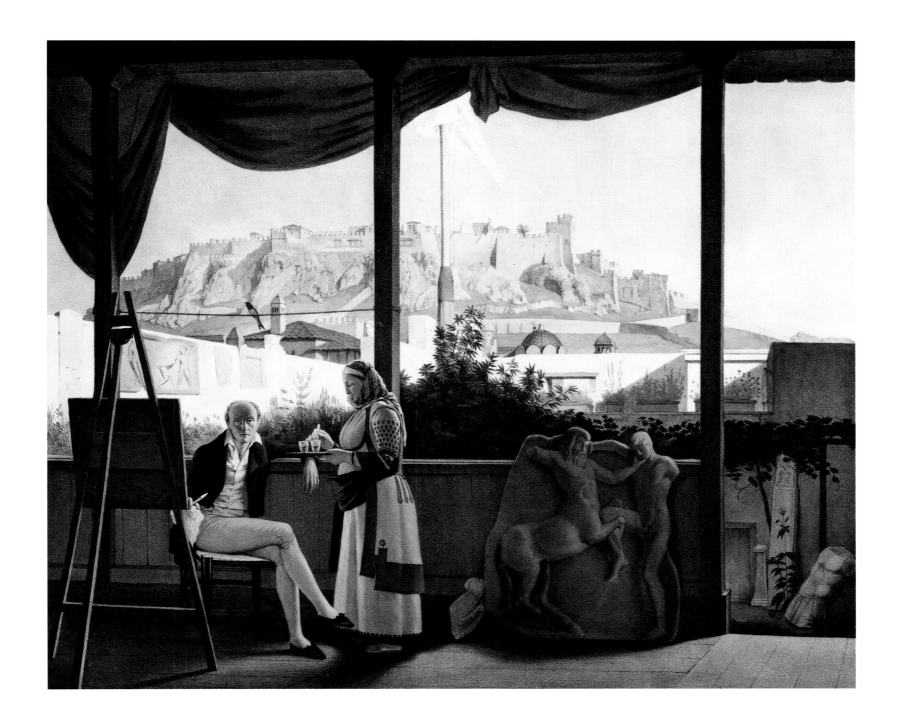

James Stuart (English, 1713–1788)
View of the Monument Walled into the Garden
End of the Hospitum of the Capuchins
Gouache on paper,
27 x 38.5 cm (10^5/$_8$ x 15^1/$_8$ in.)
London, British Architectural Library,
Royal Institute of British Architects, inv. Y30/4

Stuart's painting clearly shows how the Choragic
Monument of Lysicrates (also known as the
Lantern of Demosthenes) had been incorpo-
rated in the buildings of the Capuchin convent.
The interior of the Lysicrates Monument served
as a study for the friars, and Lord Byron, who
lodged in the convent in late 1810, wrote many
letters from here, as well as his invective poem
against Lord Elgin, "The Curse of Minerva."

Simon Claude Constant-Dufeux
(French, 1801–1871)
The Choragic Monument
Watercolor and pencil,
56.8 x 45.1 cm (22^3/$_8$ x 17^3/$_4$ in.)
Los Angeles, Getty Research Institute,
Resource Collections

This large and beautiful drawing, executed in
pen and watercolor, was probably used by
Constant-Dufeux in his lectures on architecture
at the Ecole des Beaux-Arts. It is not certain
that Constant-Dufeux ever went to Greece, so
the drawing may be based on secondary sources.

Charles Robert Cockerell (English, 1788–1863)

The Parthenon Restored.

Front Elevations Showing Ceremony

Taking Place in the Foreground

Tempera, 64.1 x 111.1 cm (25 ¼ x 43 ¾ in.)

London, British Architectural Library,

Royal Institute of British Architects, inv. 055/1

The exhaustive description of ancient Athens and especially of the Acropolis given by the second-century Greek traveler Pausanias, combined with the unusually good state of preservation of the ancient buildings of Athens, inspired many artists and antiquaries to attempt a detailed reconstruction of the city as it might have been in antiquity. In addition to this watercolor, Cockerell prepared two versions of a pencil drawing representing a view of the whole of Athens in the Antonine age, from a vantage point somewhere in the air above the present-day stadium. A good deal of imagination is required to fill out the detail in these.

In this view of the Acropolis, Cockerell stays much closer to the ancient data and even includes the arrival of the annual Panathenaic procession to the Temple of Athena (the Parthenon) accompanied by the wheeled trireme (a ship with three banks of oars) and the robe for the statue of the Athena Parthenos. The details of the pediment are based closely on the existing remains, supplemented by the drawings of Jacques Carrey. (William Page's watercolor of 1818, for example [FIGURE 19], shows how little was still *in situ* by the time Cockerell was working.) Although Cockerell discovered the principle of *entasis* in Greek architecture—the slight curvature given to all the lines in order to make them appear straight yet lively—this aspect is not visible in this painting, nor in the measured and ruled watercolor drawing of the interior of the Parthenon, which he also prepared.

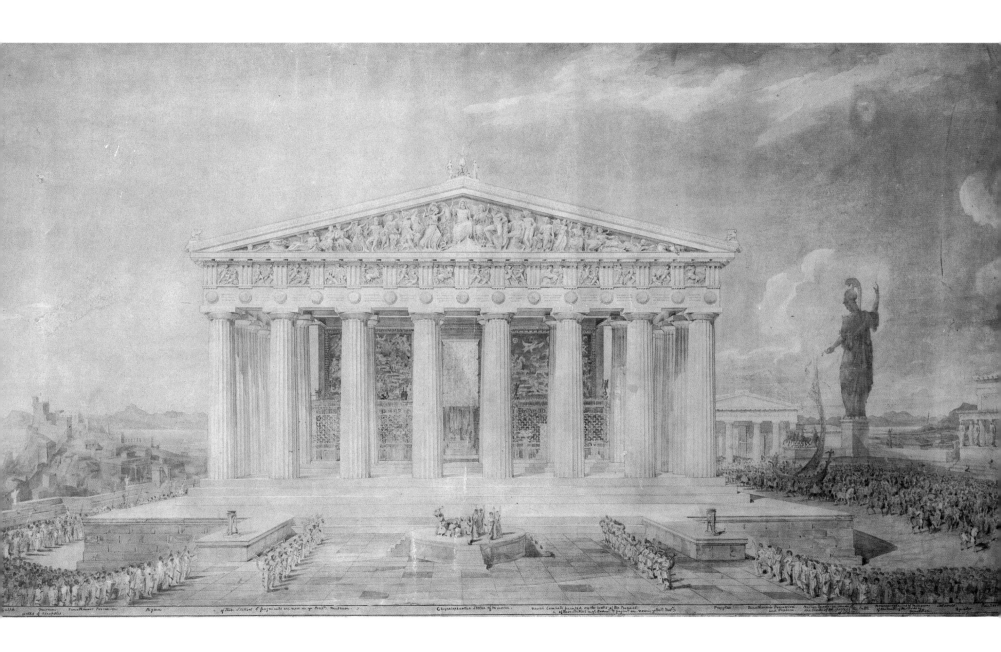

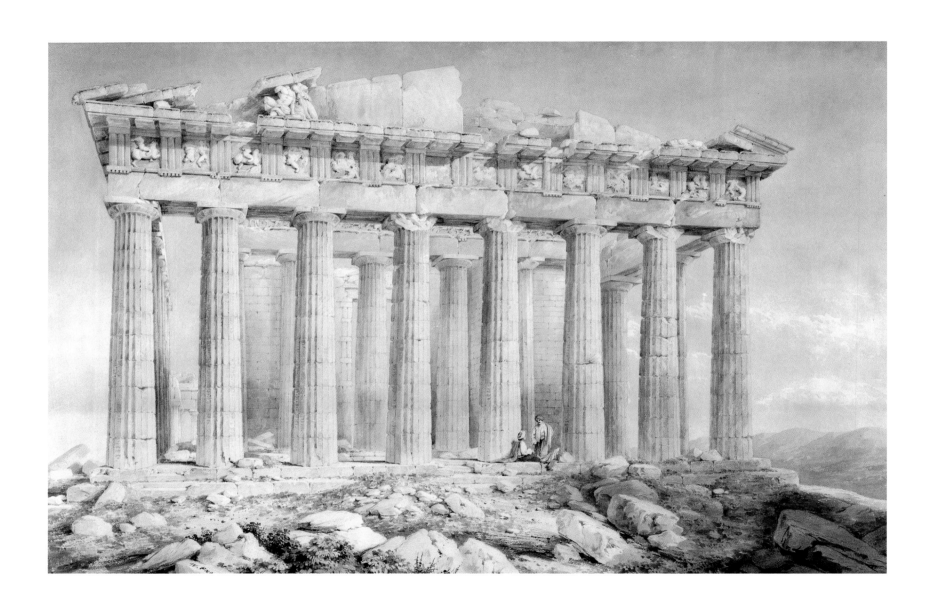

William Page (English, 1794–1872)

The Parthenon from the West

1818

Watercolor

Athens, Gennadius Library

This view of the Parthenon shows the temple substantially clear of surrounding buildings, no doubt reflecting the work of Lord Elgin's agents in removing the sculptures. The appearance of the Parthenon had thus reached more or less its present form.

Anonymous
Byron in Athens
Oil, 97 x 74 cm (38 1/8 x 29 1/8)
Athens, Benaki Museum, inv. 1100

This painting by an unknown artist shows
Lord Byron resplendent in Greek costume,
leaning against an imaginary classical building
with a view of the Acropolis — and, apparently,
the Odeion of Herodes Atticus — in the
background. The date is unknown, but clearly
Byron was already beginning his identification
with the Greek people that was to lead him to
take part in the War of Independence.

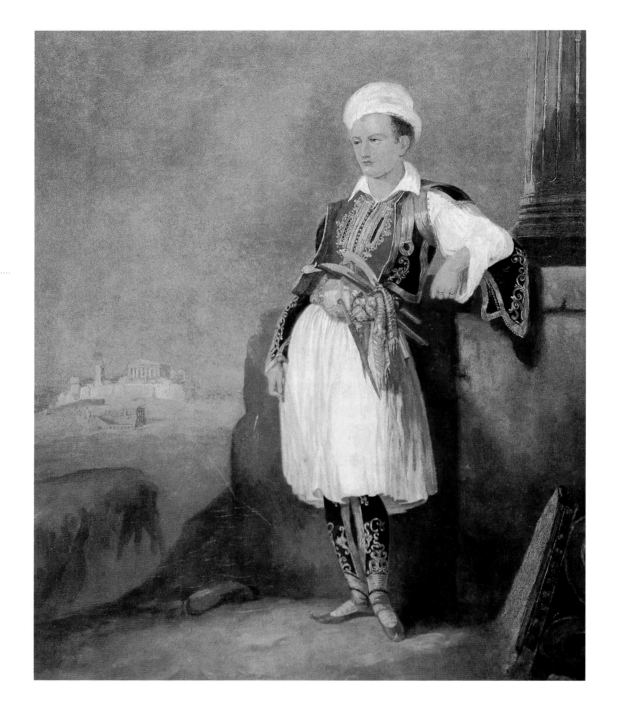

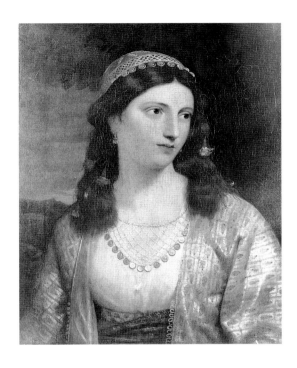

21

Charles Lock Eastlake (English, 1793–1865)
Haidee, a Greek Girl
1827
Oil on canvas, 63.5 x 50.8 cm (25 x 20 in.)
London, The Tate Gallery, inv. 398

This portrait of Teresa Macri, "The Maid of Athens," was painted in 1827 and exhibited at the Royal Academy in 1831, on which occasion it was described by the Duke of Wellington as "the best picture in the exhibition." It was later engraved by R. Graves. The portrait is based on an earlier version that was probably painted during Eastlake's three-and-a-half-month stay in Athens during 1818. Lord Byron had lived in the house of the Macri family from 1809 to 1810 and had fallen in love with Teresa, then aged twelve. He later told Hobhouse, "I was near bringing away Theresa, but the mother asked

30,000 piastres!" (letter of May 15, 1811; quoted from Leslie Marchand, *Byron: A Portrait*, p. 96). Byron's casual tone is belied by the depth of feeling in his poem to Teresa, composed in 1810, which made her famous.

> *Maid of Athens, ere we part,*
> *Give, oh give me back my heart!...*
>
> *By those tresses unconfined,*
> *Wooed by each Aegean wind;*
> *By those lids whose jetty fringe*
> *Kiss thy soft cheeks' blooming tinge;*
> *By those wild eyes like the roe,*
> *Ζωή μου, σᾶς ἀγαπῶ.*

Even after she later married, Teresa Macri Black remained one of the "sights of Athens" for the rest of her life.

Leopold Frank Karl von Klenze
(Bavarian, 1784–1864)
View of the Acropolis from the West
1846
Oil on canvas,
102.8 x 147.7 cm (40$\frac{1}{2}$ x 58$\frac{1}{8}$ in.)
Munich, Bayerische Staatsgemäldesammlungen,
Neue Pinakothek, inv. 9463
Photo: Artothek, Munich; Joachim Blauel

The Bavarian architect Leo von Klenze was responsible, with the archaeologist Ludwig Ross, for the restoration of the buildings of the Acropolis. The scholarly underpinning of Klenze's sensitive restoration work is apparent in this masterly reconstruction painting of the Acropolis. The artist shows the site as it might have appeared in antiquity, with every stone, as it were, clearly depicted. The colossal figure of the Athena Parthenos (one of three statues of Athena on the Acropolis) towers above all, and the Temple of Nike appears just as it was restored in the early years of Otho's reign. The foreground of the painting is imaginary.

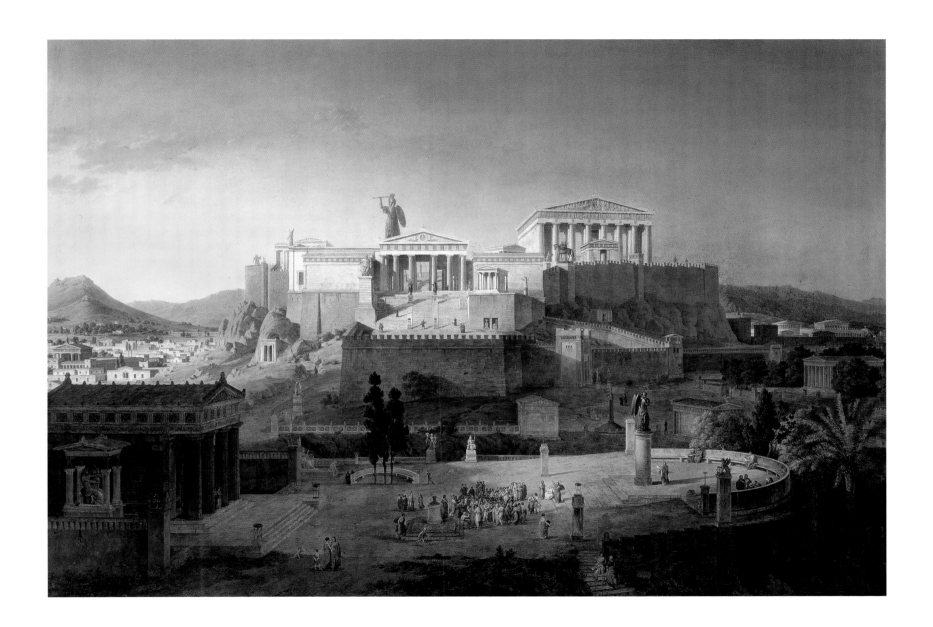

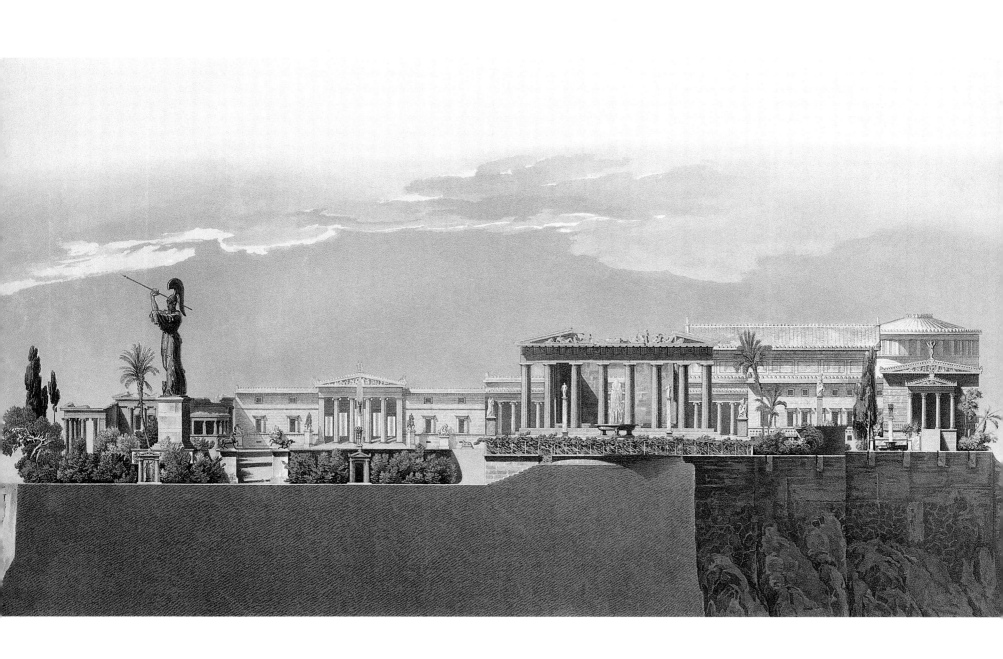

Karl Friedrich Schinkel (Bavarian, 1781–1841)

Sketch for a Palace for King Otto of Greece

on the Acropolis in Athens

1834

Colored lithograph after Schinkel,

43.2 x 78.4 cm (17 x 30⅞ in.)

Staatliche Museen zu Berlin-Preußischer

Kulturbesitz, Kupferstichkabinett, inv. F 833a

The distinguished architect Schinkel, professor at the Berlin Royal Academy, was responsible for many of the Neoclassical buildings that transformed Berlin in the early nineteenth century. Though Schinkel never visited Greece, in 1834 he was engaged by Ludwig I to prepare a plan for a royal palace for Otho on the Acropolis, one that would incorporate the existing buildings in a restored form. We can be thankful that the plan was never executed. The influence of classical architecture, and of the buildings of Athens, on Schinkel's work is visible also in his now-lost painting, *Blick in Griechenlands Blüte* (Glimpse of Greece in its heyday), and in his *Project for a Palace at Orianda*, incorporating a version of the Erechtheum.

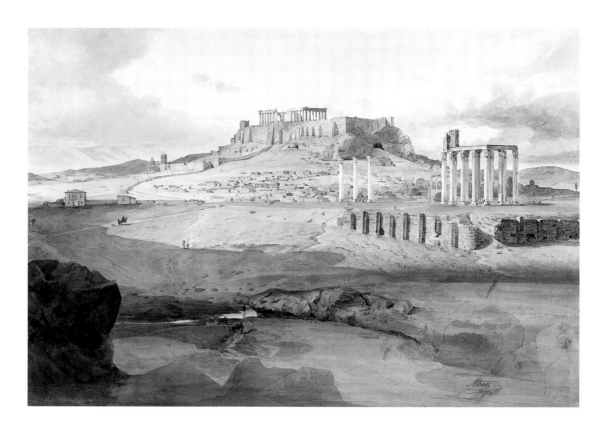

24

Ludwig Lange (Bavarian, 1806–1868)

Athens from the Southeast with the

Temple of Olympian Zeus

1835

Watercolor, 39 x 54.6 cm (15⅜ x 21½ in.)

Munich, Staatliche Graphische Sammlung,

inv. 35776

This view from somewhere near the modern Arditou Street shows a still essentially rural Athens. The hermit's hut constructed on the top of the Temple of Olympian Zeus is clearly visible in the painting. Edward Daniell Clarke remarked on this structure in 1804: "Upon the top of the entablature, on the western side of the principal group, is shewn the dwelling of a hermit, who fixed his solitary abode on this eminence, and dedicated his life entirely to the contemplation of the sublime subjects by which his mansion was everywhere surrounded" (*Travels in Various Countries of Europe, Asia and Africa,* vol. 6, p. 321). It is not clear whether the hut continued to be inhabited thirty years later.

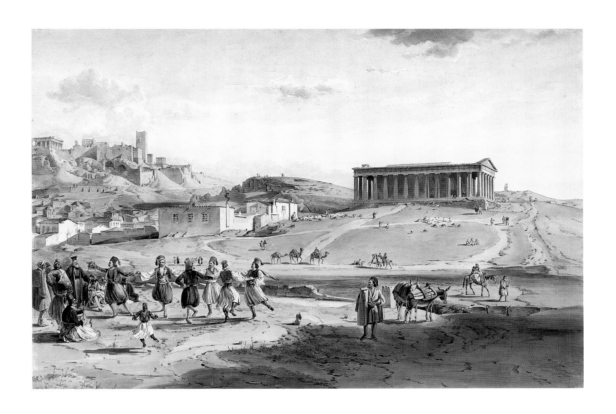

Ludwig Lange (Bavarian, 1806–1868)

The Theseion with Peasants Dancing

Watercolor, 62 x 91.4 cm (24 3/8 x 36 in.)

Munich, Staatliche Graphische Sammlung,

inv. 35759

This painting exemplifies Lange's greater interest than his teacher Rottmann in the human figure. However, while many of his figure studies are of single figures in their normal costume, or engaged in normal pursuits, this painting seems to have been worked up to portray a scarcely credible idyllic vision of Greek life, perhaps reflecting the spontaneous joy Ludwig Ross detected in the peasants when they encountered their Bavarian king. If Otho's was in a sense a fairy-tale kingdom, just as much as his nephew Ludwig II's in Bavaria, this painting expresses the nature of the fairy tale.

Martinus Rørbye (Danish, 1803–1848)
Greeks Fetching Water from the Well
at the Tower of the Winds in Athens
1836
Oil on canvas, 30 x 41.5 cm (11¾ x 16⅜ in.)
Copenhagen, Ny Carlsberg Glyptotek,
inv. I.N. 3100

The Danish painter Rørbye was in Greece in
1835 and 1836. The Tower of the Winds had
been erected in the second or first century B.C.
and was surmounted by a weather vane. Its eight
walls each bore a portrayal of the wind that
blew from that quarter. During the Turkish
period, it had been used as a *tekke* or chapel by
the mystical sect of the Whirling Dervishes,
who practiced their ecstatic dances there. Since
then, its floor and surroundings had become
covered with soil to half the height of the door.

A painting by Stuart of some seventy years
earlier shows a group of children playing about
a doorway scarcely two feet high. This romantic
view by Rørbye shows how little had changed
in those seventy years. All the soil had to be
cleared away when the tower was excavated as
part of the restoration directed by Klenze and
Ross in the 1830s.

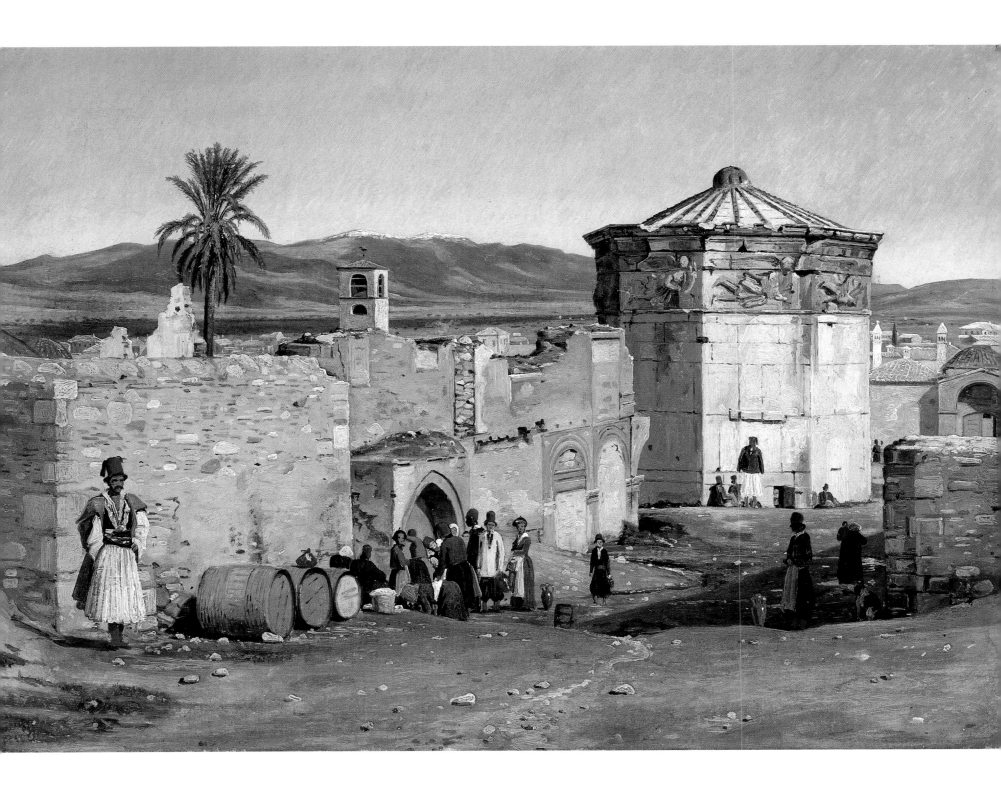

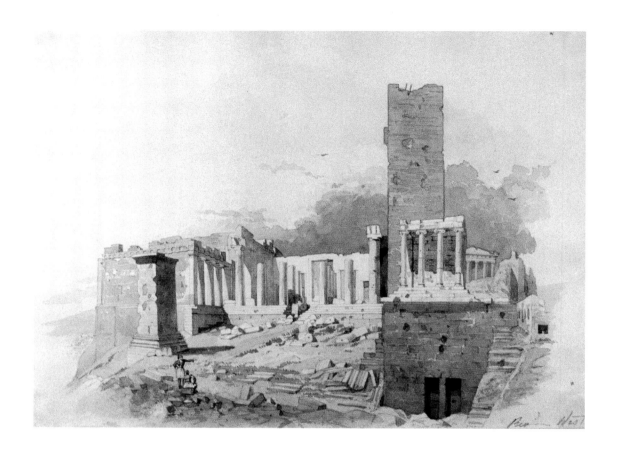

27

Lambert Weston (English, 1804–1895)
The Propylaea of the Acropolis
Watercolor, 19.5 x 26 cm (7 5/8 x 10 1/4 in.)
Museum of the City of Athens, inv. 717

The Propylaea, the monumental gateway to the Acropolis, was built in the fifth century B.C. This atmospheric watercolor, suffused with light and dissolving at the margins into Greek atmosphere, is of historical importance because it clearly shows the imposing Frankish tower built as part of the Medieval defenses of Athens.

The tower had been left untouched during the restoration by Ross and Klenze. It was finally demolished in 1874 as a gift by Heinrich Schliemann to the people of Athens, restoring the harmonious and exclusively classical appearance of the western approach to the Acropolis.

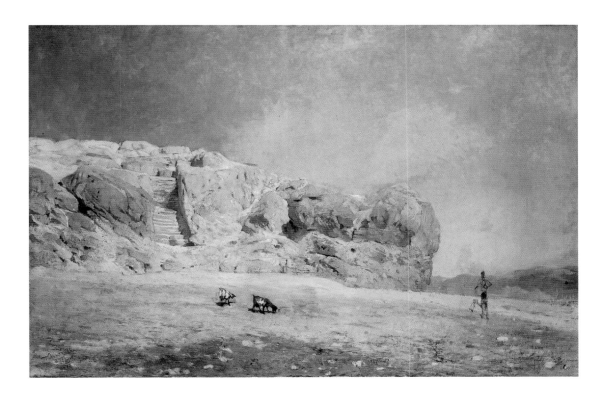

Polychronis Lembessis (Greek, 1848–1913)

The Areopagus

1880

Oil on canvas, 62.5 x 95 cm (24⅝ x 37⅜ in.)

Athens, National Gallery and

Alexandros Soutzos Museum, inv. 2424

With the growth of a national school of painting in Greece, landscape painting became an important feature of Greek art, alongside portraiture and historical painting. In Lembessis's painting, the Areopagus, or Rock of Ares, becomes a shimmering idyll that betrays both the influence of German training on the artist and his natural response to Greek light.

Iakovos Rizos (Greek, 1849–1916)

Athenian Evening

1897

Oil on canvas, 111 x 167 cm (43¾ x 65¾ in.)

Athens, National Gallery and

Alexandros Soutzos Museum, inv. 1108

This Belle Epoque vision of Greece, where the incomparable view becomes a setting for elegant living, shows an aspect of life in nineteenth-century Greece that is not as familiar as the more numerous portrayals of rural scenes and families.

Aimilios Prosalentis (Greek, 1859–1926)
The Lysicrates Monument
Watercolor, 97 x 66 cm (38 1/8 x 26 in.)
Athens, National Gallery and
Alexandros Soutzos Museum, inv. 6922

Prosalentis achieves both precision and luminosity by the use of watercolor for a large-scale study. There is a certain timeless and classic quality about the treatment, which gives a sense of the unchangingness of Greek monuments.

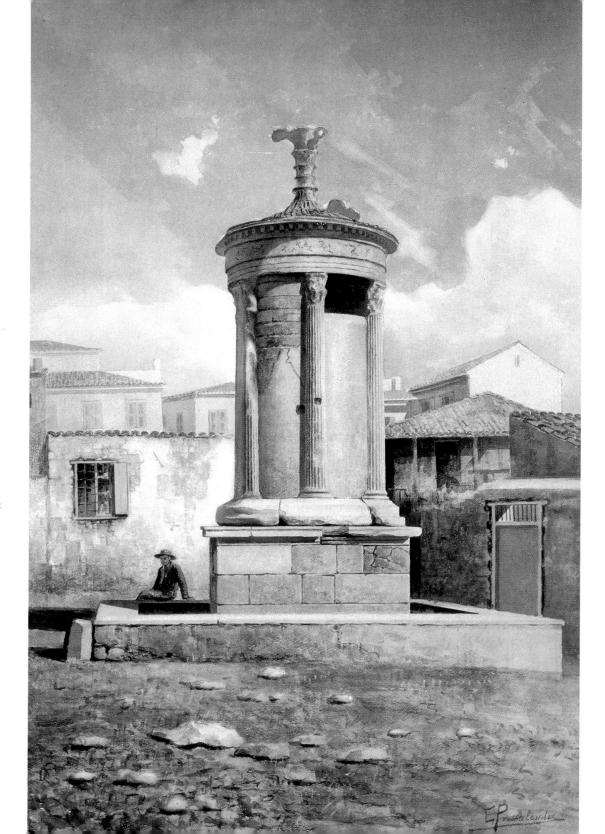

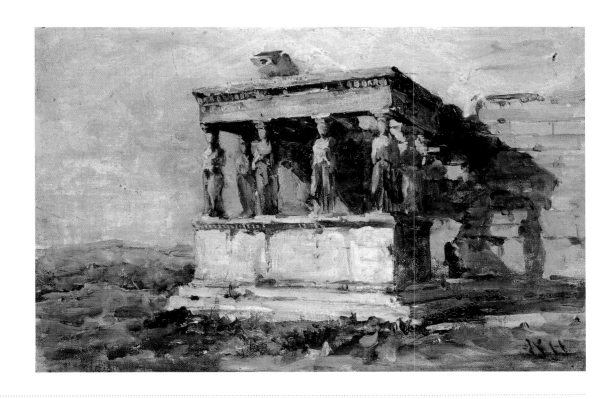

Nathaniel Hone, the younger (Irish, 1831–1917)

The Caryatids

1891/1892

Oil

Dublin, National Gallery of Ireland, inv. 1367

Reproduction by courtesy of the

National Gallery of Ireland

The Dutch-genre style of the elder Hone is superseded in the younger by an Impressionist concern with light effects in which detail dissolves in a shimmering blaze. The light behaves in a similar way whether Hone is painting his native Wicklow or scenes of Egypt or Greece. Hone traveled widely in the Mediterranean, and was in Athens in 1891 and 1892. He made a number of watercolors of scenes in Athens as well as a couple of Corfu harbor. This painting of the porch of the Erechtheum, supported by female figures (Caryatids) in place of pillars, is one of the few he worked up into an oil painting.

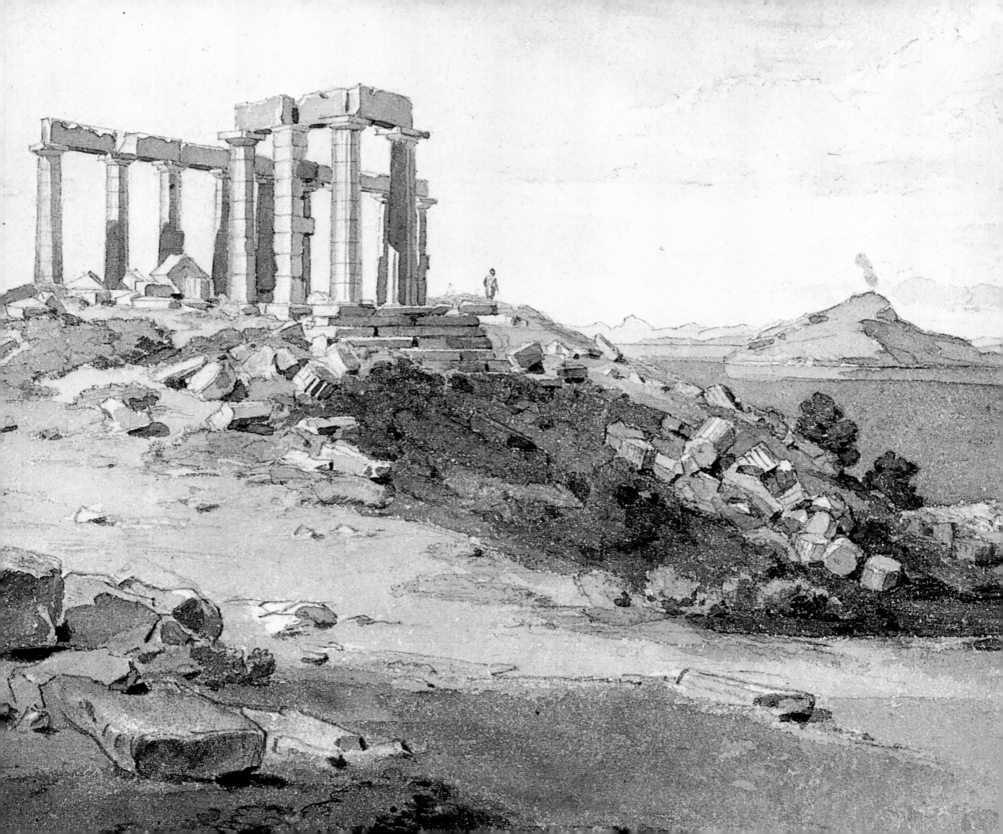

ATTICA AND

AEGINA

*T*he artistic record for Attica (the region around Athens) and the island of Aegina is much less varied than that of the city of Athens itself. Bernard Randolph (FIGURE 32) was one of the earliest visitors, arriving in the seventeenth century. Though the Society of Dilettanti included the temple at Eleusis, a half-dozen miles outside of Athens, among the objects of its expedition led by Richard Chandler in 1764 to 1766, the engravings in the resulting volumes of *Ionian Antiquities*, published in 1769, were overshadowed by the numerous lovely watercolors produced by the expedition's artist, William Pars (FIGURES 33, 34). The extension of the Grand Tour in the late eighteenth century also encouraged the publication of albums of scenes from Greece and other parts of the Ottoman Empire. Such publications of engravings provided work for two pleasing artists, W. H. Bartlett and Thomas Allom. Both included scenes such as Sunium in their portfolios. Sunium, indeed,

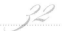

Bernard Randolph (English, 1643–after 1689)
Negroponte [Chalcis]
Engraving, 16 x 22 cm (6¼ x 8⅝ in.)
From Bernard Randolph, *The Present State of the Islands in the Archipelago* (Oxford, 1687)

In this engraving, Randolph provides his usual informative and detailed topographical view with elements of the map in its presentation. Chalcis is not strictly in Attica, as it lies on the other side of the narrow strait dividing Attica from the island of Euboea, but in the seventeenth century the strait was spanned by a fortified bridge. Randolph shows the bridge here and mentions it in *The Present State of the Islands in the Archipelago* (pp. 1–2):

From the maine to the small island [D] is a bridge built upon six good arches [only four are visible in the engraving], and thence to the maine castle [B] is a draw-bridge about 30 yards long. The maine castle is two miles in compass, fortified with six very large towers, or rondells; the walls are high and thick with a dry ditch to the land, which is almost filled up with rubbish.

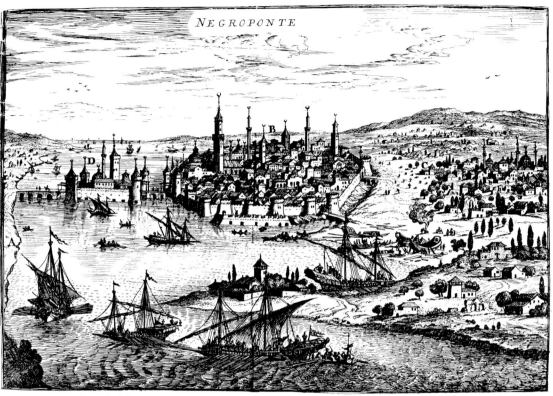

NEGROPONTE

A . Part of Achaja
B . City of Negroponte
C . Suburbs or new Town
D . Castle on the Islet .

A . Terra ferma d'Achaja
B . Citta di Negroponte
C . Borghi
D . Castello del Scoglio

became a kind of set piece for visiting artists: H. W. Williams's painting (FIGURE 35) is one of the most dramatic.

The only other eighteenth-century artist who worked in the environs of Athens was Thomas Hope, whose most notable productions record the relatively undocumented Cyclades, but who also painted scenes of Hydra (FIGURE 91 in Chapter VI) and Aegina.

In April of 1811, a group of architects comprising Charles Robert Cockerell, Carl Haller von Hallerstein, Jakob Linckh, and John Foster traveled together to Aegina to study the architecture of the Temple of Aphaia and took with them workmen to undertake excavations. This was the first major excavation undertaken at any Greek site. (Cockerell's engraving of the process of excavation is

reproduced on p. 106 in my *Literary Companion to Travel in Greece*.) Cockerell described their startling discovery of what became known as the Aegina marbles in his book *Travels in Southern Europe and the Levant, 1810–1817* (edited by S. P. Cockerell, p. 50f):

On the second day one of the excavators, working in the interior portico, struck on a piece of Parian marble which, as the building is of stone, arrested his attention. It turned out to be the head of a helmeted warrior, perfect in every feature. It lay with the face turned upward, and as the features came out by degrees you can imagine nothing like the state of rapture and excitement to which we were wrought. . . . Soon another head was turned up, then a leg and a foot, and finally, to make a long story short, we found under the fallen portions of the tympanum and the cornice of the eastern and western pediments no less than sixteen statues and thirteen heads, legs, arms &c all in the highest preservation, not 3 feet below the surface of the ground. It seems incredible, considering the number of travelers who have visited the temple, that they should have remained so long undisturbed.

From the 1830s, the most popular sites in Attica were visited by the painters who came to Athens: the usual destinations were the fifth-century B.C. Temple of Poseidon at Sunium (FIGURE 38), where Byron had carved his name on one of the pillars; Aegina, with its splendid Temple of Aphaia, still at that time generally thought to be that of Zeus Panhellenius; the city of Chalcis (FIGURE 39), which guards the crossing to Euboea; and Piraeus. J. P. Gandy (later J. P. Gandy Deering) visited Rhamnus. The beautiful tenth-century Byzantine church at Daphni remained unappreciated by those of Neoclassical taste, and James Skene (FIGURES 40, 41) seems to have been the first to pay any attention to monuments of the Byzantine Empire.

In general, the harsh and arid landscape of Attica did not attract the artists of the picturesque. Many of its most charming sites, such as the Amphiareion at Oropos and the Temple of Artemis at Brauron, were unexcavated and unknown at the time. Even the indefatigable Rottmann and Lear—artists who lavished great attention elsewhere in Greece—painted no other Attic site besides Sunium.

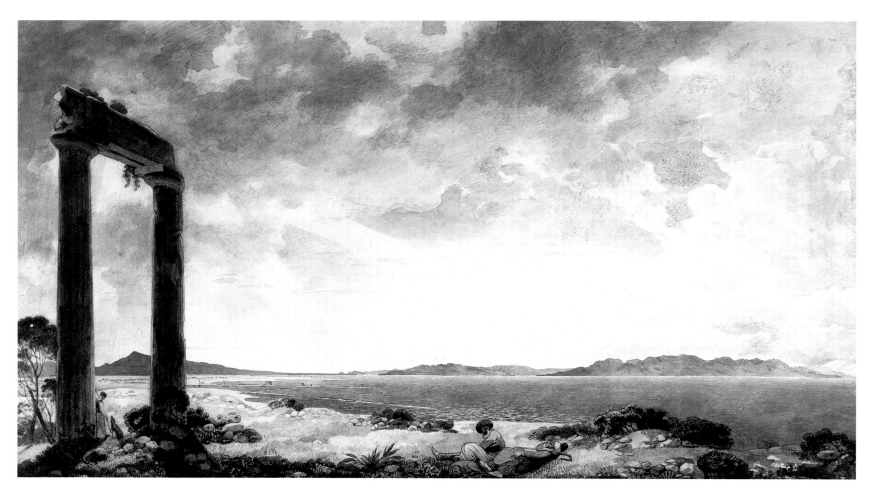

William Pars (1742–1782)

Ruin near the Port of Aigina

Watercolor

London, British Museum, Department of Prints
and Drawings, MM 11.10, L.B. 12

William Pars was selected to accompany the
expedition of the Society of Dilettanti to Greece
and Ionia under the leadership of Richard
Chandler in 1764. Many of the plates in
Antiquities of Ionia (London, 1769) are his work;
his few views of Greece are less well known.

This watercolor represents the Temple of Apollo
near the town of Aegina; only one entire col-
umn stands today.

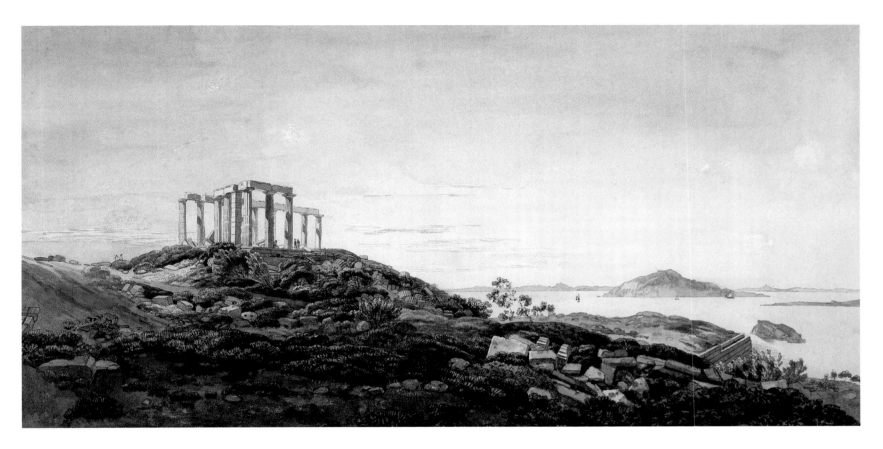

William Pars (English, 1742–1782)
Temple of Athena, Sunium
Watercolor
London, British Museum, Department of Prints and Drawings, MM 11.8, L.B. 13

The famous and beautiful temple at Sunium, dedicated to Poseidon, was misattributed by Pars and other early travelers; the actual remains of the Temple of Athena, mentioned by Pausanias, are exiguous and located further down the slope, in a less imposing situation than that of Poseidon. Confusion arose because Pausanias saw the temple only from the sea and mistook the prominent Temple of Poseidon for that of Athena (*Description of Greece*, 1.1.1).

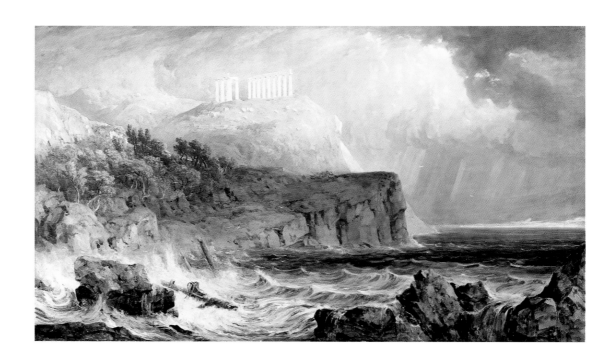

Hugh William Williams (Scottish, 1773–1829)
Temple of Poseidon, Sunium, in a Storm
1818
Watercolor, 75 x 126 cm (29 1/2 x 49 5/8 in.)
Edinburgh, National Gallery of Scotland,
cat. no. D324

"Grecian Williams," as he was known, made a career selling the paintings and engravings of Greece that he made following his tour in 1818. A relatively small number of finished paintings survive. They include this evocative view of Sunium in a storm, which is the artistic counterpart to the once-popular poem written in 1762 by William Falconer, "The Shipwreck," which described such an event at Cape Sunium. (Part of the poem is reproduced on p. 113 of my book *A Literary Companion to Travel in Greece.*) Williams, like Carl Rottmann, often uses atmospheric effects to add drama to his views of Greece (see FIGURES 38, 39). The influence of J. M. W. Turner on the treatment here is very apparent. It is striking that Williams's many paintings of Scotland show no essential difference from those of Greece in their hue or intensity of color.

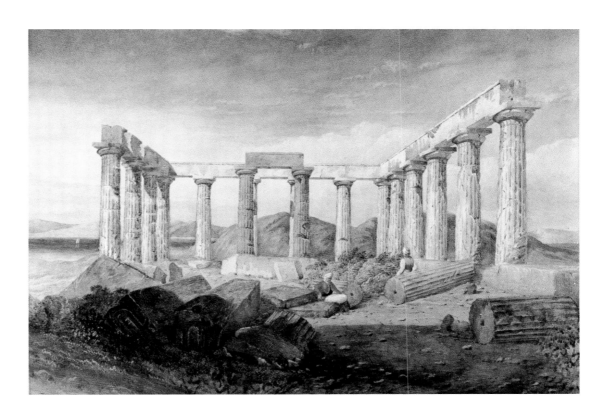

Edward Dodwell (English, 1767–1832)
Aigina: Temple of Aphaia
1805
Watercolor, 47 x 65 cm (18½ x 25⅝ in.)
Museum of the City of Athens, inv. 450

Dodwell, like most visitors to Greece, included Aegina in his tour. The Temple of Aphaia (a Cretan goddess, sometimes identified with Athena) on Aegina was at that time still thought to be the Temple of Zeus Panhellenius. Confusion arose because Pausanias's *Description of Greece* mentions the Temple of Zeus Panhellenius, but not that of Aphaia, of which these impressive remains still stand. The remains of the Temple of Zeus are scanty. The Temple

of Aphaia was correctly identified by Adolf Furtwängler in 1901. Dodwell's description of the building assumes it to be the Temple of Zeus Panhellenius, and the engraving in his *Views in Greece* is titled as such. The painting emphasizes the vegetation—pine, elder, and mastic—that surrounds the ruins, and offers a glimpse also of the panorama across the Saronic Gulf toward Athens.

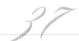

John Peter Gandy Deering (English, 1787–1850)

Reconstruction of the Mystic Temple

of Ceres in Eleusis

ca. 1812

Watercolor, 10.9 x 15.6 cm (4 ¼ x 6 ⅛ in.)

Los Angeles, Getty Research Institute,

Resource Collections

Like his brother J. M. Gandy's view of Sparta (Chapter III, FIGURE 47), Deering's depiction of Eleusis is an imaginary one. But in addition to the description of the site by Pausanias (*Description of Greece*, 1. 37–38), Deering was able to draw on the work of the Society of Dilettanti's expedition to Attica, which had resulted in the careful architectural drawings and elevations published in *Ionian Antiquities*, based on the physical remains. The Dilettanti had unearthed the Propylaea (ceremonial gateway) and drawn other remains that were visible above the ground.

The large building in the center of the picture is the Telesterion, or Hall of the Mysteries, where worshippers assembled for the secret revelation. Though the Telesterion was in fact a square hall with a portico on the front, the proportions appear more elongated in this watercolor; however, Deering has shown the correct number of columns (twelve) along the front.

The temple on the hill is imaginary. The two buildings in front of the Telesterion are the Temple of Sabina, wife of the emperor Hadrian, and a small treasury. The column on the left seems to be intended for a part of the Propylaea.

The impressionistic style of the brushwork here contrasts with the more meticulous architectural detailing in J. M. Gandy's view of Sparta.

ELEUSIS.

Gandy

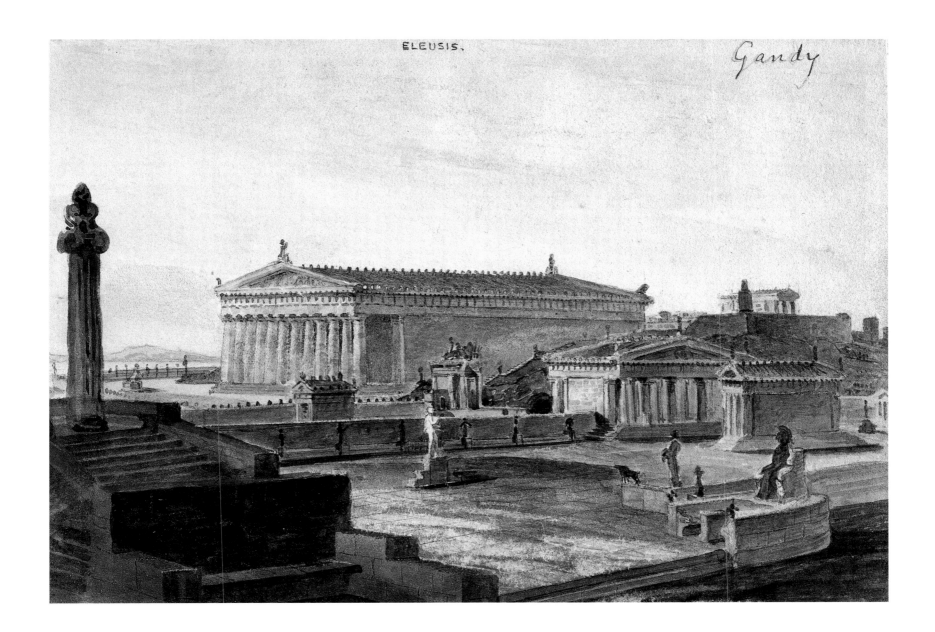

Carl Rottmann (Bavarian, 1797–1850)

Sunium

ca. 1836

Watercolor over pencil,

21.3 x 30.8 cm (8³⁄₈ x 12¹⁄₈ in.)

Munich, Staatliche Graphische Sammlung,

inv. 21377

The blue of the sea and sky (a blue that Rottmann said would require a huge bladder of cobalt to depict) form the main emphasis of this scene; even the ruin is subordinate to the picturesque form of the painting, and, like the human figure, does little more than add an accent to the composition. For Rottmann, scenery, not topography, is paramount.

Carl Rottmann (Bavarian, 1797–1850)

Chalcis

Watercolor over pencil,

38.5 x 72.5 cm (15¹⁄₈ x 28¹⁄₂ in.)

Munich, Staatliche Graphische Sammlung,

inv. 15272

This view of Chalcis could hardly be more different from Bernard Randolph's engraving (FIGURE 32) of scarcely 150 years earlier. While Rottmann emphasizes landscape, color, and atmosphere, Randolph conveyed information about topography and fortifications. Rottmann rarely included human figures and never portrayed contemporary Greeks in his paintings, and this example is no exception.

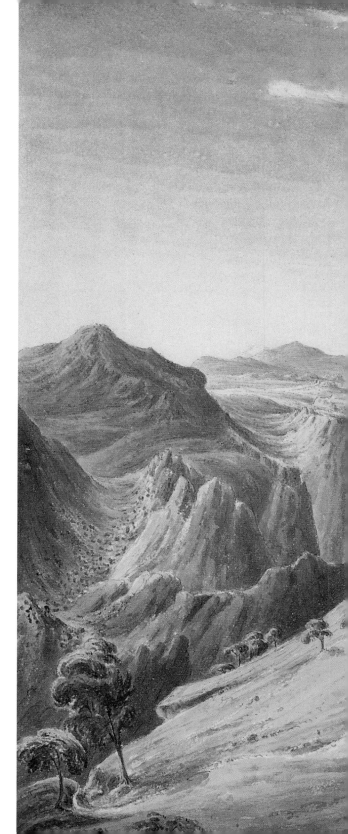

40

James Skene (Scottish, 1775–1864)

The Ancient Greek Castle of Phyle on Mount Parnes — Athens Beyond

1840

Watercolor with pencil,

37.2 x 58.5 cm (14⅝ x 23 in.)

Private collection

Photo: Goulandris Museum of Cycladic Art

This large signed and dated watercolor depicts one of the more remote sites of Attica, the castle of Phyle on the border of Boeotia. Its steep situation made it an ideal defense post, and at the end of the fifth century it was used as the seat of the resistance, led by Thrasybulus, to the tyranny of the Thirty in Athens. Most of the impressive remains are from the fourth century. As so often, Skene's style exaggerates the precipitous and beetling nature of the cliffs and walls.

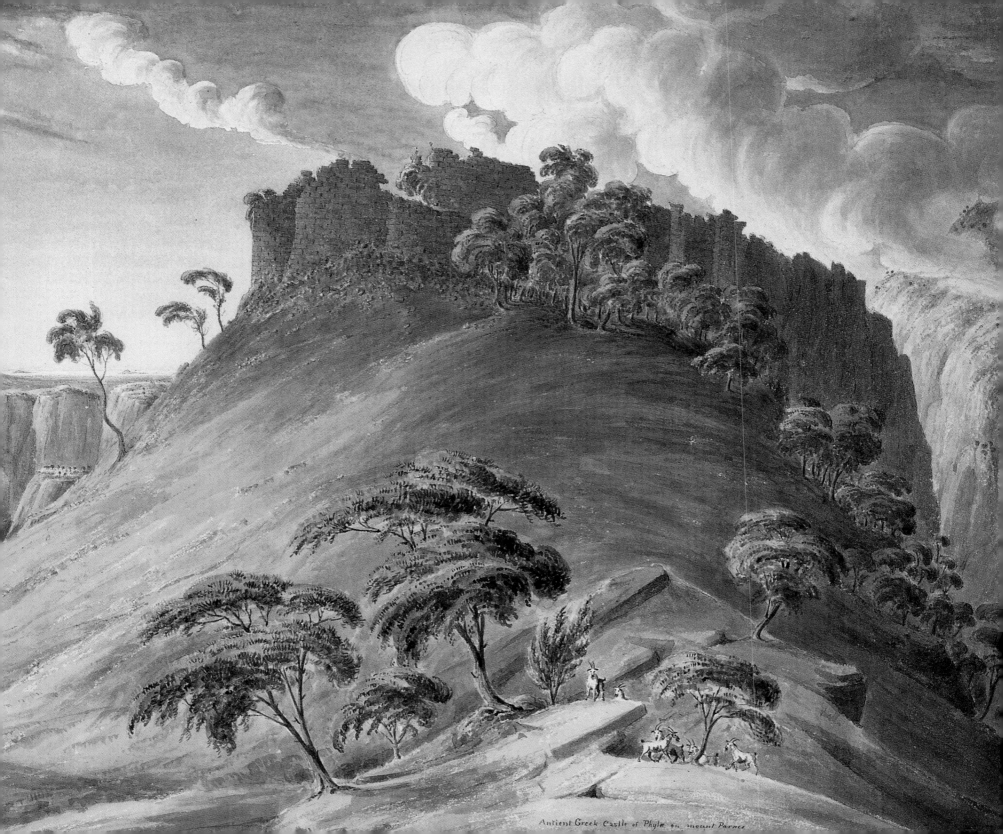

Antient Greek Castle of Phyle on mount Parnes

Byzantine church of Daphne.

41

James Skene (Scottish, 1775–1864)

View of the Monastery of Daphni

after 1851

Watercolor

Athens, National Historical Museum

Skene noted in his diary, "The old church of Daphni though now unused is still in good preservation, and in many respects interesting both externally for its form and internally for its mosaiks, coats of arms, pictures and evidences of its early date, that of the twelfth century" (quoted from Historical and Ethnological Society of Greece, *James Skene: Monuments and Views of Greece, 1838–1845*, caption for pl. 42). These remarks show the beginnings of an interest in Byzantine architecture and art — an interest that was to be highly uncommon among Western travelers, at least until the 1930s, when the architectural writer Robert Byron became an enthusiastic proponent of the style. Although Skene frequently shows an interest in the buildings of medieval Greece, his remarks scarcely convey the high artistic value now attached to this jewel of the high Byzantine period. The church dates (despite Skene's assertion) from the end of the eleventh century, and the contemporary mosaics are regarded as one of the highest achievement of Byzantine "humanism."

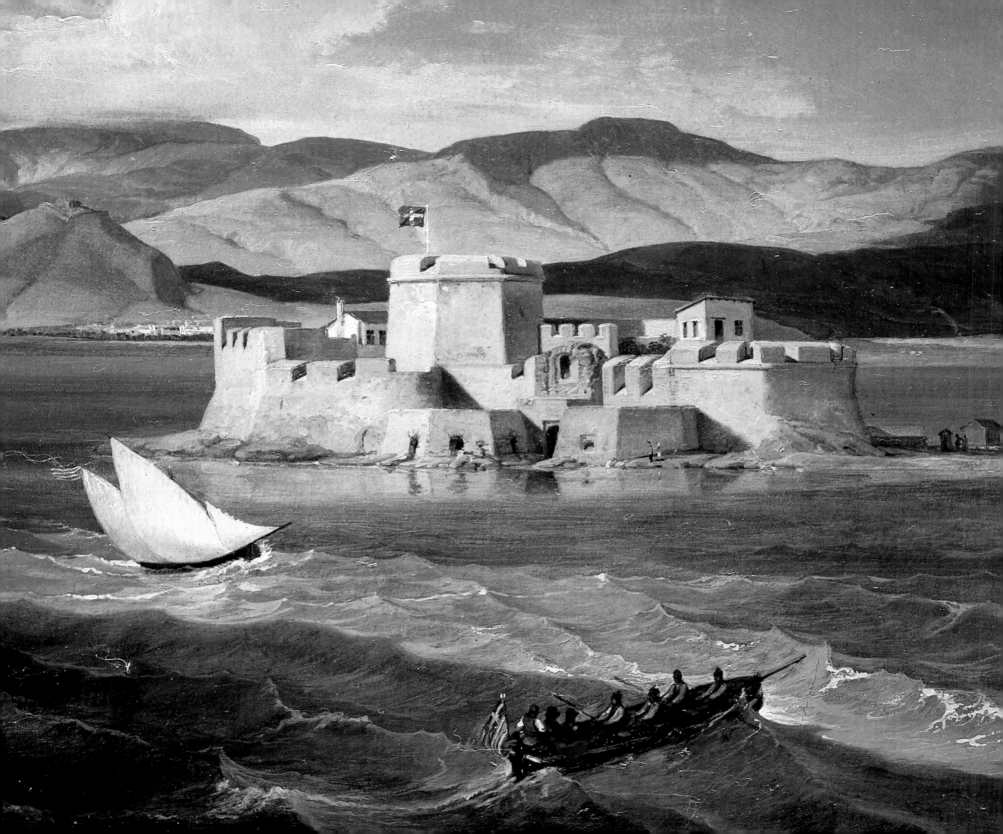

THE PELOPONNESE

After Athens, the Peloponnese was the most familiar region of mainland Greece to early visitors. From the times of the earliest pilgrims to the Holy Land, travelers would make their first landfall in the Ionian Islands, then travel along the coast of the Peloponnese to Piraeus, and from there proceed inland to Athens. The first pictorial records of the region by Europeans date from the seventeenth century, and are found in the works of the English merchant Bernard Randolph and the Italian geographer Vincenzo Coronelli, who traveled in Greece during the mid-1670s in the entourage of the Marquis de Nointel. These take the form of engravings designed to accompany a printed text. Mistra (FIGURE 42) is one of the few sites Randolph selects for illustration (most of his engravings are maps), and it complements neatly the description in his text. Coronelli created many illustrations, providing at least vignettes of most of the major towns of Greece and the islands (FIGURE 43, for example).

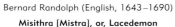

Bernard Randolph (English, 1643–1690)
Misithra [Mistra], or, Lacedemon
Engraving by John Griffier, 15.5 x 21.5 cm (6 ⅛ x 8 ½ in.)
From Bernard Randolph, *The Present State of the Morea,
Called Anciently Peloponnesus* (London, 1686)

Bernard Randolph, a merchant in the Levant, composed two
lively travel surveys in the 1680s: *The Present State of the
Morea* and *The Present State of the Islands in the Archipelago.*
This engraving of Mistra, from the former, was accompanied
by a detailed written account (p. 8) that clearly conveyed
the ancient town's topography and landmarks—including a
thirteenth-century hilltop castle:

*Mesithra, formerly called Lacedemon, is situated at the side of
a large Plain on a rising ground, about 25 miles from the sea
side, having very high mountains all to the west of the plain.
The Castle stands to the west on a very high hill, steep on the
west and south part, where it is inaccessible. . . . The way into
the Castle is very difficult. . . . The plain is very pleasant, full of
small villages, olive, and mulberry trees.*

Randolph was a talented draftsman, although his drawings,
like other topographical drawings of the period, betray a certain
naiveté of perspective that causes the landscape to verge on
the diagrammatic. Every significant feature has to be shown,
without regard for distance, angle, or atmospheric haze.
Reference in the title to Lacedemon, another name for Sparta,
indicates that Randolph made the then-common error of
assuming that Mistra was built on the site of ancient Sparta.

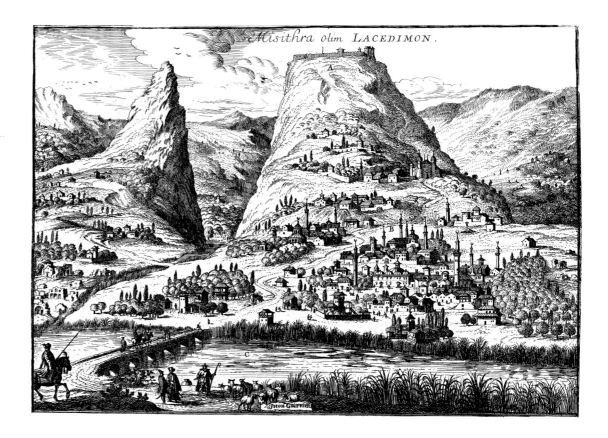

These two men were working at a time when mapping was just beginning to be invaded by a more illustrative approach, as can be seen in some contemporary atlases, such as that of van der Aa, and the engravings of André Mallet.

After these pioneers, the visual record of the Peloponnese is blank until the arrival of the proto-archaeologists and topographical artists in the early nineteenth century. Greece became increasingly popular as a tourist destination after the Napoleonic Wars ended in 1815, as access to much of the traditional area of the Grand Tour had been blocked by war. Travelers who had become used to the idea that a visit to the Mediterranean should involve the study of topography and the collection of antiquities expanded their activities into Greece. Edward Dodwell (FIGURE 48) first visited Greece in 1801, and was there again with William Gell a decade later. Gell's very thorough, though very dry, *Itinerary of Greece* was mocked by Byron for the speed at which the ground had been covered,

but Gell had plainly stopped long enough, from time to time, to sketch and paint, for some fine watercolors survive from his hand. Dodwell produced an extensive portfolio of paintings, and in 1819 he published them as engravings in *A Classical and Topographical Tour through Greece*, which ranged over Attica, the Peloponnese, and parts of northern Greece.

At about the same time, in 1810 to 1811, Otto Magnus von Stackelberg formed part of a traveling party that included the English architect Charles Cockerell, the German architect Haller von Hallerstein, and others; together this group was responsible for the discovery of the Aegina marbles (described in Chapter II) as well as those of the temple at Bassae (see below). But Stackelberg traveled more widely than the rest and took an interest in scenery and costume as well as antiquities (FIGURE 49). Other early travelers had been interested in costume and had included engravings in their books, but Stackelberg was the first to make it an art form. Costume paintings became increasingly popular with the onset of the War of Independence in 1821, which increased Europeans' awareness of Greeks.

The discovery in 1812 of the sculptures of the Temple of Apollo Epicurius at Bassae inspired a great many paintings. The setting of the temple is unusually spectacular and romantic, and is the subject of paintings or drawings by Haller von Hallerstein and by Cockerell (FIGURE 44). The independent poet-artist William Haygarth accompanied the published edition of his *Greece, A Poem, in Three Parts*, a fine and rather Wordsworthian production, with sepia-tinted engravings of scenes, of which those of Corinth (FIGURE 50) and Bassae (reproduced in my *Literary Companion to Travel in Greece*, p. 51) are notable examples. These were based on the predominantly monochrome watercolors he made during his journey, all in shades of brown or brown-and-blue. Later in the century, the ubiquitous Lear did not omit to include Bassae in his portfolio of luminous studies of the Greek scene (FIGURE 62).

The Greek War of Independence fostered new artistic depictions of the Peloponnesian scene. Philhellenes from Britain, Germany, France, and elsewhere helped the Greeks fight for liberation from Turkish rule. Many of the Europeans who fought on the Greek side — especially the Bavarians — were also accomplished artists. Among the Bavarian soldier-artists were Carl von Heideck (FIGURE 52), Johann Haubenschmid (FIGURE 53), Ludwig Koellnberger (FIGURE 54), and

Vincenzo Marco Coronelli (Italian, 1650–1718)

Malvasia

Engraving

From Vincenzo Marco Coronelli, *Memorie istoriografiche delli regni della Morea, e Negroponte e luoghi adiacenti* (Amsterdam, 1686), following p. 106

Vincenzo Coronelli first published his account of the Peloponnese in 1685. It was based on his travels in the previous two years as official geographer for Venice. In 1687 it was translated into English by R. W. Gent as *An Historical and Geographical Account of the Morea, Negropont, and the Maritime Places, as far as Thessalonica*. The book's numerous city views and plans combine the purposes of a map or plan with those of a landscape view. Like Randolph (FIGURE 42), Coronelli distorts perspective in order to represent topographical features fully. The usefulness of such drawings to mariners and travelers in recognizing the places they have come to is never forgotten.

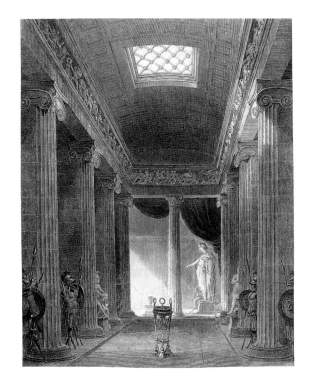

Charles Robert Cockerell (English, 1788–1863)
Interior of the Temple of Apollo Epicurius at Bassae
Engraving, 15.8 x 11.9 cm (6 ¼ x 4 ⅝ in.)
From Charles Robert Cockerell, *The Temples of Jupiter
Panhellenius at Aegina, and of Apollo Epicurius at Bassae near
Phigaleia in Arcadia* (London, 1860), p. 59;
Los Angeles, Getty Research Institute, Resource Collections

Bassae was the second classical temple whose sculptures were
unearthed by Cockerell and his companions after their suc-
cess on Aegina (see Chapter II). In July 1812 they obtained
a firman from the Pasha of the Morea allowing them to dig.
According to Cockerell's description, a fox scampering into
a hole showed him the first glimpses of the broken marbles
of the frieze, which portrayed the battle of the Greeks and
Amazons. The sculptures, once unearthed, were brought to
London and are housed in the British Museum.

Cockerell's interest, as an architect, in how Greek build-
ings might originally have looked is apparent in this drawing
of the interior of the temple. It depicts clearly the effect of
the unusual side door of the temple, opening to the south at the
western end in such a way as to cast a dramatic light on the cult
statue. Cockerell's position on the contemporary controversy
as to whether Greek temples had roofs or were open to the sky
("hypaethral") is also made plain in this illustration. Unlike both
earlier and later artists (such as Dodwell and Lear), Cockerell
shows no interest in depicting the picturesque aspect of the
magnificent scenery surrounding the temple.

Adalbert Marc (Chapter V, FIGURE 76). Heideck was one of the first, leading a volunteer troop, with
the blessing of the king of Bavaria, from 1826 to 1827. Koellnberger, whose naive style has its own
charm and is of some topographic value, first came to Greece with King Otho in 1833. His paintings
provide a vivid record of military activity against Turks and bandits as well as architectural views and
scenes of peace, such as threshing. His colleagues Marc and Haubenschmid are equally unsophisti-
cated painters, but have an anecdotal value and charm. The War of Independence also gave an outlet
to the talents of the Greek naive painter Panagiotis Zográfos, who depicted battle scenes in paintings
like the one shown in Chapter V, FIGURE 77.

With the establishment of Otho as king of Greece in 1833, Germans began to come in
increasing numbers. These included two of the finest and most prolific artists of them all, Carl
Rottmann (FIGURES 45, 56–60) and his pupil Ludwig Lange (FIGURE 55). Carl Rottmann was sent
by Ludwig I of Bavaria, the father of King Otho, to work on a series of paintings for the arcades of
the royal Hofgarten in Munich; these were to match the existing Italian series. In the course of his
stay in Greece, Rottmann produced more than two hundred sketches and watercolors of Greece, in

addition to the larger oils, which were largely completed after his return. Twenty-nine of a projected thirty-eight were completed. Rottmann's is a purely landscape genius: architectural remains and individuals take second place to scenery, cloudscape, and the intense and glowing colors of the Greek landscape. Lange, by contrast, showed a much greater interest in the contemporary scene and produced a very valuable record of costumes and occupations, all presented with a light, deft charm.

The Bavarian painter Peter von Hess, who had produced two large formal paintings representing King Otho's arrival at his capital city of Nauplia (FIGURE 51), wrote to Rottmann warning that Greece would hold no interest for a landscape painter. But Rottmann disagreed and felt sure that he would find views worthy of his notice. His intense feeling for landscape, nurtured on scenes of Switzerland and south Germany, resulted in some of the most poetic watercolors of Greece ever produced. His views of Karytaina (FIGURE 57), Sparta (FIGURE 45), and Santorin (Chapter VI, FIGURE 95) are among his most characteristic. The oil paintings, with their dense weight of paint and their thick, highly reflective, and (now) discolored varnish, seem less satisfactory.

Some of Koellnberger's paintings, which portray scenes of the pursuit and arrest of brigands, show as vividly as the writings of contemporary travelers (such as the archaeologist Ludwig Ross, the dilettante Prince Pückler-Muskau, and the American writer Julia Ward Howe) that the Peloponnese remained a risky area for travel through the post-war period. By the 1840s conditions were more settled and travelers began to come again. But it became much less popular to penetrate deep into the region, and many, like Friedrich von Gärtner (FIGURE 61) and James Skene, went no further south than Corinth, and concentrated their efforts on central Greece. Since then, however, the Peloponnese has been thoroughly picked over by archaeologists, and the picturesque qualities of unkempt ruins gave place to the scientific exploration of the ancient cultures of the Peloponnese. The great sites of the modern tourist trail—Corinth, Mycenae, Epidaurus—were excavated, studied, and laid bare by Heinrich Schliemann and his successors in the 1870s. Painters sought out areas less touched by the modern age, and even Edward Lear spent relatively little time in the Peloponnese. After Lear's voluminous output, there seems to have been no new vision of these regions until the impressionist style of twentieth-century painting allowed a fresh eye to be cast on the scene.

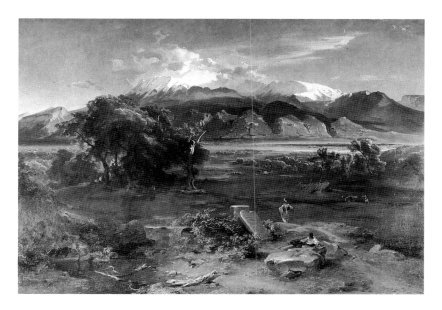

Carl Rottmann (Bavarian, 1797–1850)
Sparta—Taygetos
ca. 1841
Encaustic on plaster, 157 x 200 cm (61¾ x 78¾ in.)
Munich, Bayerische Staatsgemäldesammlungen,
Neue Pinakothek, inv. WAF 865
Photo: Artothek, Munich

This is one of the series of encaustic paintings designed for the Hofgarten in Munich; it is based on several sketches and watercolors made on site. Rottmann was much more interested in landscape than in the contemporary Greek scene and saw that landscape as being somehow validated when it was a setting for classical Greek history. It is particularly revealing that he included in this large painting of the Spartan plain an entirely imaginary group: the philologist Friedrich Thiersch, professor of Greek at Munich University, is lying on the ground in front of a large and equally imaginary stone with a Greek inscription honoring an athletic victory by one Democrates (an appropriate dedication for the translator of Pindar).

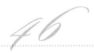

Antoine-Chrysostome Quatremère de Quincy
(French, 1755–1849)

Olympian Jupiter

Colored lithograph,

30.1 x 24 cm (11⅞ x 9½ in.)

From Antoine-Chrysostome Quatremère

de Quincy, *Le Jupiter olympien, ou,*

L'art de la sculpture antique... considéré sous un

nouveau point de vue (Paris, 1814), frontispiece;

Los Angeles, Getty Research Institute,

Resource Collections

Quatremère de Quincy, sculptor and connoisseur, mentor of Jacques-Louis David, was one of the first Western art-lovers to condemn the depredation of Greece in the interest of museums. In his *Lettres sur l'enlèvement des ouvrages de l'art antique à Athènes et à Rome* (Letters on the removal of works of ancient art from Athens and Rome) (1796), he argued forcefully that such removal was an affront to civilization. His Neoclassical interest in ancient art was expressed in his major book, *Le Jupiter olympien, ou, L'art de la sculpture antique... considéré sous un nouveau point de vue* (Jupiter Olympius,

or, The art of antique sculpture... considered from a new point of view), which contains a number of magnificent colored plates offering restorations of ancient works on the basis of ancient descriptions (mainly those of Pausanias). His vision of the Zeus of Olympia is typical and must have been among the stimuli that urged the German philologist Ernst Curtius to excavate the site in 1874.

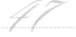

Joseph Michael Gandy (English, 1771–1843)

The Persian Porch and the Place of Consultation

of the Lacedemonians

ca. 1816

Watercolor and gouache over pen and pencil,

43 x 68 cm (16⅞ x 26¾ in.)

Los Angeles, Getty Research Institute,

Resource Collections

There are a number of unexecuted architectural designs as well as fantastic city-views of this kind among the works left by J. M. Gandy. This view of Sparta does not seem to be based on authentic information. The topography of ancient Sparta provided a kind of parlor game for many visitors to the site from the eighteenth century onward, as the remains on the ground are exiguous in the extreme. Some writers and cartographers tried to reconstruct the city's ground plan on the basis of the detailed, but undeniably confusing, description of the monuments in Pausanias's *Description of Greece*. One such attempt was a map prepared to accompany *The Voyage of the Young Anacharsis*, a novel written by the Abbé Barthelemy in 1788. However, the disposition of the buildings in Gandy's painting does not correspond to the indications either of Pausanias or of the map, though it is tempting to think that the large temple in the foreground, with a statue of an armed Athena before it, may be intended for the famous Temple of Athena of the Brazen House. The Persian Porch, or Persian Colonnade, described by Pausanias (3.11.3) as "The most striking monument in the market-place," was built in the 270s B.C. from the spoils of the Persian Wars.

The view of Mt. Taygetus that forms the background of the painting is a plausible one, and might be derived from other paintings known to Gandy. The drum-like circular towers with a pinnacle are a favorite device in Gandy's fantastic architectural designs.

It is interesting to compare this painting with the stylistically similar reconstruction painting of Athens by Charles Cockerell (see Chapter I, FIGURE 18) and to contrast it with the painting by Rottmann of the actual site of Sparta (FIGURE 45), in which the absence of actual remains gives more scope for delighting in the scenery of the Valley of the Eurotas.

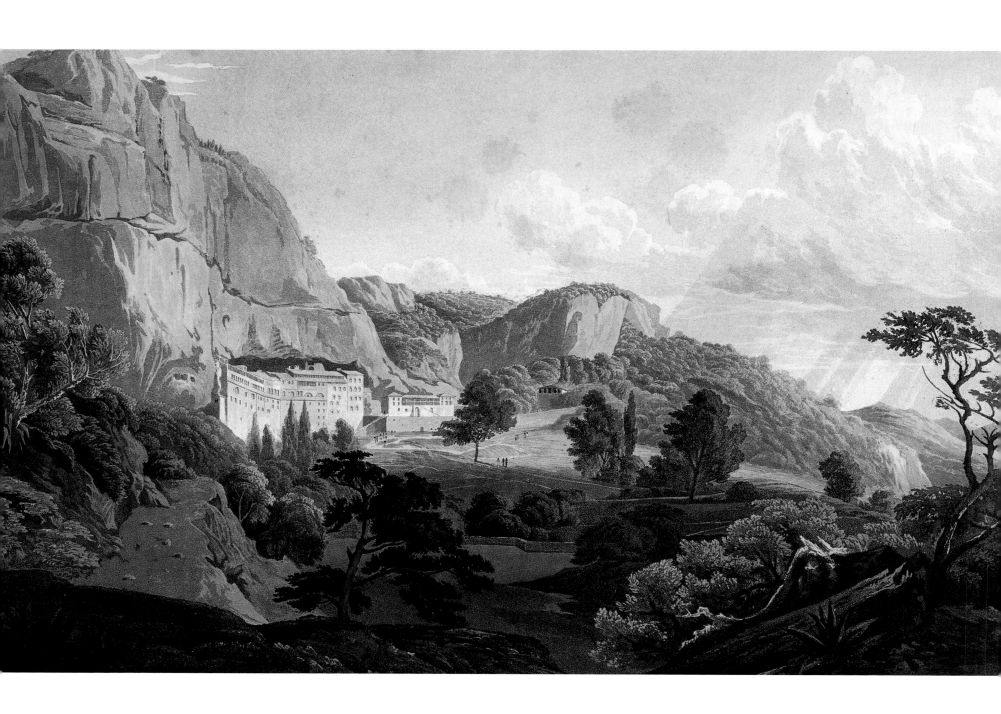

Edward Dodwell (English, 1767–1832)

The Monastery of Megaspelion in Arcadia

Colored lithograph

From Edward Dodwell, *Views in Greece* (London, 1821); Sacramento, California State Library

The great monastery of Megaspelion was a popular destination among the eighteenth- and nineteenth-century travelers. Founded under the Byzantine emperors John Cantacuzenos and Constantine Palaeologos, it was highly prosperous and in Dodwell's day housed about 450 monks.

It is erected upon a steep and narrow ridge, and against the mouth of a large natural cavern.... It is a large white building, of a picturesque and irregular form, consisting of eight stories, and twenty-three windows in front. A magnificent precipice, of four or five hundred feet in height, rises from the cave, and overhangs the monastery in such a manner, that when the Arnauts, who ravaged a great part of the Morea, found it impossible to take the monastery in front, on account of the narrow and defensible passes, they attempted to roll down upon it large masses of stone from the precipice above; but they all fell beyond the walls of the consecrated edifice. (Edward Dodwell, *A Classical and Topographical Tour through Greece*, vol. 2, p. 449.)

Freiherr Otto Magnus von Stackelberg
(Bavarian, 1787–1837)
Woman of Mani
Colored lithograph by Levilly,
14.6 x 9.5 cm (5¾ x 3¾ in.)
From Freiherr Otto Magnus von Stackelberg,
*Costumes et usages des peuples de la
Grèce moderne* (Paris, 1830?), pl. 11;
Cooper-Hewitt, National Design Museum,
Smithsonian Libraries, Smithsonian Institution,
fGT 947.S77
Reproduced by permission of Art Resource, NY
Photo: Andrew Garn

Otto Magnus von Stackelberg arrived in Greece in 1810 and took part in the discovery of the frieze of the temple at Bassae. In addition to an illustrated publication of this temple, he published a large collection of colored lithographs, of which this portrait is a representative example.

His work is one of the first signs of interest shown by foreigners in contemporary Greeks and their costumes and customs. Although the model is stiffly posed, the various elements of the costume are rendered in careful detail, from the elaborate head covering and the fringed wimple to the broad stripes of the dress and the red Turkish slippers.

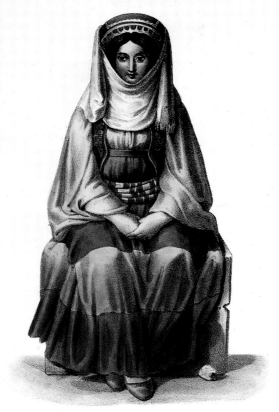

Levally Lith.　　　　　　　　　　　　　Imp. Litho. de M.elle Formentin.

Femme de la Maina
dessinée par le Baron de Stackelberg.

chez P. Marino, éditeur,　　　　(N.° 11.)　　　　rue Montmorency, N.°35, a Paris.

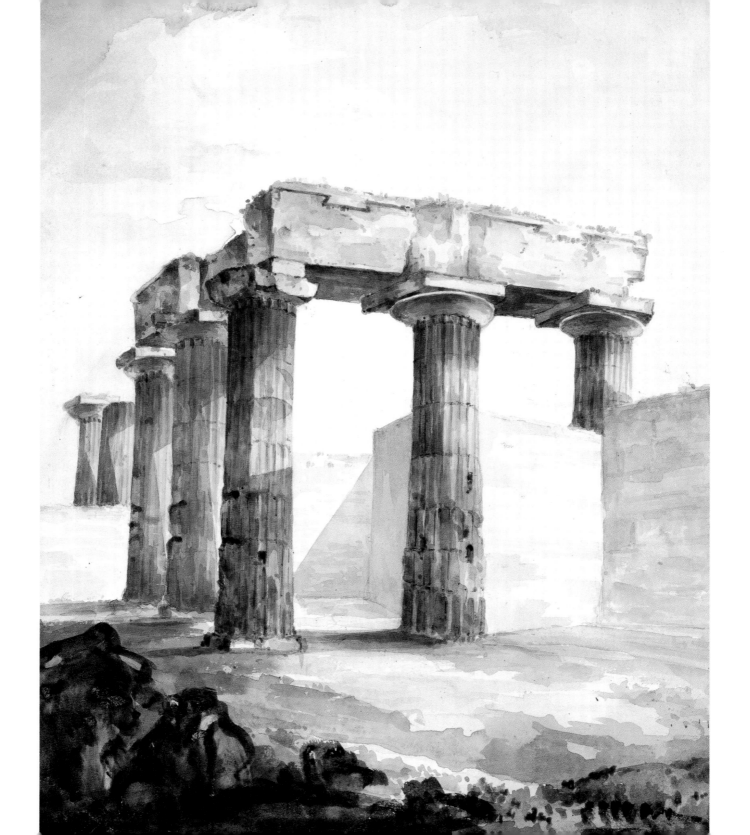

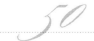

William Haygarth (English, 1784–1825)

Temple at Corinth

Watercolor

Athens, Gennadius Library, GT 2051 q. no. 57

William Haygarth, a shy man who nonetheless formed part of Byron's circle in Greece in the second decade of the nineteenth century, was the author of a poem celebrating the Greek scene (*Greece, A Poem, in Three Parts*). In it, he tried to "predict in poetry what I certainly should not be so hardy as to foretell in prose — the moral regeneration of Greece" (Preface). His artistic response — in verse as in this water-color — is suffused with an almost mystical sense of a continuing life of the ancient world.

Wealthiest of Greece's children, 'midst thy games,
Thy theatres, and temples; that one hand
Was stretch'd to grasp the treasures of the East;
And that thy double sea resounded far
With shouts of mariners, unfurling wide
The bellying canvas of thy laden fleets.
This still endears thee, though the wretched cot
Stands where the sumptuous palace once was seen;
Though thy long walls are shatter'd, and in place
Of marble fanes, those mould'ring shafts survive,
Sole relics of thy former pomp and pow'r.
And yet thou art not cast for ever down;
Thro' the dark night of time the Muse beholds
Thy glory's second noon; thy lofty rock
Gilded by liberty's returning day,
Shall be the point to which awak'ning Greece
Shall turn her anxious eye . . .

51

Peter von Hess (Bavarian, 1792–1871)

Entry of King Otto of Greece into Nauplia,

February 6th, 1833

1835

Oil

Munich, Bayerische Staatsgemäldesammlungen,

Neue Pinakothek

Photo: Artothek, Munich

Peter von Hess came from a family of painters and was a specialist in genre and landscape painting. In 1833 he traveled with King Otho to Greece and prepared two monumental paintings of the king's entry into Nauplia and his reception in Athens. Both paintings contain detailed portraits of major contemporary figures. In 1839 Hess entered the service of the czar and painted a series of scenes from the Russian war.

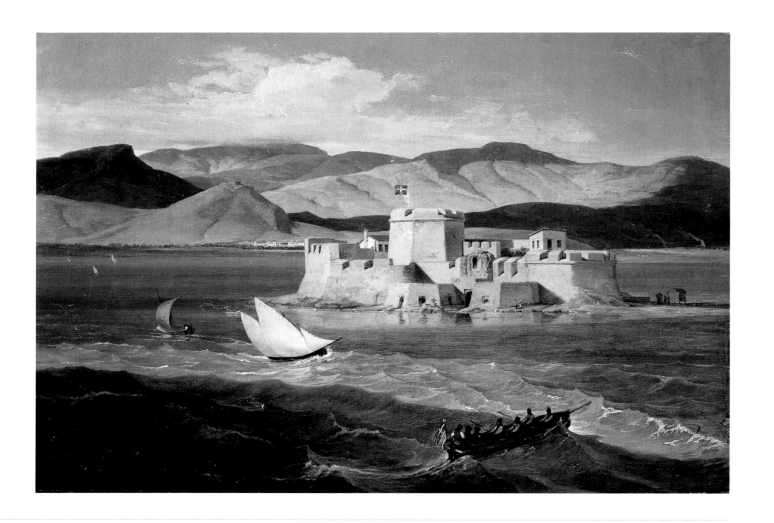

Freiherr Carl Wilhelm von Heideck
(Bavarian, 1787–1861)
The Fort of Burzi near Nauplia
Oil on canvas, 28 x 40 cm (11 x 15¾ in.)
Munich, Städtische Galerie im Lenbachhaus,
inv. G4159

Freiherr Carl Wilhelm von Heideck, known as Heidegger, came of a military family with a talent for painting. In 1826 he was sent by King Ludwig I of Bavaria to lead a volunteer group to assist the Greeks in their rising against the Turks. He became one of the regents who accompanied the young King Otho to Greece in the winter of 1832/1833. In addition to a distinguished military career, he was also an accomplished painter, mainly of Greek scenes. This small painting foreshadows the work of Rottmann in the intensity of its blue coloring.

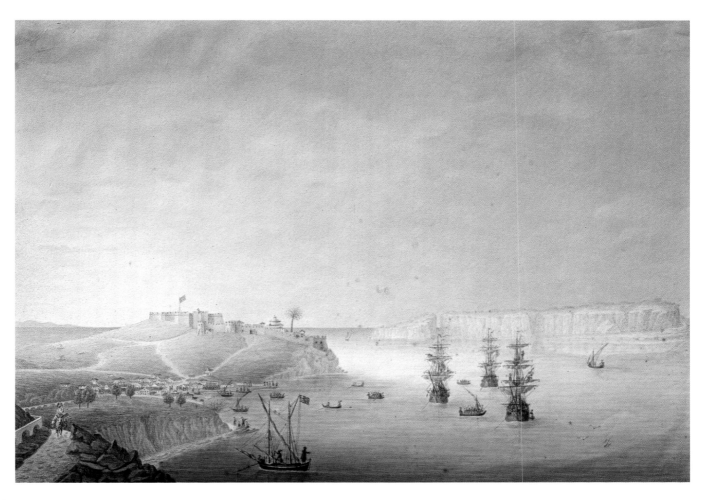

Johann Nepomuk Haubenschmid
(Bavarian, 1792–1858)

Navarino

1849

Watercolor, 26.4 x 37.2 cm (10 3/8 x 14 5/8 in.)

Ingolstadt, Bayerisches Armeemuseum, 136/66

The Bavarian officer Haubenschmid was one of many amateur artists in the Bavarian army. This watercolor of Navarino was worked up in Germany in 1849 on the basis of a sketch made while in Greece in 1833. Other paintings by him show scenes of camp life, but here he turns his attention to the picturesque scenery of the Bay of Navarino, scene of the important defeat of the Ottoman navy in 1829.

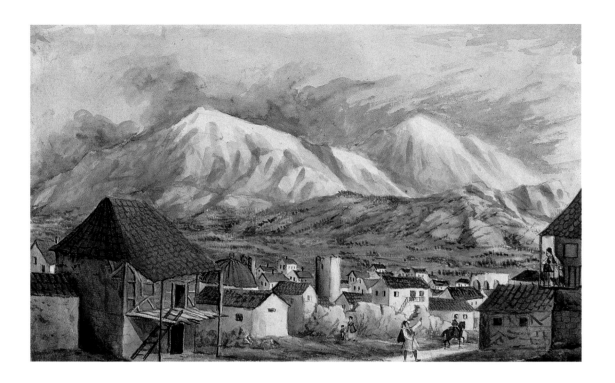

Ludwig Koellnberger (Bavarian, 1811–1892)

Tripolitza [Tripolis]

ca. 1836

Watercolor, 13.7 x 21.3 cm (5⅜ x 8⅜ in.)

Munich, Bayerisches Hauptstaatsarchiv,

Kriegsarchiv, BS III 21/I no. 33

Ludwig Koellnberger's paintings of Greek scenes (of which 102 survive) show the hand of an untutored but sprightly artist, with an interest in landscape and especially in the lively movement of people and groups across that landscape: genre scenes, military exercises, ships at sea, and costume pieces are as numerous as plain topographical landscapes and architectural sketches. This wintry and mountainous scene is one of his more atmospheric works. It is notable that the white of the mountains and clouds is represented by letting the blank paper show through, whereas in many of his other works highlights are added in white paint. This feature contributes to the liveliness and lightness of this painting.

Ludwig Lange (Bavarian, 1806–1868)

Mycenae

Watercolor, 19.1 x 19.8 cm (7 ½ x 7 ¾ in.)

Munich, Staatliche Graphische Sammlung,

inv. 35844

The ruins of the Bronze Age palace at Mycenae attracted many of the painters of this period. They had been scarcely noticed in earlier centuries, Edward Dodwell being the first to portray the ruins (accompanying the plate with some very dubious speculations about the history of the palace). The ruins are magnificently situated in a wild and mountainous landscape, but most painters concentrated on the monumental gateway known as the Lion Gate, from the two heraldic lions surmounting it. At that time clogged to half its height with the soil of centuries, the gate has now been cleared to ground level. Like his master Rottmann, Lange emphasizes atmospheric effects, but he devotes more attention to the detail of the monuments themselves than Rottmann was accustomed to do.

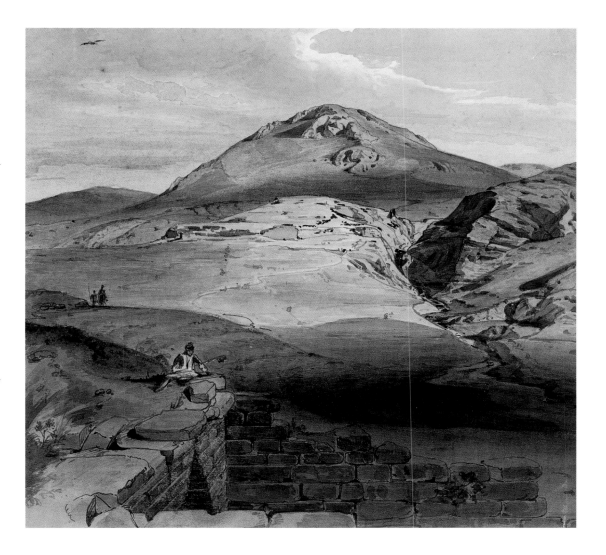

Carl Rottmann (Bavarian, 1797–1850)

Nemea

1850

Encaustic on plaster,

157 x 200 cm (61¾ x 78¾ in.)

Munich, Bayerische Staatsgemäldesammlungen,

Neue Pinakothek, inv. WAF 851

Photo: Artothek, Munich; Jochen Remmer

Carl Rottmann's oil painting of Nemea is one of the formal series completed after his return from Greece for the Hofgarten arcades in Munich; it was completed in 1850. It represents the moment in King Ludwig I of Bavaria's visit to Greece (in 1835) when he was received by a Greek deputation. Rottmann left Greece in 1834, so the figures in the scene were painted from his imagination and on the basis of his watercolor sketches of the ruins and landscape. At this time Rottmann's eyesight had become very poor, and he may not have completed the work himself; it is certain in any case that he used assistants in several of these paintings.

Ludwig Lange wrote of this painting:

This ceremonial moment gives us a glimpse into the modern history of Greece and was perfectly suited to incorporate the great originator of the painting into the scene, as well as to ennoble through its portrayal of a modern festival that place which was famous for its festivals in antiquity. The valley, sanctified by memories from ancient and modern history, as well as from myth (being the place where the Nemean Lion dwelt), has now, with its herbs and low scrub, become a place of herdsmen and their flocks.

(Die griechischen Landschaftsgemälde von Karl Rottmann in der königlichen Pinakothek zu München, pp. 13–14.)

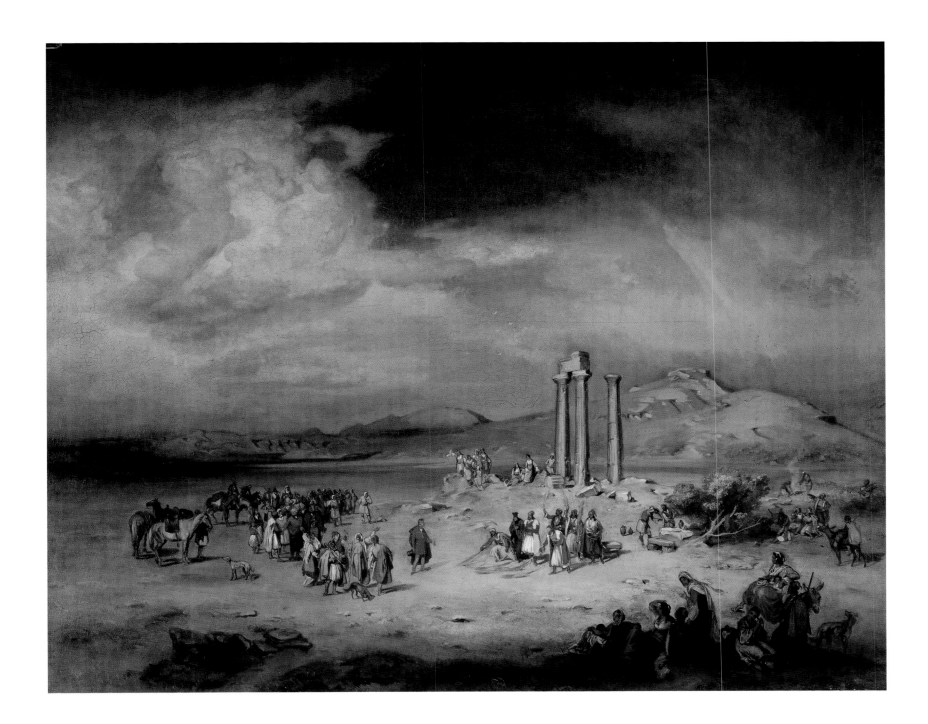

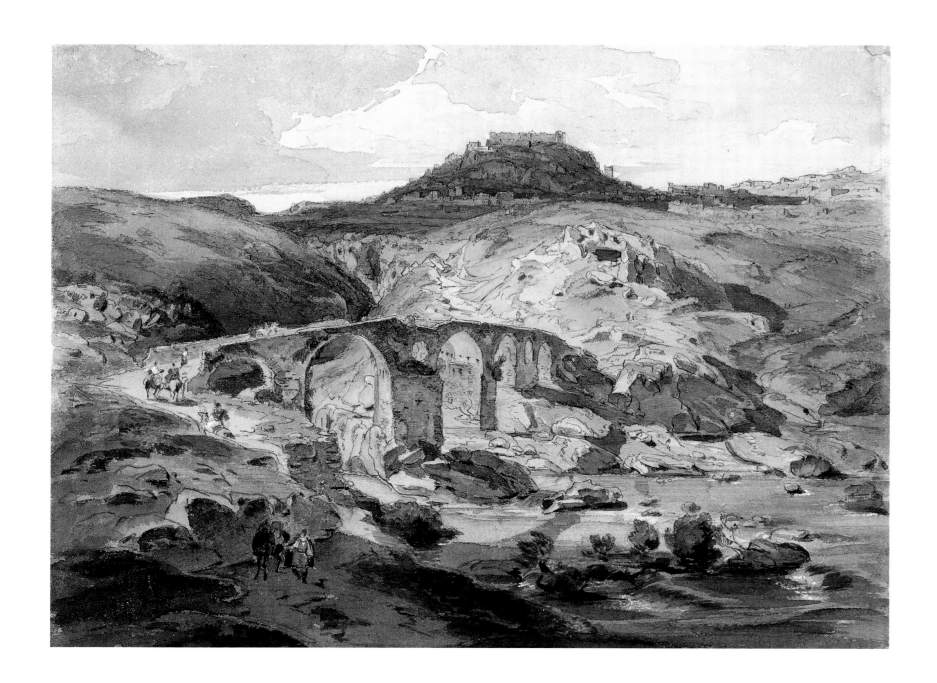

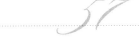

Carl Rottmann (Bavarian, 1797–1850)

Karytaina

Watercolor over pencil,

24.8 x 32.5 cm (9 ¾ x 13 ⅞ in.)

Munich, Staatliche Graphische Sammlung,

inv. 21382

This watercolor of the medieval city of Karytaina, approached by a fine Turkish bridge, is one of the most impressive of Rottmann's landscapes. As usual, it contains no classical features, but the architectural elements add accent and context to the drama of the landscape, where often Rottmann is dependent on atmospheric effects to give character to his scenes.

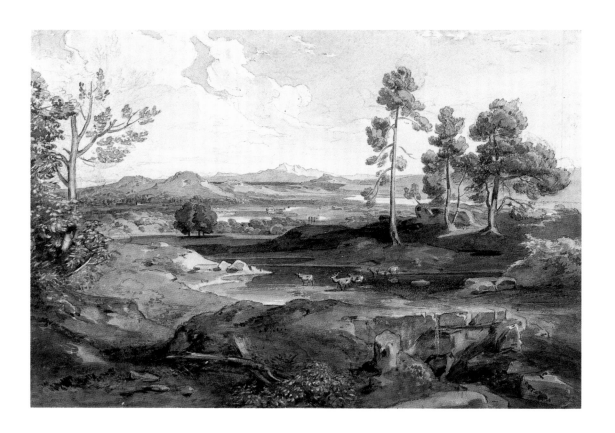

Carl Rottmann (Bavarian, 1797–1850)

Olympia

Watercolor over pencil,

21.3 x 29.7 cm (8⅜ x 11⅝ in.)

Munich, Staatliche Graphische Sammlung,

inv. 21366

Rottmann's view of Olympia, like his other paintings, shows scant interest in architectural remains. Though the site of Olympia was known in Rottman's day, there was little to see above ground. In 1829 the French Expédition Scientifique de la Morée spent about six weeks digging, but did no more than ascertain the existence of a temple and remove a fragment of a metope to the Louvre. The great English topographer W. M. Leake had mapped the site, but it was left to Ernst Curtius to excavate it, in the first scien-

tific excavation in Greece ever conducted with the support of the authorities. Even Curtius on his first visit had been scarcely interested in the thought of the antiquities that lay beneath his feet. "The place itself makes no great impression, but it was a great joy to me to recite the ode of Pindar on the Hill of Kronos and to imagine to myself the horses and mules gathering here from the different parts of the world" (letter from Curtius to his parents, May 15, 1838; quoted from Deutsches Museum, *100 Jahre deutsche Ausgrabung in Olympia*, p. 30).

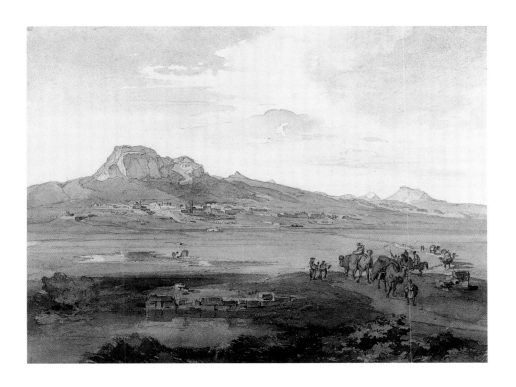

Carl Rottmann (Bavarian, 1797–1850)

Corinth

Watercolor over pencil,

24.7 x 31.8 cm (9¾ x 12½ in.)

Munich, Staatliche Graphische Sammlung,

inv. 21387

Rottmann made a large number of sketches and watercolors of Corinth from many angles. This distant view of the hill of Acrocorinth is unusual for Rottmann because he includes contemporary figures. They are laid out, however, with their camels, for picturesque effect. Like many of these views, this watercolor was once the property of Ludwig I. It is a preliminary sketch for the major encaustic view designed for the Hofgarten and now housed in the Antikensammlung in Munich (Bayerische Staatsgemäldesammlungen, inv. WAF 853). The translucency of the brushwork in this watercolor compares well with the much heavier treatment in the larger version.

Carl Rottmann (Bavarian, 1797–1850)
Sicyon with Corinth
1836/1838
Encaustic on plaster,
157 x 200 cm (61¾ x 78¾ in.)
Munich, Bayerische Staatsgemäldesammlungen,
Neue Pinakothek, inv. WAF 868
Photo: Artothek, Munich

Rottmann made versions in oil as well as water-color and encaustic of this scene; it was the first of the cycle of Greek paintings for the Hofgarten to be completed, in 1838, and was perhaps executed with especial care, for in this case the more finished work conveys a greater depth of feeling than the more luminous watercolor.

Over the broad lines of this barren landscape reigns a deep sorrow; this long extended shore, these steeply climbing hills, the traces of human habitations and of erstwhile great urban designs and buildings, awake a sense of the past and its greatness, which gives wings to our imagination and carries us far beyond reality. As the whole of the foreground land-scape lies in half darkness and only a few rays of sunlight fall across the distance, the present is enshrouded in mourning, and only from the distance of the past is their a glimmer of cheerfulness and happiness. (Schorns Kunstblatt, vol. 91 [13 November 1838], p. 370; quoted from Erika Bierhaus-Rödiger, Carl Rottmann: 1797–1850, p. 358.)

Perhaps an overdramatic reaction to the paint-ing, the reviewer's words nonetheless convey the brooding atmosphere Rottmann seems often to have striven for in his use of strong atmospheric effects. (The two oil versions are in the Niedersächsische Landesgalerie, Hannover, and in the Bayerische Staatsgemälde-sammlungen, Munich; the watercolor is in the Staatliche Graphische Sammlung in Munich.)

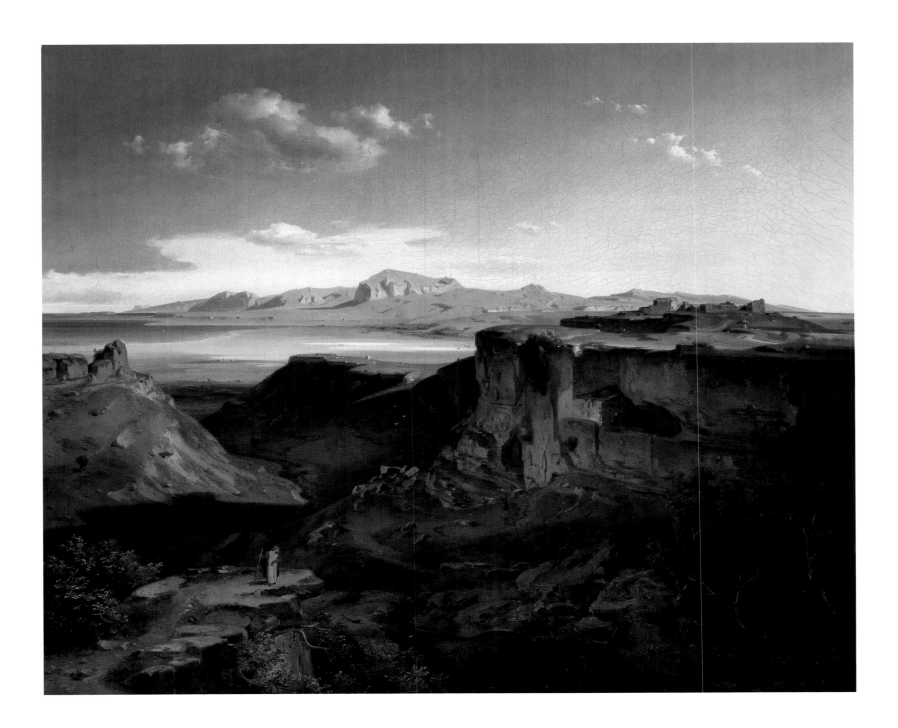

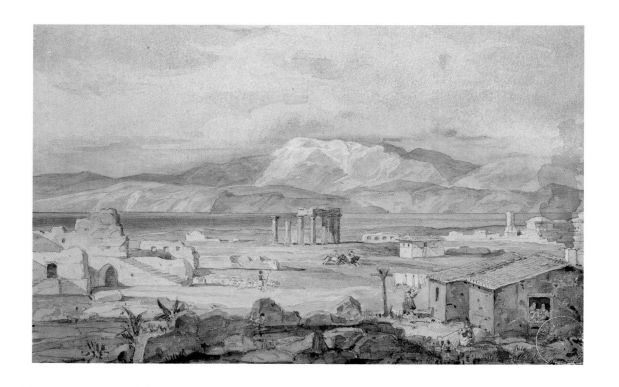

Friedrich von Gärtner (Bavarian, 1727–1847)

Parnassus Seen from Corinth

Pencil and watercolor,

13.5 x 20.3 cm (5¼ x 8 in.)

Munich, Architektur Museum, Technische

Universität, GS 287

The architect Gärtner, who designed the Royal Palace in Athens, visited Greece in company with King Ludwig I in 1835 to 1836. This painting is the only evidence of activity outside the capital. Though it does not have the intensity of the work of his contemporary Rottmann, his architect's eye is evident in the assured drawing of the buildings, and the picture is an interesting document of the appearance of the town before the excavation of the ancient city.

Edward Lear (English, 1812–1888)

The Temple of Apollo at Bassae

1854/1855

Oil on canvas,

146.4 x 229.5 cm (57 ⅝ x 90 ⅜ in.)

Cambridge, Fitzwilliam Museum, acc. no. 0460

Lear's view of Bassae is one of the most success-ful of his oil paintings of Greek scenes. It is one of rather few that he painted, on Pre-Raphaelite principles, directly from nature in oils. It sets the temple firmly in its magnificent setting: mountains and especially the great vallonia oak in the foreground form the true subject of the painting, to which the illuminated columns of the temple add an accent that is almost an epiphany from the world of the gods. Lear seems to have responded to the numinous qual-ity of the place in much the way that Haygarth did in *Greece, A Poem, in Three Parts:*

Lead me to the awful groves
Where lingers still the genius of the place
And with his shadowy finger dimly marks
The spot where sages taught, where poets sang,
Where heroes bled . . .

In recent years pollution from the power station at Tripolis has damaged the stone and the tem-ple has been encased in a giant plastic bubble, completely destroying the symbiotic splendor of temple and landscape.

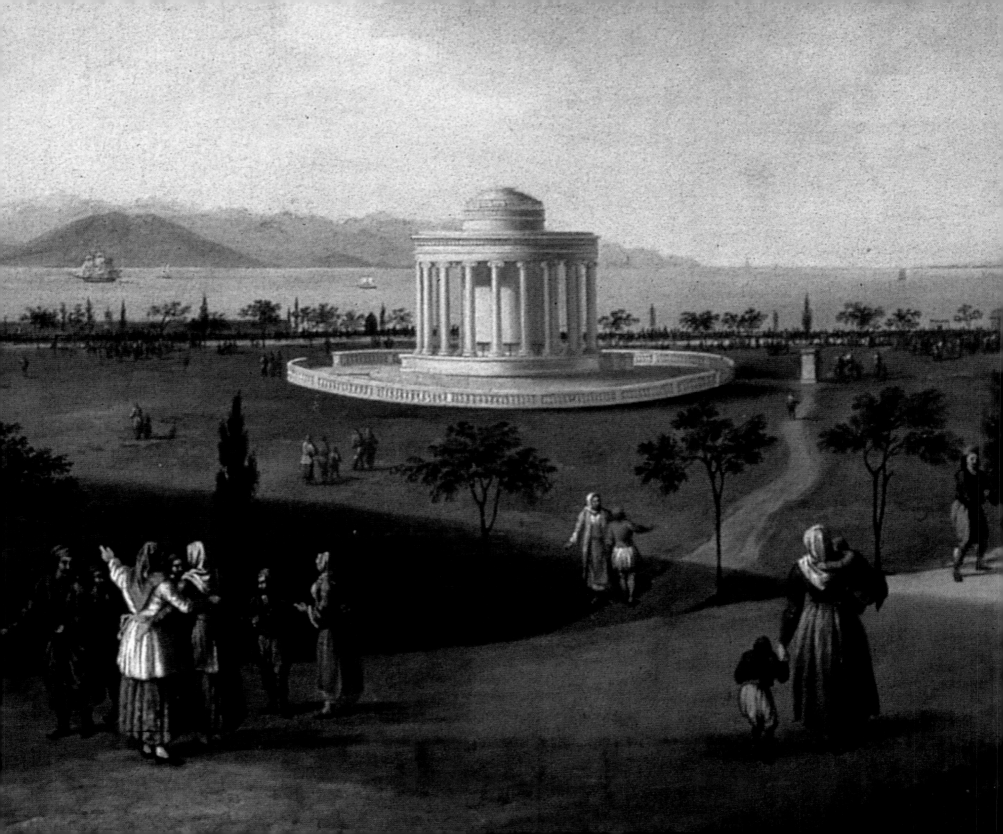

THE IONIAN ISLANDS

The Ionian Islands are an extensive archipelago off the western coast of Greece. The seven major islands are Corfu (the largest and perhaps most important politically, having been at times a seat of government), Paxos, Lefkas (or Lefkada), Ithaca (claimed to be the legendary home of Ulysses), Cephalonia, Zakynthos (or Zante), and Kythira.

From the Middle Ages onward, visitors to Greek lands often made their first landfall on one of the Ionian Islands—yet prior to the nineteenth century the islands received little attention from outside painters. In part this is a result of political circumstances. For more than five centuries the islands were under Italian domination: from 1267 to 1386 ruled by the house of Anjou, and from 1386 to 1797 by Venice. The importance of the islands to Venice's trade routes meant that military security was tight and tourists were unknown, and the records that were made of the islands were for maritime purposes. Particularly fine pictorial maps were produced by

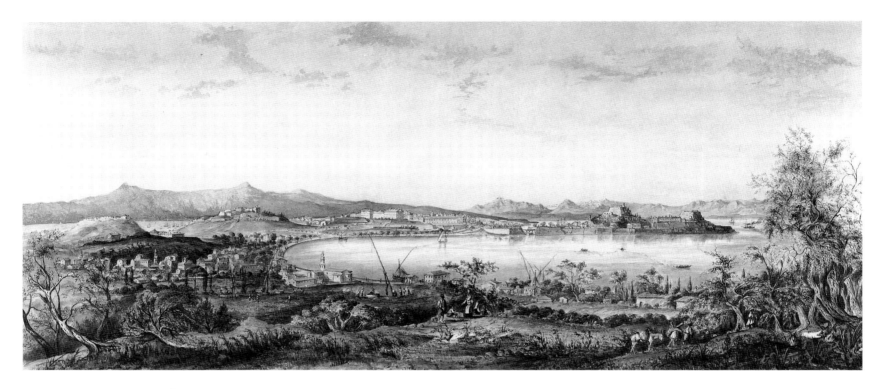

Arthur James Herbert (English, dates unknown)
Corfu from the South
ca. 1861
Watercolor, 37 x 85.5 cm (14 1/2 x 33 5/8 in.)
London, Government Art Collection, inv. 9278
© Crown copyright: UK Government Art Collection

Herbert was deputy quartermaster-general for the Ionian Islands in 1861, and this painting is one of two commemorating his stay. The meticulous brushwork reflects both leisure and love of the place.

the Italian geographer Vincenzo Coronelli in the seventeenth century and by a Dutch cartographer, Gerard van Keulen, in the eighteenth century. The islands then came under French rule from 1797 to 1799 and 1807 to 1814, with an interlude as the Septinsular Republic, under Russian protection.

In 1814 the islands became a British protectorate, and remained so until unification with Greece in 1864. It is from this fifty-year period that the most significant paintings of the islands date. (Edward Dodwell's prospect of the Bay of Vathi in Ithaca is a rare earlier exception.) Many visitors to Greece had reason to be grateful for the hospitality of Sir Thomas Maitland, lord high commissioner of the Ionian Islands from 1815. Maitland was a despotic character whom the islanders called "King Tom," but he was able to smooth the path of English and Scottish travelers to Greece, and the Ionian Islands came to seem almost an extension of the home country for subsequent British visitors.

Corfu, naturally, as chief of the islands, came in for particular attention. Many fine paintings of views of the island are by the hand of British officers and officials stationed there, who,

like visitors of other nationalities, responded to the uniquely beautiful natural scenery as well as to the elegant Italianate architecture of the island. These artists include Joseph Cartwright, who was paymaster-general to the British garrison from 1816 to 1820; Josef Schranz (FIGURE 64), Arthur James Herbert, deputy quartermaster-general in Corfu in 1861 (FIGURE 63); and presumably the obscure Mr. Savage, who painted a collection of watercolors of some historical interest.

The Ionian Islands were also the subject of Edward Lear's first excursions to Greek lands. He arrived in Corfu on April 19, 1848, at the end of a Mediterranean tour. He had already achieved some distinction as a wildlife artist, landscape painter, and drawing master to Queen Victoria, and the tour's purpose was to find him new subjects to satisfy the growing rage for landscape painting among art collectors and patrons. Lear was at once overwhelmed by the beauty of the Ionian landscape.

"I wish I could give you any idea of the beauty of this island," he wrote to his sister Ann, "it really is a Paradise" (*Edward Lear: The Corfu Years*, ed. Philip Sherrard, p. 41). He was so overwhelmed by just looking at the landscape that he almost forgot to paint. He left on May 30th and continued to Athens and thence to northern mainland Greece, then as now a relatively unusual destination for a traveler.

In 1855 Lear returned to Corfu to accompany his dear friend Franklin Lushington, who had been appointed Judge to the Supreme Court of Justice in the Ionian Islands. During his two-year stay, Lear painted more than one hundred views of Corfu alone, in addition to traveling to and painting other islands in the archipelago. The body of work he created on the Ionian Islands represented a transformation in his art and in the representation of the Greek landscape. Never before had a painter—not even Rottmann—been as sensitive to the luminous quality of the Greek air, the colors and brilliance of the Greek landscape, and the texture and hues of its varied vegetation.

Lo!—all the hedges and trees have said to each other—"bless us!—here is April the 10th and there is no time to lose" and out they have all come in full leaf most wonderfully!—& as for flowers, things have now reached their utmost, & I suppose there is now no more possible room for any more.... There is hardly any green left since an immense crop of marigolds, geraniums, orchises, irises and cannonilla have come out. The hills are positively an immense crop of geraniums all gold color—& in the olive woods, the large white heath looks like snow, and the pale lilac asphodels in such profusion as to seem like a sort of pale veil over all the ground. The hedges are absolutely pink, & in fact the whole thing is almost absurd from its very oddity.

(Letter to Ann Lear, April 13, 1856; Vivien Noakes, *Edward Lear*, pp. 134–35.)

At this time Lear began working on his first large canvases for London exhibition. Modern taste, however, generally agrees in preferring the spontaneity and luminosity of his watercolors to the more carefully worked oils (with some exceptions, such as the intensely felt view of Bassae shown in Chapter III, FIGURE 62). Though they are only working sketches (and liberally covered with hand-written notes on colors, textures, and types of plants), they convey the character of the Greek land-scape with sun-drenched immediacy. The paintings of Lear's "Corfu period" (represented here by FIGURES 65, 66) are the most assured of his watercolors; by comparison, his earlier sketches are often slight and certainly less assured, while the views of Crete from 1864 rely on his ability to catch a scene with the fewest strokes of brush and pencil and sometimes seem perfunctory. Lear spent most of his time on the island of Corfu, but did make occasional excursions to the other islands, including Ithaca, Zakynthos (Zante), and Lefkas (then called Santa Maura), in the course of his visit in 1848.

In 1857, while Lear was in Corfu, Angelos Giallinas was born on the island. Giallinas was to become one of the most distinguished of modern Greek painters, and his impressionistic response to the Greek scene (not just to Corfu) is only now beginning to receive its due (see FIGURE 67 for an example). Unfortunately, for legal reasons the large collection of paintings that Giallinas left to the municipality on his death is not open to the public.

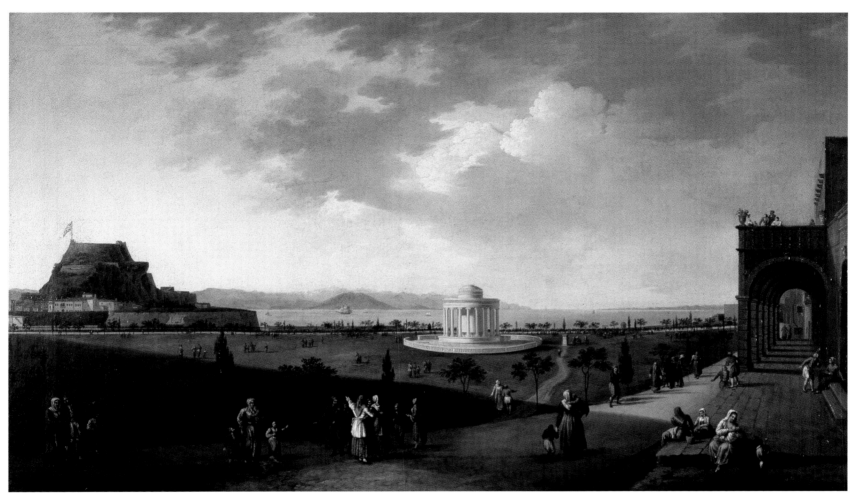

Josef Schranz (Maltese, 1803 – after 1853)

View of the Spianada, Corfu

Oil on canvas, 58.5 x 95 cm (23 x 37 ⅜ in.)

London, Government Art Collection, inv. 5212

© Crown copyright: UK Government Art Collection

This picturesque evocation of the Spianada, the waterfront park in Corfu, with the rotunda built by Sir Thomas Maitland in 1815 to 1824, portrays the island in the heyday of British rule, presumably some time in the 1830s.

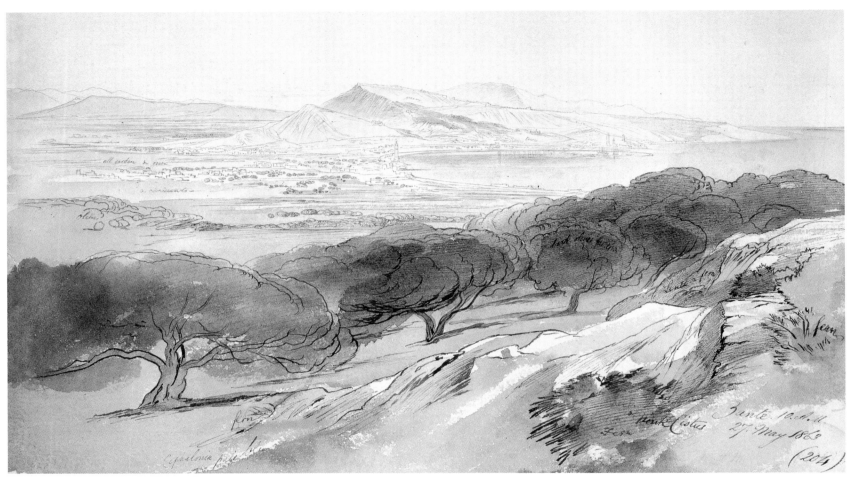

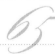

Edward Lear (English, 1812–1888)

Zante, 27 May 1863

Pencil and watercolor

Athens, Gennadius Library, no. 142

This watercolor depicts the town of Zante (also known as Zakynthos) from a viewpoint on the top of Mt. Skopos to the south of the town. Because Lear painted fewer views of the Ionian Islands other than Corfu, those that he did paint, like this one, are more "finished" than many of his pictures of Corfu. Zante, like Corfu, is notable for its Italianate architecture, and this painting is of value as a historical record of the town, which was badly damaged in the earthquake of 1953.

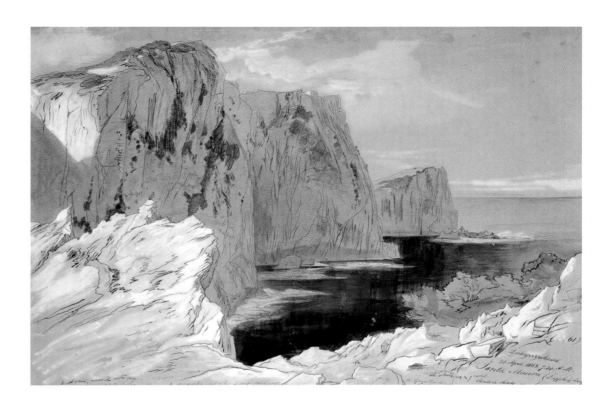

Edward Lear (English, 1812–1888)
Santa Maura, 21 April 1863
Pencil and watercolor
Athens, Gennadius Library, no. 139

This is one of two views of Santa Maura (modern Lefkas or Lefkada) in the Gennadeion collection; the other depicts the causeway between the island and the mainland. This dramatic scene is the cliff known as Sappho's Leap (Cape Doukato, at the southwest point of the island), where, according to legend, the poetess Sappho leapt to her death, in the sixth century B.C., through unrequited love for the seaman Phaon. Lear lets no images of this probably unfounded legend disturb his response to the landscape; he concentrates on rendering the lines of the cliff and the intense color of the sea in its bay, noting the detail of the foreground to be worked up later if a commission for an oil painting should be forthcoming.

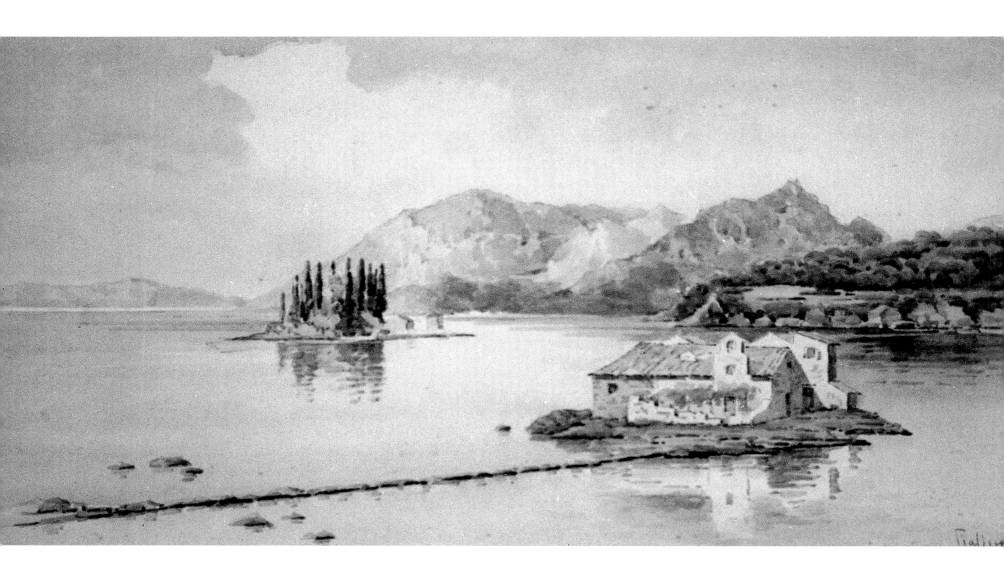

Angelos Giallinas (Greek, 1857–1939)

Corfu: Pondikonisi

ca. 1918

Watercolor, 24 x 46 cm (9 ³/₈ x 18 ¹/₈ in.)

Museum of the City of Athens, inv. 1263

This very characteristic work of the Corfiot painter Giallinas, whose oeuvre consists entirely of watercolor works, suffuses a careful rendering of the famous beauty spot with a shimmering light and poetic intensity that are entirely distinctive. Though this is not one of Giallinas's larger-scale watercolors, it achieves a certain monumentality of treatment that is characteristic of his bigger paintings.

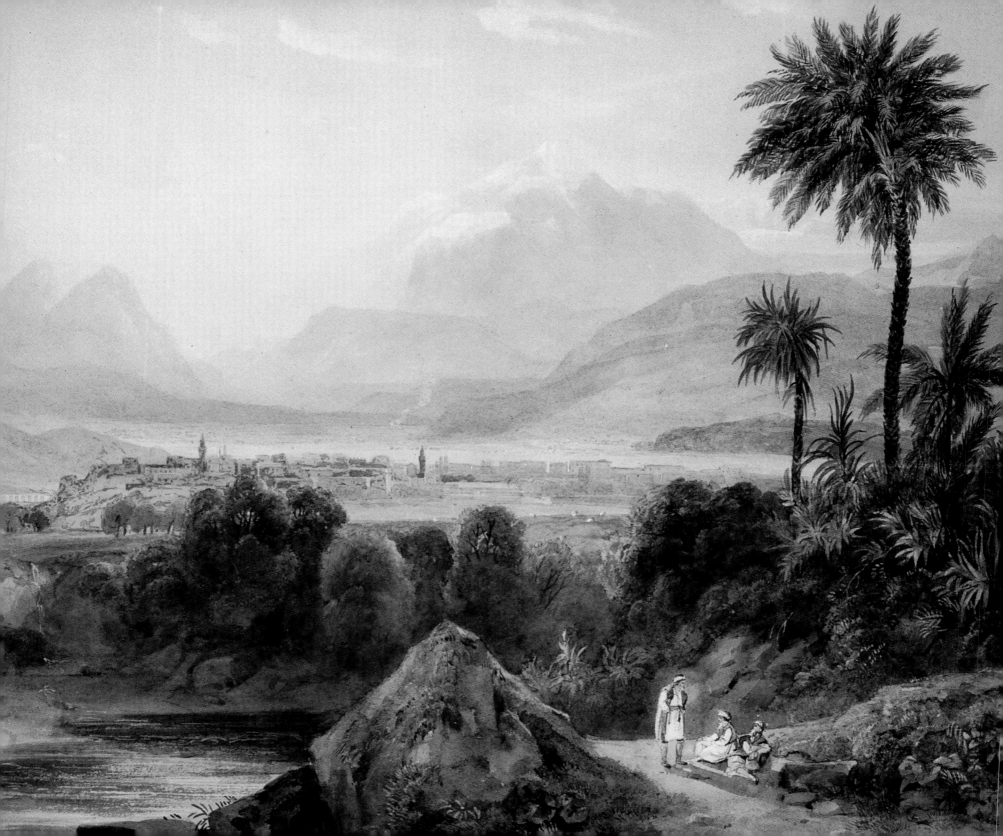

CENTRAL, WESTERN, AND NORTHERN GREECE

With the exception of Athens and Attica, mainland Greece was in general much less visited by artists, or indeed by archaeologists and travelers of any kind, than the Peloponnese; it still remains rather less familiar to the average visitor to Greece—apart from the splendors of Delphi—than the southern parts and the Greek islands. The modern state of Greece incorporated the northern regions of Macedonia and Thrace much later than the heartlands of Attica and the Peloponnese. Going north seemed always an excursion into the wild and dangerous regions of the Ottoman Empire, where the mountains were ruled by klephts (brigands) and armatoles (Greek guerrilla fighters employed by the Turkish government as a militia). In addition, classical remains were relatively sparse north of Delphi (Philippi being a rare and remote exception), so that those with an archaeological bent were not drawn to the region, whose architectural glories—Meteora, Kastoria, and the monasteries of Mt. Athos—are from the Byzantine period.

From our perspective, the region falls into three parts: (1) the regions of classical fame in Boeotia and Phocis; (2) the western regions, including Mesolongi and Epirus, which came to international fame with the outbreak of the War of Independence in 1821; and (3) Thessaly, Macedonia, and Thrace, where visitors were rare and only Edward Lear managed to travel as far as Mt. Athos.

CENTRAL GREECE: BOEOTIA AND PHOCIS

Small in extent but of great significance in the classical period, the mountainous region of Phocis divides the plain of Boeotia from western and northern Greece. The passes are few and the mountains formed a natural barrier that visitors based in Athens rarely passed.

Few strangers meet us on our itinerary here: Edward Dodwell, Carl Rottmann, and Ludwig Lange all paid homage to the great classical sites of Thebes, Delphi (see Introduction, FIGURE 4), and Mt. Parnassus, as well as the Oracle of Trophonius at Levádhia (FIGURE 73) and the ancient and medieval ruins of Orchomenos. James Skene was the first painter to cover the whole region with any thoroughness, and the large collection of his watercolors in the National Historical Museum in Athens contains views of many minor sites, such as Chaeronea, Tithorea, and the Cave of Odysseus Androutsos on Parnassus, as well as the more obvious ones (FIGURES 71, 72) mentioned above. Edward Lear's views of this region (FIGURE 68, for example) are less well-known than his paintings of Corfu, Crete, and the north.

WESTERN GREECE: EPIRUS, MESOLONGI, AND THE WAR OF INDEPENDENCE

Mesolongi holds a position of peculiar importance in the history of modern Greece as well as in that of Western involvement with the country. It quickly became the Western center of resistance to the Turks at the outbreak of the War of Independence in 1821, and endured three sieges before its final destruction in the attack by Ibrahim Pasha's troops in April 1826: most of the inhabitants fled before the final destruction, but of the nine thousand who escaped, only eighteen hundred arrived alive at Amphissa. Those who remained behind had set fire to their weapons and powder magazines, thus involving both enemy and defenders in a common mass destruction.

The defenses against the two earlier sieges, in 1822 and 1823, stirred the hearts of philhellenes abroad, whose involvement in the Greek cause was already becoming strong. In January

1824 the most famous of all the philhellenes, Lord Byron, arrived in Mesolongi to aid the cause with money and inspiration (FIGURE 74). However, the low-lying malarial atmosphere of the lagoon city induced a fever that resulted in his death there the following April, without his having ever raised his sword against the enemy. Memory of Byron's dedication to Greek liberation inspired others, however, and he occupies pride of place in the Garden of the Heroes in Mesolongi, which was dedicated at the conclusion of the war. The bones of the unidentified dead were gathered in a large tomb in the same garden and given a formal funeral in the presence of King Otho and Queen Amalia on October 14, 1838.

Other parts of western Greece were rarely visited by foreigners. The high mountain chain of Pindus that dominates Epirus was often impassable. This hostile landscape provided an ideal refuge for the insurrectionists in the War of Independence, and more than one battle was fought there, including that of Arta (FIGURE 77). Most of the region was under the rule of the formidable Ali Pasha of Ioannina, who carved out a virtually independent fiefdom within the Ottoman Empire, and ruled it with brutality and rigor until his murder in 1822. Most visitors to the region felt constrained to pay a call on Ali; Byron celebrated his handsome looks and his savagery, and no one who traveled in the region could be unaware of his presence. He spent much of his time on a secluded island in the lovely lake of Ioannina (FIGURE 79), an unusual feature in the Greek landscape. The town itself (FIGURE 69) still retains some of its Ottoman character.

NORTHERN GREECE: THESSALY, MACEDONIA, AND THRACE

These regions, poor in classical sites, attracted fewer visitors than the south of Greece, and the record of paintings is correspondingly sparse. Besides Lear, our only representative for Athos (FIGURE 85) and Kavalla, those who did come include William Haygarth, who landed in northwest Greece and made his way thence to Athens. James Skene and William Gell reached the Pass of Thermopylae (FIGURE 83) and the Vale of Tempe (FIGURE 82), the route to the north; and Bavarian troops in the 1830s were stationed at the northern approaches to the kingdom, so that painters like Koellnberger (FIGURE 84) had opportunities to portray their surroundings. The monasteries of Meteora near Kalambaka seem to have been virtually unvisited: the Russian pilgrim V. Grigorovich Barskii (FIGURE 80) came not primarily as an artist, and Haygarth (FIGURE 81) is unusual among the painters in having treated this site (though, of course, Lear was there, too).

Charles Robert Cockerell (English, 1788–1863)
A Greek House in Ioannina
1811
Engraving, 18 x 23.5 cm (7 1/8 x 9 1/4 in.)
From Thomas Smart Hughes, *Travels in Sicily, Greece and Albania* (London, 1820), facing p. 438;
Los Angeles, Getty Research Institute, Resource Collections

This engraving, which shows the house of Nicolo Argyri, was an illustration for a book by Thomas Smart Hughes, who describes the house as follows:

[It] is the same which Lord Byron and Mr. Hobhouse occupied . . . and . . . it affords perhaps as good a specimen as can be met with of a modern Greek mansion. From the street we enter by a pair of folding doors . . . into a large stone portico or piazza, enclosing three sides of an area or court . . . fronted by a garden, which is separated from it by a palisade: in the basement story, which is flanked by this portico, are stables, granaries, and other offices: very near the folding doors a flight of stone steps leads up to a fine picturesque gallery or corridor . . . supported on the stone arches of the portico and shaded by the long shelving roof of the house; this is a place of exercise for the inmates in bad weather, and of indolent repose during the violence of the heat. (Travels in Sicily, Greece and Albania, p. 438.)

70

Hugh William Williams (Scottish, 1773–1829)

View of the Town of Thebes

1819

Watercolor, 48 x 70 cm (18⅞ x 27½ in.)

Athens, Benaki Museum, inv. 25194

Like his view of Sunium (see Chapter II, FIGURE 35), Williams's view of Thebes is notable for its emphasis on atmosphere, rather in the manner of Turner. Here, however, it is haze and the effect of sun in clouds, rather than the drama of storm, that dominates this painting of what is today a rather charmless town.

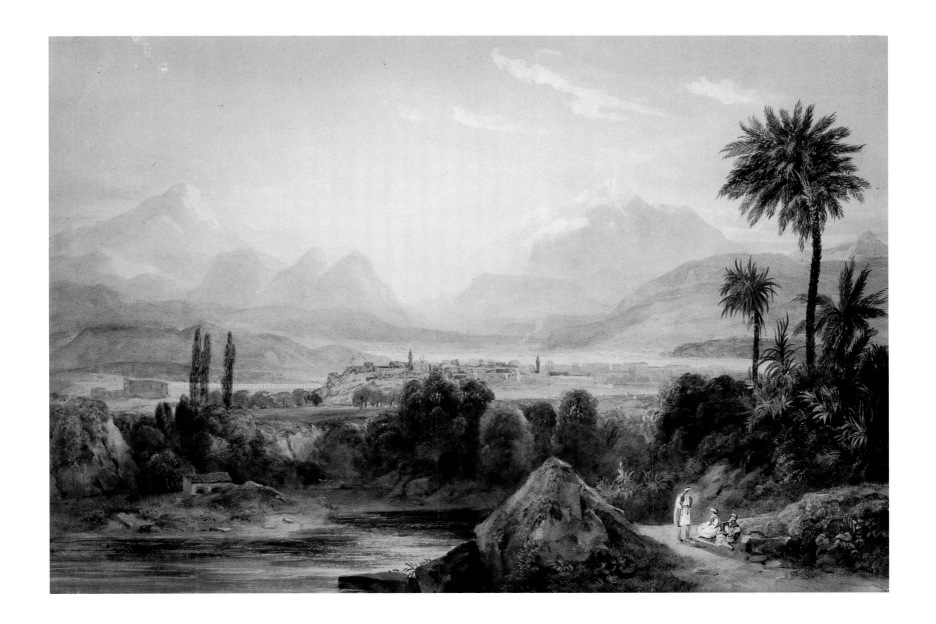

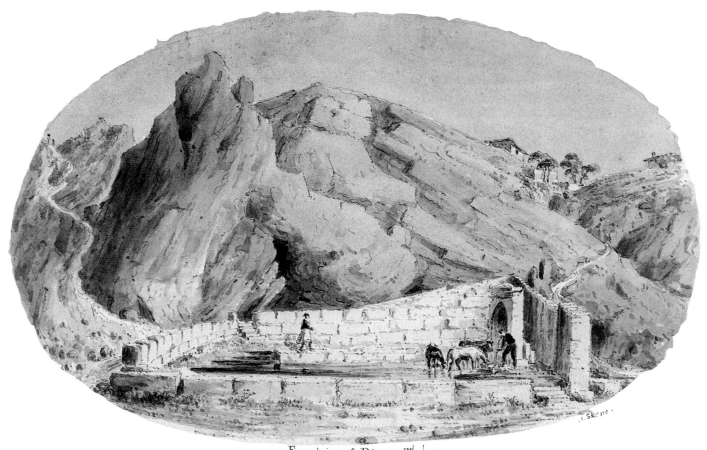

Fountain of Dirce, Thebes.

J. Skene

71

James Skene (English, 1775–1864)

Thebes, View of the Fountain of Dirce

after 1851

Watercolor

Athens, National Historical Museum

The modern town of Thebes has obliterated most of the ancient remains, so that Skene's view of the picturesque fountain of Dirce is an interesting record of the lost classical past. In this view the distorting effect of the curvature of the mirror in the camera obscura (a precursor of the modern camera, used as an aid to sketching and drawing) is less marked than in Skene's broader landscapes.

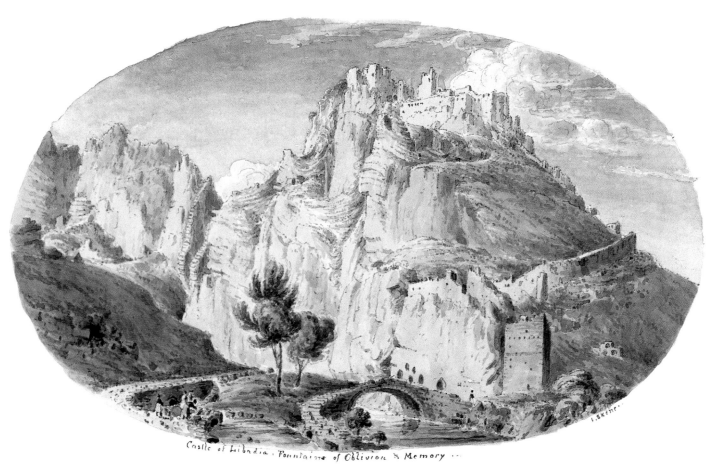

Castle of Libadia, Fountains of Oblivion & Memory ...

72

James Skene (English, 1775–1864)
View of the Castle of Levadia
after 1851
Watercolor, 12.5 x 19 cm (4⅞ x 7½ in.)
Athens, National Historical Museum

General views of the mountain town of Levádhia are rare. In the Turkish period the town was equal to Thebes in importance, and it was of interest to travelers as the site of the oracle of the hero Trophonius. In his diary Skene writes: "Two beautifully limpid sources of water, the fountain of Forgetfulness and the fountain of Memory, rise close to the oracular cavern of Trophonius.... I partook of each without any other effect than pleasure in the refreshing draught" (quoted from Historical and Ethnological Society of Greece, *James Skene: Monuments and Views of Greece 1838–1845*, pl. *72*).

Ludwig Lange (Bavarian, 1806–1868)

Oracle of Trophonius at Levádhia

1836

Watercolor, 55.7 x 51.4 cm (21⅞ x 20¼ in.)

Munich, Staatliche Graphische Sammlung,

inv. 35863

To consult the oracle of Trophonius, enquirers performed various preparatory rites and descended to a subterranean cavern, where they experienced revelations in varying forms. Lange's is one of the very few depictions of the niches at the oracle. (For Pausanias's description of the rites associated with the Cave of Trophonius, see my book, *A Literary Companion to Travel in Greece*, pp. 169–71.)

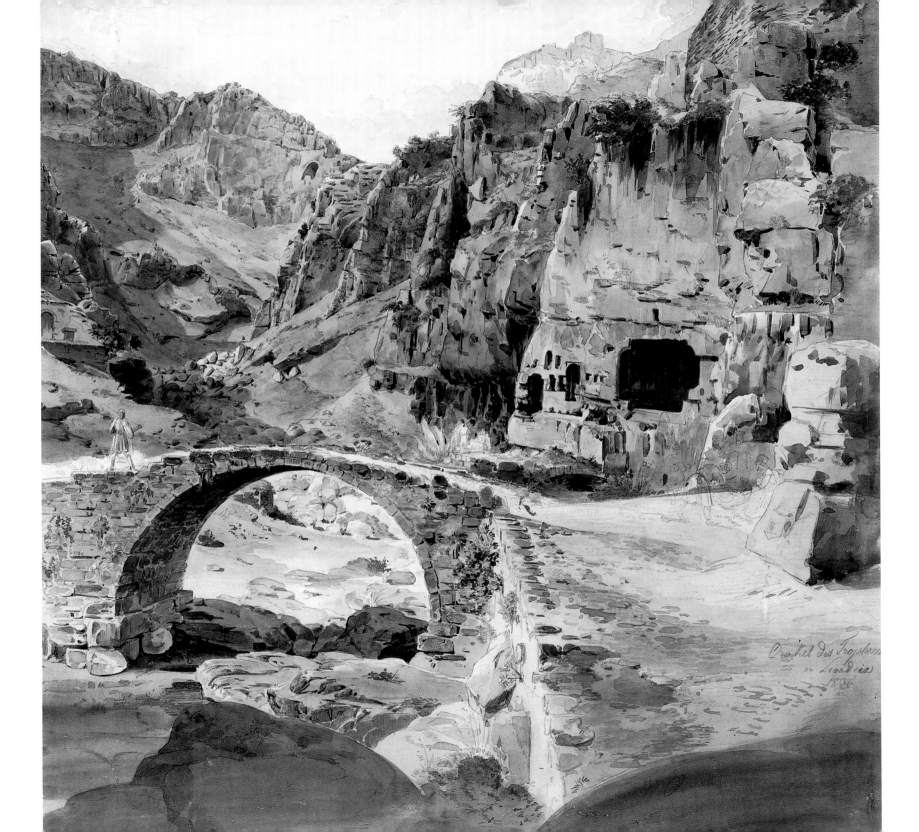

Citadel des Troglodytes
à Loadica
1836

Theodoros Vryzakis (Greek, 1814–1878)

The Arrival of Lord Byron in Missolonghi

1861

Oil on canvas, 155 x 213 cm (61 x 83⅞ in.)

Athens, National Gallery and

Alexandros Soutzos Museum, inv. 1298

Vryzakis was a Greek-born artist who achieved prominence in Munich with his grand historical pictures of scenes from the Greek War of Independence, executed between the years 1851 and 1865. This painting depicts the moment when Byron stepped on shore at Mesolongi, ready to fight for Greek independence, and was welcomed by George Karaiskakis and other Greek leaders: the landscape with its lagoon and the looming bulk of Mt. Arakynthos is clearly suggested. Karaiskakis is the kilted figure in the foreground; beside him, in European costume, is Alexander Mavrokordatos. (There is a copy of this painting in the Municipal Museum in Mesolongi.)

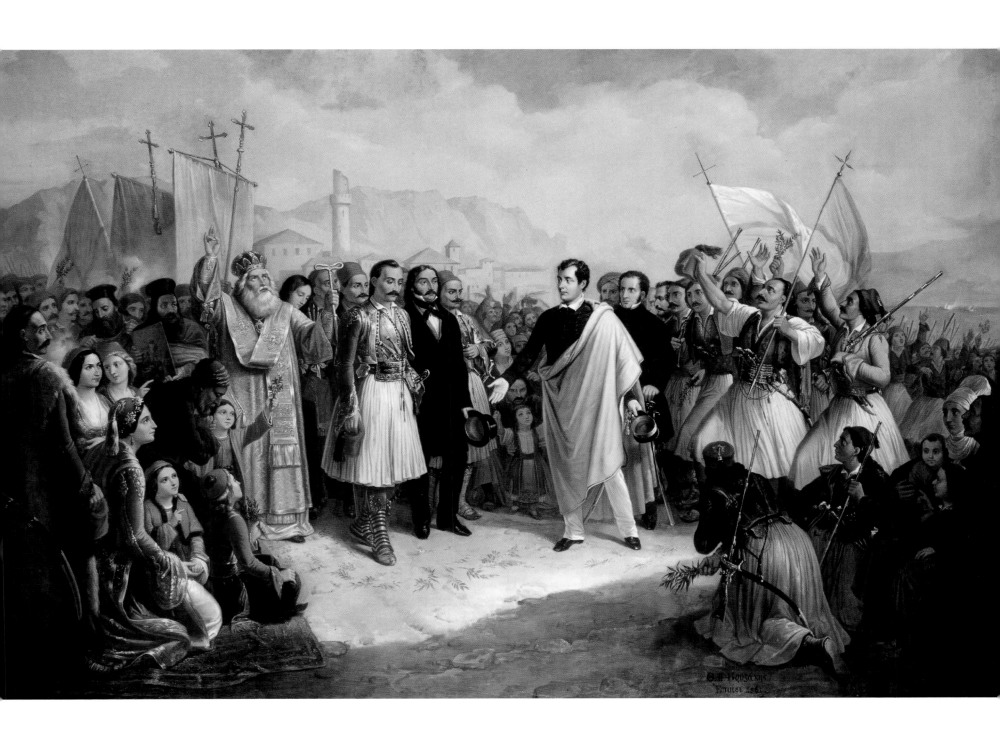

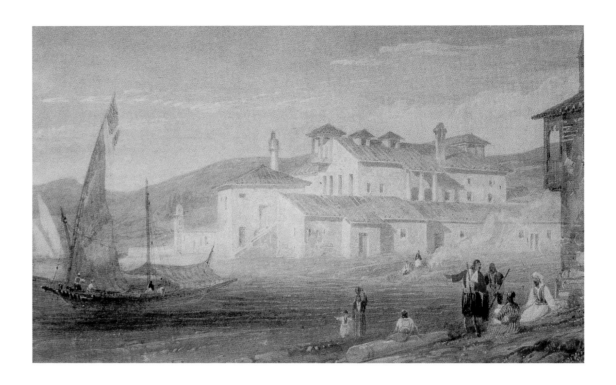

William Purser (English, ca. 1790–1834)

View of Missolonghi with Lord Byron's House

1824

Watercolor

Athens, Benaki Museum

This painting is a valuable record of Byron's house on the shore of the lagoon in Mesolongi. Like most of the city, it was destroyed in the final siege; a small monument now marks its location. Although Byron's doctor, Julius Millingen, wrote that Byron's "receiving room resembled an arsenal of war, rather than the habitation of a poet, . . . decorated with swords, pistols, Turkish sabres, dirks, rifles, guns, blunderbusses, bayonets, helmets, and trumpets" (*Memoirs of the Affairs of Greece*, p. 90), it was while living here that Byron wrote these anguished lines on the eve of

his thirty-sixth birthday (*Lord Byron: Selected Letters & Journals*, ed. Leslie A. Marchand, pp. 320–21):

'Tis time this heart should be unmoved,
Since others it hath ceased to move:
Yet, though I cannot be beloved,
Still let me love! . . .

If thou regret'st thy youth, why live?
The land of honourable death
Is here:—up to the field, and give
Away thy breath!

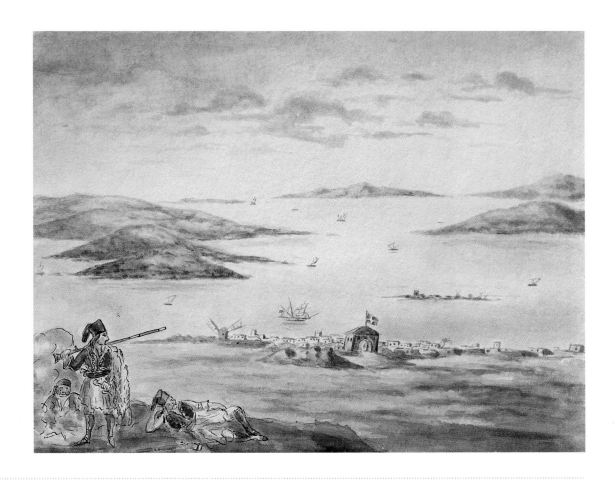

Adalbert Marc (Bavarian, dates unknown)
Missolonghi
1834
Watercolor, 14.5 x 17.5 cm (5 ¾ x 6 ⅞ in.)
Ingolstadt, Bayerisches Armeemuseum,
IV A Graph. no. 49a [2], no. 9

Ten years after Byron's death, the town of Mesolongi had reverted to the life of a peaceable fishing village, dependent for its livelihood on the eels of the lagoon. Despite the deficiencies of his technique, the Bavarian-Greek officer Marc in this painting effectively conveys the impression of the now-tiny village. The main gate and the windmill are depicted in this view from the north, with the Greek flag flying proudly over the gate, which is one of the few parts of the walls still standing from the time before the siege.

Panagiotis Zográfos
(Greek, late 1700s—mid-1800s)
The Battle at Arta
Watercolor, 53 x 62 cm (20⅞ x 24⅜ in.)
Athens, Gennadius Library

The region of Epirus, north of Mesolongi, saw some of the fiercest fighting of the War of Independence, and several of the battles were portrayed in the pictures by Panagiotis Zográfos, prepared under the direction of General Makriyannis. The battle at Arta took place in November 1821:

On the 16th there came from Marati to the chapel of Elijah, where we were encamped, Photomaras, Karaiskakis, and Ago with other Turks on our side, and we made a joint plan to send three hundred men from Marati to occupy the mills of Arta, which lie outside the town on the borders of the land, and the place called Mouchousti, which is near the mills. From our company were detailed a hundred men to occupy the Twelve Apostles and the monastery of Hodegetria on the borders of the land. . . . The three hundred were fallen upon by a large force of foot and horse; and we by some eight hundred of foot, as the country was hilly, and cavalry no use. And I tell my readers, I swear by my country, those three hundred were not men, but in their feet they were eagles and in their hearts lions. They fired one volley at the Turks and then drew their swords. And they slaughtered the Turks and followed them into the outskirts of Arta as far as the Serai and round about the
strong-points and there they left them. . . . When the eight hundred came down on us . . . we swept them in front of us, and with one spirited charge we threw the Turks out of Hodegetria. (The Memoirs of General Makriyannis, 1797–1864, ed. and trans. by H. A. Lidderdale, p. 31.)

Zográfos has given a bird's-eye view of the whole progress of the battle, representing the various movements of troops as well as the topography of the town in a bend of the River Arachthus, spanned by the famous bridge—itself the subject of a well-known folk song (see my *Literary Companion to Travel in Greece*, pp. 197–98).

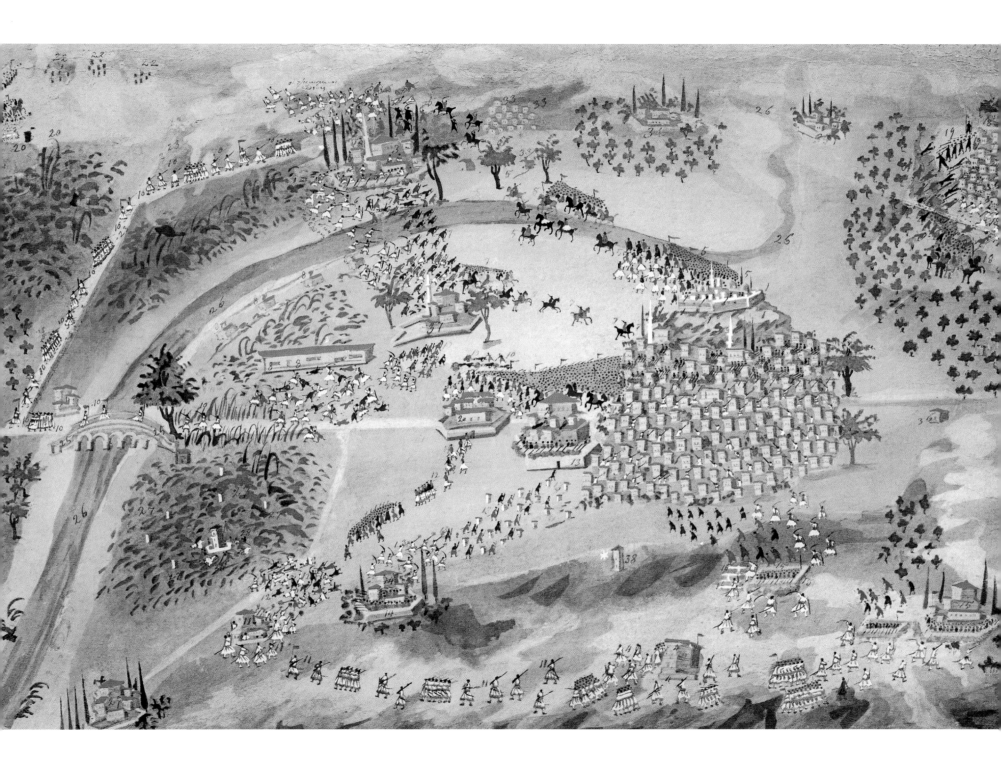

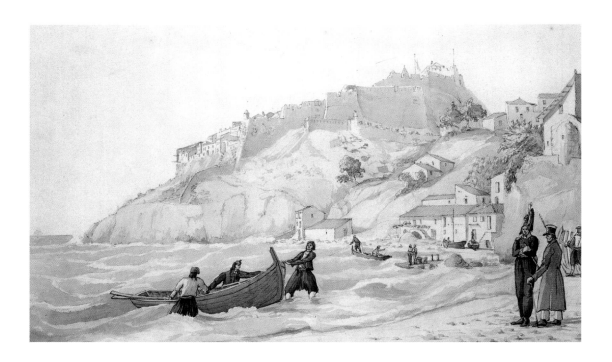

Joseph Cartwright (English, 1789–1829)

View of the Town of Parga

ca. 1820

Watercolor on paper,

32.5 x 53 cm (12¾ x 20⅞ in.)

Athens, Benaki Museum, inv. 23978

Like the Ionian Islands, which it faces across the Ionian Sea, Parga came under Venetian rule in the sixteenth century and later became part of the British Protectorate. In 1819 it was sold by Sir Thomas Maitland, the high commissioner for the Ionian Islands, to Ali Pasha, the Turkish ruler of Epirus, who destroyed the city and caused its inhabitants to flee to Corfu.

Cartwright was stationed with the British garrison of Corfu from 1816 to 1820, and used his leisure time to paint a number of local scenes. This view of the dramatically positioned castle of Parga was a popular one with the painters: Edward Lear made both a watercolor (in the possession of Sir Steven Runciman) and an oil painting (private collection, London), though his concern for compositional effects has constrained him to a more distant view, framed by shapely, gnarled trees. Cartwright's more naive approach represents the topography faithfully but emphasizes the scene of daily life, with fishermen hauling their boat onto land under the gaze of a couple of Westerners.

Edward Lear (English, 1812–1888)

Ioannina (10 April 1857)

Watercolor

Athens, Gennadius Library, no. 95

This slight but brilliantly evocative sketch conveys the unusual setting of Ioannina on its promontory on the lake. It is a good example of Lear's ability to create atmosphere with the most economical of means, and foreshadows the more impressionistic style of his later watercolors of Crete.

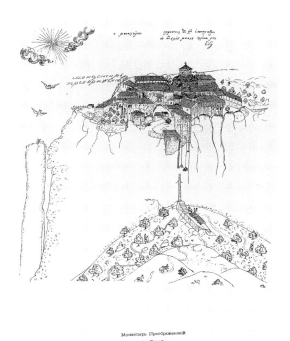

Монастырь Преображенскій
въ Епирѣ.

Vasilii Grigorovich Barskii
(Russian, 1701/1702–1747)
**The Monastery of Metamorphosis
(Transfiguration) at Meteora**
Engraving
From Vasilii Grigorovich Barskii,
*Stranstvovaniia Vasil'ia Grigorovicha Barskago
po sviatym miestam Vostoka s 1723 po 1747*,
vol. 4 (St. Petersburg, 1887), following p. 125

The extraordinary monasteries of the Meteora, literally "up in the air," are built on a series of pinnacles just north of the town of Kalambaka. They date from the eleventh century, when the rocks began to be used as dwellings by hermits. During the fourteenth century, donations from the Serbian royal family brought the buildings to their present state of splendor. The wonder-ful frescoes of several of the monasteries date mainly from the sixteenth century.

The monasteries were rarely visited by outsiders before the eighteenth century, and the earliest depiction we have is in a series of charming naive drawings by the Russian monk Vasilii Grigorovich Barskii, who visited them during a pilgrimage to the Holy Places of theEast in 1745. They schematically but vividly depict the extraordinary topography of the monasteries, access to each of which was made either by rope ladder or by ascent in a basket at the end of a rope.

The monastery of the Metamorphosis is the largest of the Meteora complexes and possesses more than six hundred manuscripts and other works of art. This drawing clearly shows the ascent via basket, raised by a windlass. Although this method is still used to deliver goods, visitors can now ascend by steps in the rock.

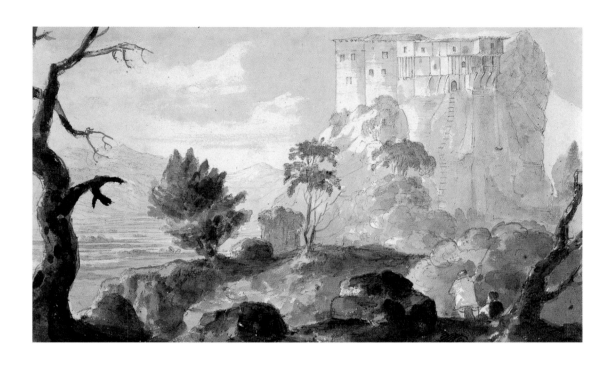

William Haygarth (English, 1784–1825)

The Monastery of St. Nicholas, Meteora

(Sept. 6, 1810)

Sepia watercolor

Athens, Gennadius Library,

GT 2051 q. Box 1, no. 30

William Haygarth visited Meteora in the early stages of his tour through Greece in 1810 to 1811, beginning from the northwest coast and heading gradually south. He is one of rather few travelers who followed the overland route after reaching Greek lands at Corfu, and the collection of his watercolors in the Gennadius Library records his progress from Ithaca and Ioannina through central Greece to Athens and the Peloponnese. Designed from the outset as a basis for the engravings in his *Greece, A Poem, in Three Parts*, these monochrome studies are not great art but represent a personal and felt response to the scenes he visited. They convey something of the excitement and delight that is more formally expressed in the Romantic periods of his poem.

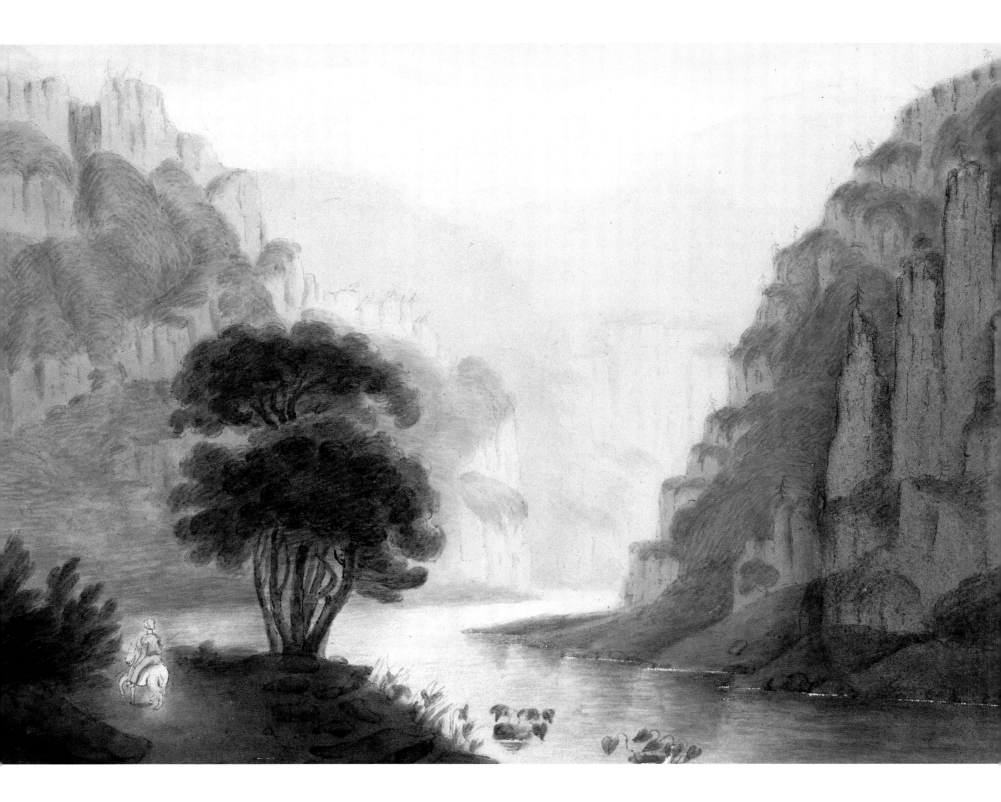

William Gell (English, 1777–1836)

View of the Valley of Tempe

1801/1802–1806

Watercolor, 19 x 26.5 cm (7 1/2 x 10 3/8 in.)

Athens, Benaki Museum, inv. 22946

One of the most famous beauty spots of Greece, the Vale of Tempe runs between Mt. Ossa and Mt. Olympus, and its moist verdure contrasts refreshingly with the aridity of the surrounding landscape. Gell gives an accurate record of the topography, while the coloring gives an almost subaqueous feel to the scenery. The light effects seem to anticipate those of H. W. Williams (FIGURE 70). It is not certain when Gell painted this view, one of rather few finished paintings made in the course of his rapid research for his itineraries of Greece, which concentrate for the most part on archaeological data or (in the case of *Narrative of a Journey in the Morea*) on the misfortunes of his companion, Mr. F.

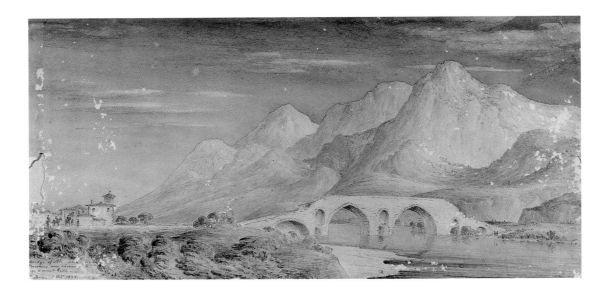

James Skene (English, 1775–1864)
View of the Bridge of Alamana on the
Spercheius River [near Thermopylae]
1838
Watercolor, 22 x 48 cm (8⅝ x 18⅞ in.)
Athens, National Historical Museum

Thermopylae was the site of the heroic resistance of the Spartans to the Persian invaders in 480 B.C., in which the Spartans died to the last man. Skene was drawn to visit the region no doubt for its classical associations, but found little to remind him of the battle of ancient fame. Instead, his eye for the picturesque settled on this charming Turkish bridge. Such bridges are a feature of the landscape of northern Greece, being particularly common in Epirus. The most famous, because of its appearance in folk song, is the magnificent bridge at Arta. The importance of bridges and bridge-builders in the Ottoman Empire is indicated by the occurrence of the distinguished surname Köprülü, "Bridge-builder." Bridges were erected under the sponsorship of a community or, more often, of a wealthy individual. Wherever possible their foundations at either end were laid on high rocks at a narrowing of the river; the difficulty of making secure foundations in a flat mud base is the explanation of the common legend, perhaps a reflection of actual practice, that a human sacrifice was necessary to ensure that the foundations would hold. The arches vary in shape and size to allow the passage of tall ships without having to make the entire bridge very high.

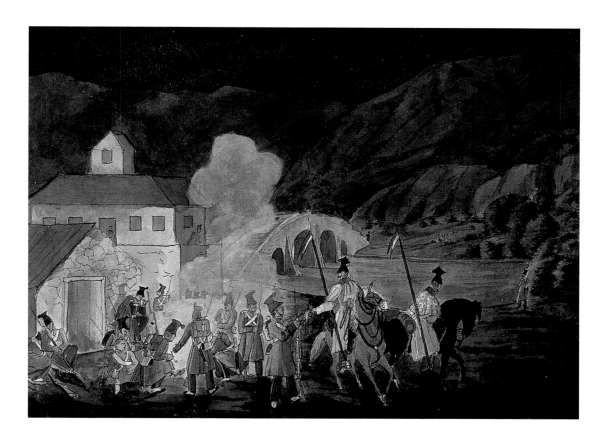

Ludwig Koellnberger (Bavarian, 1811–1892)

Bivouac on the Spercheius [near Lamia]

1835

Watercolor, 13.8 x 18.8 cm (5⅜ x 7⅜ in.)

Munich, Bayerisches Hauptstaatsarchiv,

Kriegsarchiv, BS III 21.II no. 26

The Bavarian-Greek officer Koellnberger made a record of his time in Greece in a large series of paintings that concentrate in large part on the events and situations of life in the camp and on the march. Though not a great artist, he has conveyed in this little painting the nighttime atmosphere of the camp and its charming location by the famous bridge of Alamana.

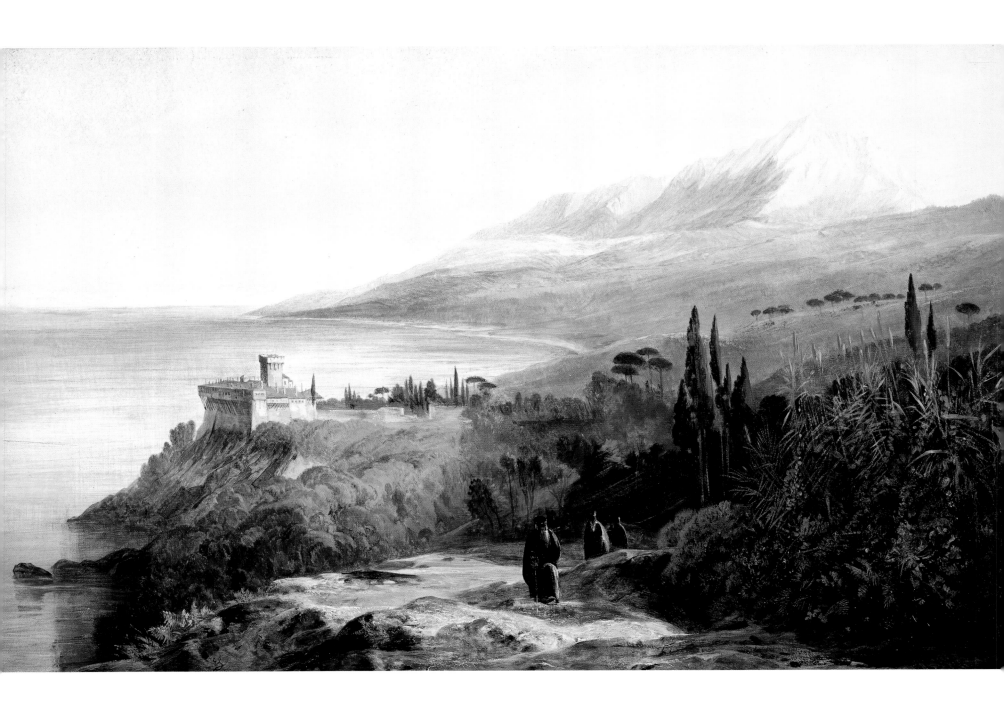

Edward Lear (English, 1812–1888)
Mt. Athos and the Monastery of Stavroniketes
1857
Oil on canvas,
34.3 x 54.6 cm (13½ x 21½ in.)
New Haven, Connecticut,
Yale Center for British Art, Paul Mellon
Collection, no. B1981.25.415

Lear's tour of northern Greece in late 1856 was a hasty affair (August to October), involving a walk of fifty miles from Salonika, across the Isthmus, to Mt. Athos. It was his third attempt to visit the Holy Mountain, which was (and is) inhabited exclusively by monks, and to which no female creatures are admitted. This time he was successful.

What a place—what a strange place is that Mt. Athos! Apart from the very valuable set of drawings I have brought back, my tour has been one of the most singular bits of my whole life. . . . At Mt. Athos, many many thousand monks live on through a long long life of mere formal blank. God's world maimed & turned upside down:— God's will laughed at & falsified: nature wounded & trampled on:—that half of our species which it is the natural & best feeling of mankind to love & esteem most-ignored & forbidden:—this is what

I saw at Athos:—& if what I saw be Christianity, then the sooner it be rooted out, the better for humanity.

Disgruntled as usual with the circumstances of his tour, Lear was able to enthuse only about the landscape:

I never saw any more striking scenes than these forest screens & terrible crags, all lonely lonely lonely: paths thro' them leading to hermitages where these dead men abide,—or to the immense monasteries where many hundred of these living corpses chant prayers nightly & daily: the blue sea dash dash against the hard iron rocks below— & the oak fringed or chesnut covered height above, with always the great peak of Athos towering over all things, & beyond all the island edged horizon of wide ocean. (Letter to Emily Tennyson, October 9, 1856; *Edward Lear: Selected Letters*, ed. Vivien Noakes, pp. 138–40.)

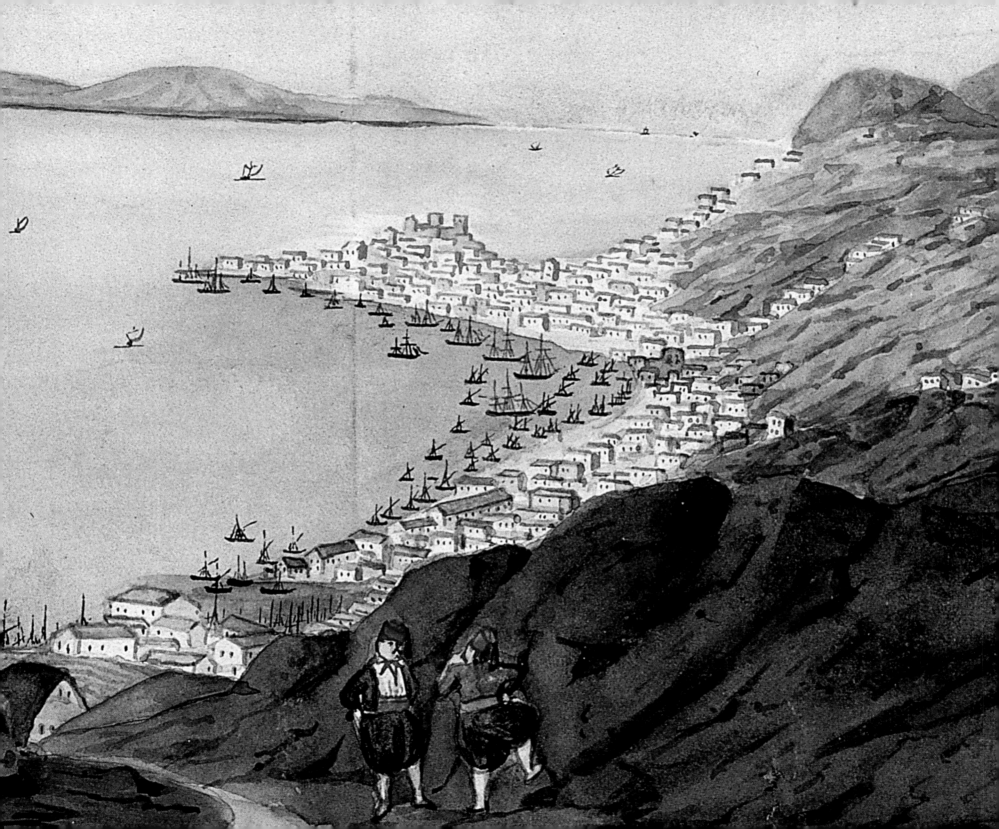

Like the Peloponnesian coast, the Aegean Islands became important to the West for navigational reasons long before any interest in the antiquities of Greece had arisen. By the fourteenth century the existing Ptolemaic maps of the region had come to be seen as inadequate for practical purposes — if indeed they were widely known at all — and the exact observations of sea captains and merchants were brought into service to create the first portolan charts. As early as 1313 the portolan chart of Petrus Vesconte contains more accurate information on the shape of the Peloponnese and the Aegean Islands than the first edition of the second-century-A.D. *Geography* of Ptolemy, printed one and a half centuries later. These charts were also much more informative regarding place names and often contained pictorial details of individual cities, a technique that by the sixteenth century had developed into elaborate topographical views accompanying fairly accurate maps.

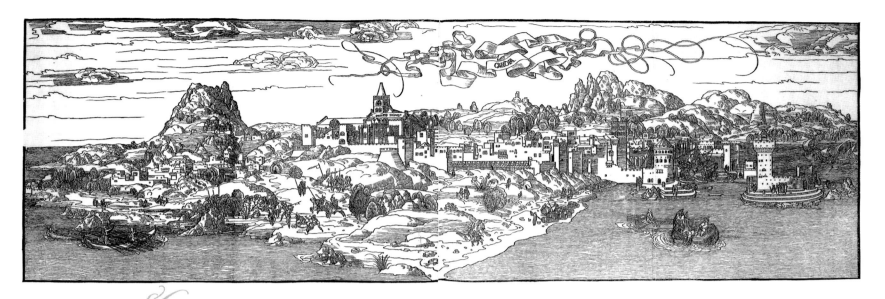

Bernhard von Breydenbach (German, ca. 1440–1497)
Panorama of Medieval Heraklion in Crete [Candia]
Engraving by Erhard Reuwich
From Bernhard von Breydenbach, *Peregrinatio in terram sanctam*
(Mainz, 1486); San Marino, California, Huntington Library

The lawyer and cleric Bernhard von Breydenbach made a pilgrimage to Jerusalem between April 25, 1483, and February 2, 1484, and published his account in 1486 with woodcuts by Erhard Reuwich. The illustrations included not only panoramas of several cities on the pilgrimage route, including (in Greece) Modon (Methone), Corfu, Rhodes, and this view of Candia (Iraklion), but also illustrations of local costumes. Breydenbach's was one of the earliest detailed pilgrimage accounts to be published. These woodcuts are not designed for practical orientation in the manner of a mariner's chart, nor as mechanical decorative motifs like the woodcuts in Hartmann Schedel's *Liber Chronicarum* (see Introduction, FIGURE 1), but seem intended—like contemporary Flemish painting—to give a sense of place, setting, and landscape, as well as a tolerably accurate representation of the actual buildings. A pilgrimage account, like a modern travel book, aimed to transport the reader to the scenes described.

Two of the first map books of the Aegean were made by Cristoforo Buondelmonti, who toured the Greek islands in 1414, apparently to collect Greek books and manuscripts for the humanist Niccolò Niccoli. *The Description of Crete* (1417) and the *Book of the Islands of the Archipelago* (1422) both accompanied descriptions of geographical features with, to quote the former, "numerous pleasant tales of the men of antiquity and of the exploits of heroes," and with simple outline maps of the islands. Buondelmonti's manuscripts do not survive, and we know his work from later copies and translations, often with considerable variations among them. His *Isolario* (Book of islands) was employed about sixty years later by Bartolommeo Zamberti degli Sonnetti, who accompanied each island map with a sonnet describing the main features of the island in question. (See, for example, the map of Rhodes on p. 274 in my *Literary Companion to Travel in Greece.*)

Holy Land pilgrimage was another spur to mapping and illustration of travel accounts, a good example being provided by Bernhard von Breydenbach's *Peregrinatio in terram sanctam* (Pilgrimage to the Holy Land), which was written in 1486 and subsequently translated into many languages. Woodcuts like the view of Iraklion (FIGURE 86), on Crete, portrayed cities along the pilgrimage route.

During the sixteenth century a number of atlases of the seaways of the Aegean were made, including notably André Thévet's *Grand Insulaire* (a manuscript now in Paris, at the Bibliothèque Nationale de la France). This formed the basis of his *Cosmographie Universelle*, published in Paris in 1575. FIGURE 87 provides a good example of Thévet's richly detailed, pictorial style of mapmaking.

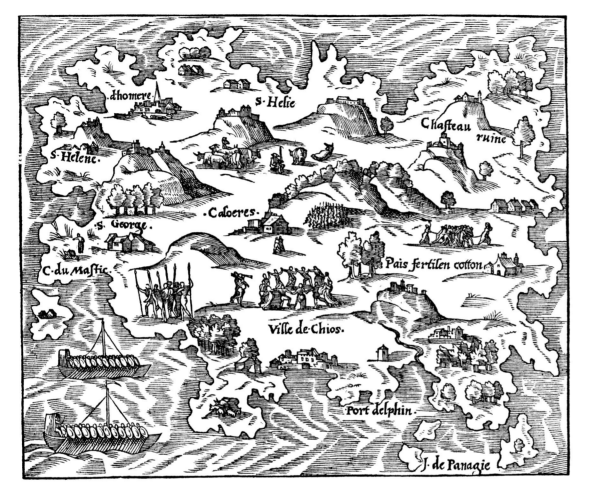

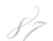

André Thévet (French, ca. 1502–1590)

Map of Chios

1575

Woodcut, 13 x 15 cm (5⅛ x 5⅞ in.)

From André Thévet, *Cosmographie Universelle* (Paris, 1575);

London, The British Library

Reproduced by permission of The British Library

Thévet's pictorial map of Chios gives a notably inaccurate, and extravagantly indented, portrayal of the coastline of the island. It would be of little use for orienteering or exploring without the aid of a guide, but it does give an impression of the main features of the island and their general direction in relation to each other.

The choice of features for inclusion is interesting, comprising economic data (the location of plantations of cotton and the famous mastic trees of Chios, described by all visitors), the ruined castle of Diefcha, a monastery labeled Caloeres (Nea Moni, built between 1042 and 1054 by Constantine IX), and some ruins popularly called the School of Homer. (In this century the same name was attached to some ruins on the northern outskirts of Chios town, probably a sanctuary of Rhea-Cybele; but Thévet attaches the name to Kato Phana, the ancient Phanai, where there was a temple of Apollo.) The decorative value of the map is high, and it is a useful compendium of basic information about the island—but not a reliable map in the modern sense.

Many Italian navigators prepared their own *isolarii*, and in the seventeenth century—the heyday of Dutch maritime trade—a number of Dutch atlases of the Aegean also appeared. A fine example is the travel account of J. J. Struys, with its highly detailed panoramic views (for example, Delos, FIGURE 88). The tradition continued into the eighteenth century with the atlases of Olfert Dapper, Peter van der Aa, Gerard van Keulen, and others.

Venetian rule in Crete also provided a stimulus to mapmaking, as Italians sought to chart their domain. The doyen of Venetian cartographers was Vincenzo Coronelli (see Chapter III, FIGURE 43); however, the writings and reports of other Venetian officials in Crete concentrate

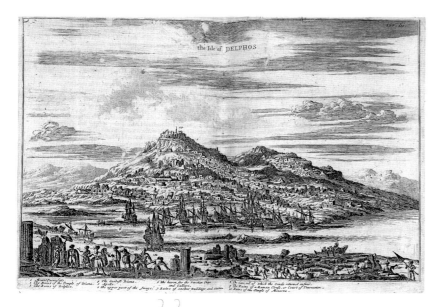

the Isle of DELPHOS

The Dutch mariner J. J. Struys spent twenty-six years traveling throughout Europe and Asia to compile his travel account and illustrations of the places he visited. His journey coincided with the height of Dutch international maritime trade, and it is not surprising to find a Dutchman producing such a book at this period. The book was popular and was translated into German, English, and French. Pictorial values are uppermost in this engraving, in which the island of Delos is named Delphos, a common metonymy in the seventeenth century.

mainly on the defenses of the Cretan cities rather than on wider geographical issues.

Early in the eighteenth century Johann Bernard Fischer von Erlach depicted an imaginary view of the Colossus of Rhodes (FIGURE 89), but it was not based on any experience of the locality. The first look at the Aegean islands from an angle not purely practical was cast by the Comte de Choiseul-Gouffier, who visited Greece in 1776 accompanied by the painter J.-B. Hilaire as well as other antiquaries and scholars. On his second voyage, in 1784, the year of his appointment as ambassador to the Sublime Porte, Choiseul-Gouffier was accompanied by "a small, sailing academy" of artists, classicists, topographers, and writers. Choiseul-Gouffier's *Voyage pittoresque de la Grèce*, published in 1782, documented what the group saw and included depictions of such famous scenes as the plane tree of Hippocrates on the island of Cos (FIGURE 90) along with mainland scenes; it is also notable for its frontispiece, described in the book by Choiseul-Gouffier himself (vol. 1, Preface) as follows:

Greece, depicted as a woman in chains, is surrounded by the funerary monuments erected in honour of the great men of Greece who devoted themselves to liberty. . . . Greece seems to summon the spirits of her great men, and on the nearby rock these words are written: EXORIARE ALIQUIS.

These words were one of the first indications of the philhellenic sentiment in the West that was to have such explosive repercussions forty years later.

Choiseul-Gouffier had been preceded by a few British travelers, chief among them members of the expeditions of the Society of Dilettanti. Lord Sandwich in 1738 to 1739 and Lord Charlemont in 1749 had both traveled through the Aegean, the latter accompanied by the artist Richard Dalton; but their artistic records concentrate on the antiquities of the mainland sites of Greece and Turkey, interspersed with a few costume paintings from the islands. The picturesque qualities of the islands themselves came only slowly to be appreciated.

Thomas Hope's tour of Greece and Ionia in 1788 to 1796 was the first source of extensive artistic responses to the islands, and Hope's paintings and drawings—many of them perhaps in fact by the French artist Michel François Préaulx—are a precious record both of contemporary topography and of developing artistic and picturesque taste. He seems to have been the first European

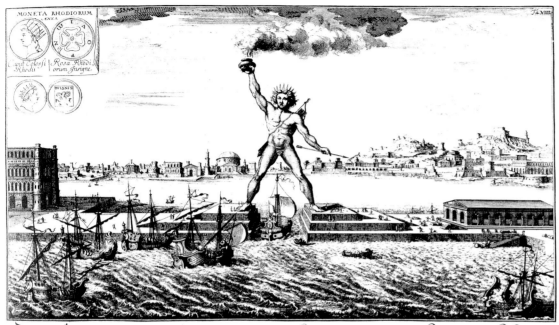

Die der Sonnen gewidmete Wünder-Statua,
Coloſſus zu Rhodis, welche unter dem Cariſchen Fürſten——
Theagones ungefehr, im Jahr der Welt 3600. durch Charem——
Lyndium von 70 Ellen höhe aus Ertz gegoſſen und auffgerichtet.
Plin. L. 2. c. 62. et L. 34. c. 7. Strab. L. 12.

Le merveilleux Coloſſe de Rhodes dedié
au Soleil, qui fût jetté en bronze par Chare Lyndien,
ſoûs le gouvernement de Theagone Prince de Carie,
environ l'an du monde 3600. Il avoit 70. aunées de haut.
Plin. L. 2. ch. 62. et L. 34. ch. 7. Strab. L. 12.

Johann Bernard Fischer von Erlach (Austrian, 1656–1723)
Colossus of Rhodes
Engraving
From Johann Bernard Fischer von Erlach,
Entwurf einer historischen Architektur
(Vienna, 1721; Dortmund, 1978), pl. VIII
Reproduced by permission of Harenberg Verlag, Dortmund

Fischer von Erlach's book *Entwurf einer historischen Architektur* (Outline of an historical architecture) was an illustrated history of what he conceived to have been the development of world architecture, from the Temple of Jerusalem via the Seven Wonders of the Ancient World to the buildings of contemporary Rome and other cities. One of the most famous of the Seven Wonders was the Colossus of Rhodes, erected to commemorate the raising of the siege of Rhodes by Demetrius Poliorcetes in 304 B.C., but it stood only for about sixty years. It was popularly supposed to have straddled the entrance to the harbor, though it is certain that Greek engineering could not have achieved such a feat. It was, however, very large. Fischer von Erlach's townscape is as imaginary as the statue and conveys another view, this time the architect's, of what an ancient Greek city ought to have looked like.

artist to paint islands as distant from Athens as Rhodes and Santorin. His views of Hydra (FIGURE 91) and Naxos are characteristic of his highly detailed style.

In the early years of the nineteenth century Carl Haller von Hallerstein excavated on Melos and made some fine drawings, and William Gell traveled as far as Chios; however, communications were not easy and most artists found a richer reward by staying on the mainland.

With the conclusion of the War of Independence, travel became less hazardous. Chios came into the public eye through the exciting but imaginary paintings of the *Scenes from the Chios Massacres* by Delacroix. During the 1830s tourists and artists ventured further afield from the traditional mainland sites, visiting not only Tenos (FIGURE 92) and Poros (FIGURE 94), but also Santorin (FIGURES 95, 96), Rhodes (FIGURE 97), and Syros (FIGURE 93). But Crete and the Dodecanese remained out of reach, both geographically and politically, for Western visitors. (In fact, Crete did not become formally annexed to the Greek state until 1913.) Those nineteenth-century travelers who did go there included topographers and scholars like Robert Pashley and T. A. B. Spratt, both of

Jean-Baptiste Hilaire (French, 1753–1822)
View of the Public Square of Cos
Engraving, 21.2 x 34.6 cm (8 ⅜ x 13 ⅝ in.)
From Marie-Gabriel-Auguste-Florent Choiseul-Gouffier,
Voyage pittoresque de la Grèce, vol. 1 (Paris, 1782), pl. 59;
Los Angeles, Getty Research Institute, Resource Collections

Some of the finest plates in Comte de Choiseul-Gouffier's *Voyage pittoresque* are engravings after the painter J.-B. Hilaire; the whereabouts of the originals is now unknown. Choiseul-Gouffier valued Greece for its classical past as well as for the opportunities it offered to connoisseurs of the new cult of the Picturesque, and many of the plates portray scenes that, while picturesque in themselves, are also rich in classical associations. This one focuses on the famous plane tree that still stands in Cos town and that is popularly supposed to have been there since Hippocrates lived in Cos in the fourth century B.C. (The idea is not impossible, but a thousand years is a more normal maximum for a plane.)

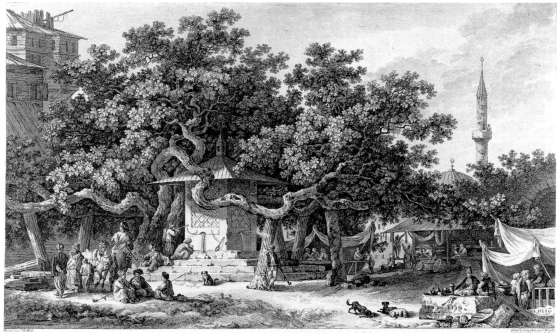

VUE DE LA PLACE PUBLIQUE DE COS.
A.P.D.R.

whom published books chronicling their travels. But these are scarcely to be counted among the artists. Pashley traveled in Greece, Asia Minor, and Crete in 1833, and in 1837 published the two volumes of his *Travels in Crete*. Pashley's book contains valuable information on antiquities, topography, history, contemporary life, folklore, and popular songs and ballads, as well as a number of small vignettes and a few larger engravings; Spratt's *Travels and Researches in Crete*, published in 1865, has some rather insipid engravings. Together, their illustrations are the only visual representations of Crete bridging the period between the Middle Ages and the arrival of Edward Lear on the island.

Edward Lear arrived in Crete in the spring of 1864, having abandoned his winter home of half a century in Corfu, which had now been returned by Britain to Greek rule. The success of earlier travel books inspired him to approach this visit in a systematic way. He kept a diary of his travels, one that would be the basis of a later work (which, in the end, he never published). Such a book would have provided text for the illustrations. He made an enormous number of sketches in Crete. With his usual extraordinary facility pushed to even more extreme lengths, he was able to

capture in a few minutes the essential details of a scene with enough annotation to enable him to work it up into a finished picture later. The result is that the watercolors from this visit, while luminous and atmospheric, are perhaps less satisfactory than the more careful drawings of his earlier period. Often, natural features are no more than hinted at, and Lear does not trouble to fill the page of the brown paper he usually used at this time. The tour was a thorough one, beginning and ending at Chania (FIGURE 98), taking in the northern coast as far as Rethymnon (FIGURE 99), and making a great swoop south around Mt. Ida and north again to Iraklion, then known as Megalokastro. Few antiquities were visible at this time: all the Minoan remains still lay underground, and even the classical city of Gortyn had rather little to show. So Lear's concentration is all on towns and scenery; his picture of Knossos in its undisturbed state (FIGURE 100) is particularly fascinating.

"I much doubt Crete being a picturesque country in any way," he wrote at the beginning of his visit, on April 15, "or that it will repay much trouble in seeing it. Its antiquities etc. so old as to be all but invisible; its buildings, monasteries, etc. nil; its Turkish towns fourth-rate. Rats O! and gnats" (*Edward Lear: The Cretan Journal*, ed. Rowena Fowler, p. 31). This expression of jaded middle age must have been somewhat modified by the time he concluded his painterly tour, though few of his views of Crete are as enchanting as those of the Corfu years.

Although the twentieth-century rise of sun-worship and the package tour have made the Dodecanese and Crete among the most desirable of Greek destinations, the modern visitor is still largely constrained—perhaps not unwillingly—to see the islands through the eyes of painters of a nineteenth-century idyll.

Thomas Hope (English, 1769–1851)
View of the Town and Harbour of Hydra
ca. 1795
Watercolor, 21.5 x 29 cm (8 ½ x 11 ⅜ in.)
Athens, Benaki Museum, no. 27348

Thomas Hope, who achieved fame as an interior designer in the Neoclassical style, acquired an interest in the classical style during two visits to Greece in the late 1700s. His many drawings of Greek landscapes and towns are minutely detailed, thus providing an invaluable historical record of the appearance of the towns in the eighteenth century. This sepia watercolor of Hydra is based on a drawing in the third of five volumes of Hope's Greek drawings now in the Benaki Museum collection. It displays Hope's attention to topographical detail, showing the two types of roofs—flat and tiled—that characterized the town. The numerous windmills are another of the town's notable features.

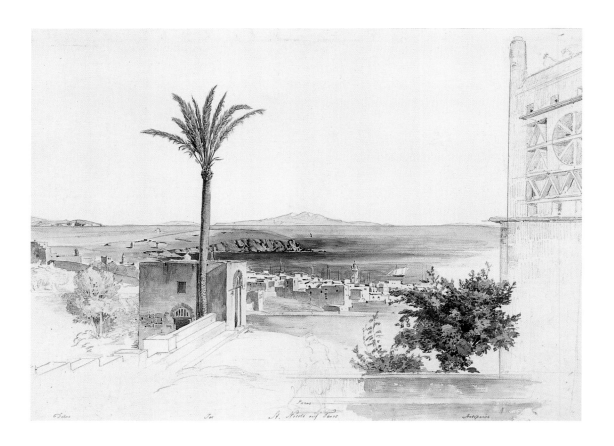

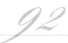

Ludwig Lange (Bavarian, 1806–1868)
View from the Island of Tenos toward the Islands of Delos, Ios, Paros, and Antiparos
ca. 1834
Watercolor and pencil,
39.2 x 53.1 cm (15⅜ x 20⅞ in.)
Munich, Staatliche Graphische Sammlung,
inv. 35927

With a light touch, Ludwig Lange here conveys, for perhaps the first time in history, the quality of light and shade of the sea surrounding a Greek island. The right foreground is occupied by the corner of one of the famous and distinctive dovecotes of Tenos, and in the distance can be seen the tower of the church of the Panaghia Evangelistria, home of the wonder-working icon discovered in 1822, which draws flocks of pilgrims to the island. The island of Syros is visible on the horizon. But Lange has subordinated topographical information to pictorial values and produced an evocative and atmospheric work of art.

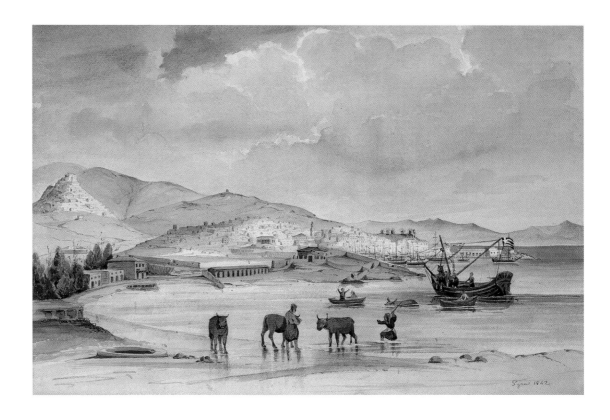

Wilhelm von Weiler

(German, active 1830s–1840s)

View of the Town of Hermoupolis

on the Island of Syros

1842

Watercolor on paper, 33 x 45 cm (13 x 17¾ in.)

Athens, Benaki Museum, no. 24008

The German architect Wilhelm von Weiler was responsible for preparing plans of Syros in 1836, but it is not known how long he spent in Greece. Compared to Lange's romantic approach, this painting, with its concern for topographical detail, represents a return to a more eighteenth-century style of representation.

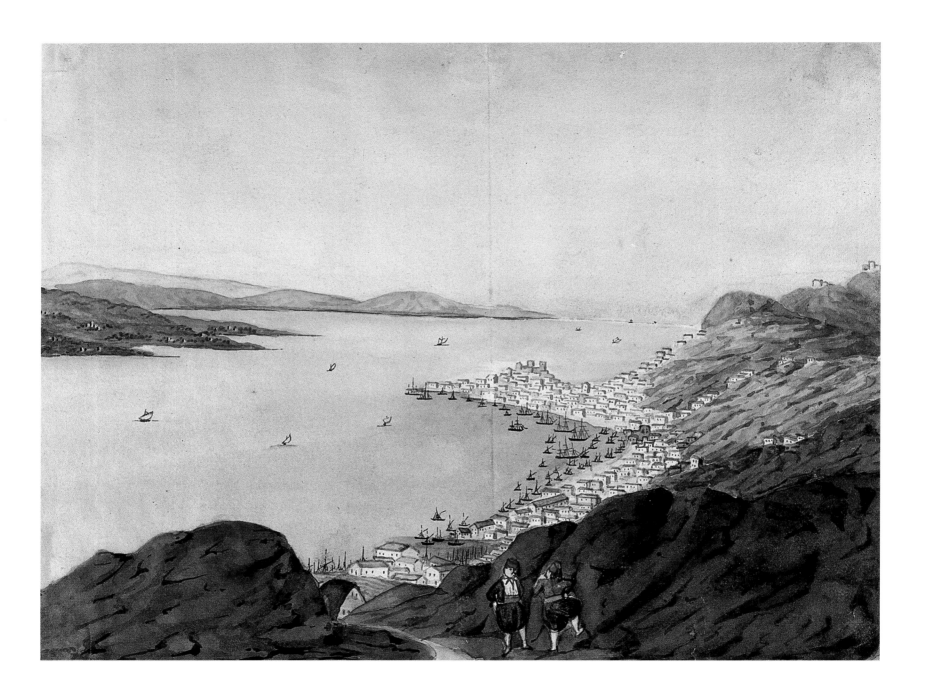

94

Ludwig Koellnberger (Bavarian, 1811–1892)

Poros

ca. 1837

Watercolor, 18.8 x 24.4 cm (7 $\frac{3}{8}$ x 9 $\frac{5}{8}$ in.)

Munich, Bayerisches Hauptstaatsarchiv,

Kriegsarchiv, BS III 21/I no. 22

This unusual view from the heights above the harbor of the small island of Poros conveys some of the picturesque drama of the landscape, including the nearby Peloponnesian mainland. The figures are less gratingly naïve than in some of Koellnberger's other views.

Carl Rottmann (Bavarian, 1798–1850)

Santorin

1845

Watercolor over pencil,

27.7 x 38.1 cm (10⅞ x 15 in.)

Munich, Staatliche Graphische Sammlung,

inv. 21394

This watercolor, with its saturated blue tones, is one of the most impressive of Rottmann's views of Greece, and one of very few that he made away from the Greek mainland. (His island journey has given us views also of Poros, Naxos, and Delos). He made a number of sketches on the volcanic island of Santorin, and there is another, closely similar version of this watercolor in the Städelsches Institut in Frankfurt am Main. Though it has the appearance of a full-scale sketch, it was never worked up as one of the series of oil paintings for the Arcades in Munich.

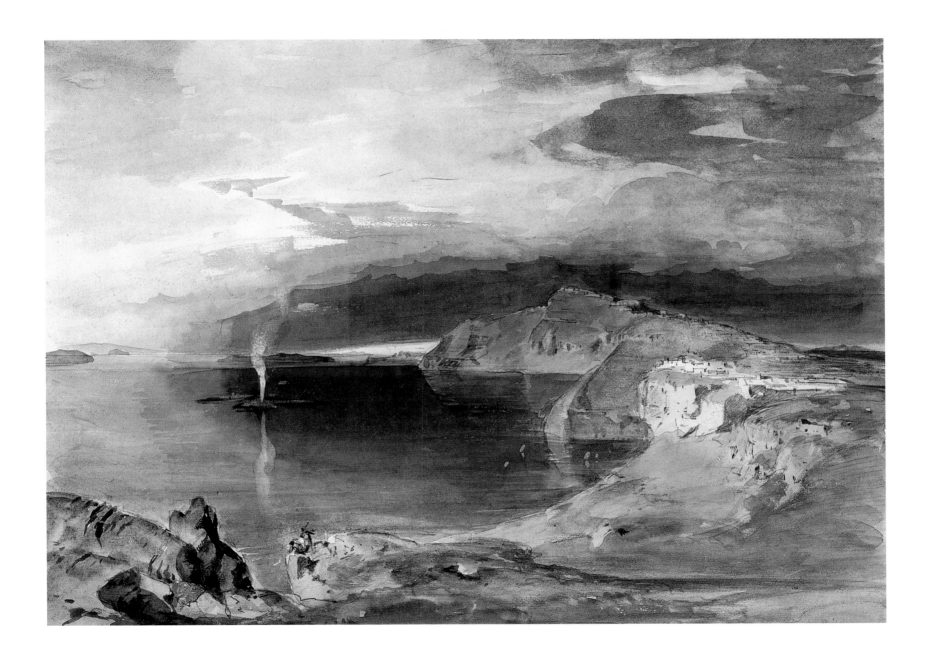

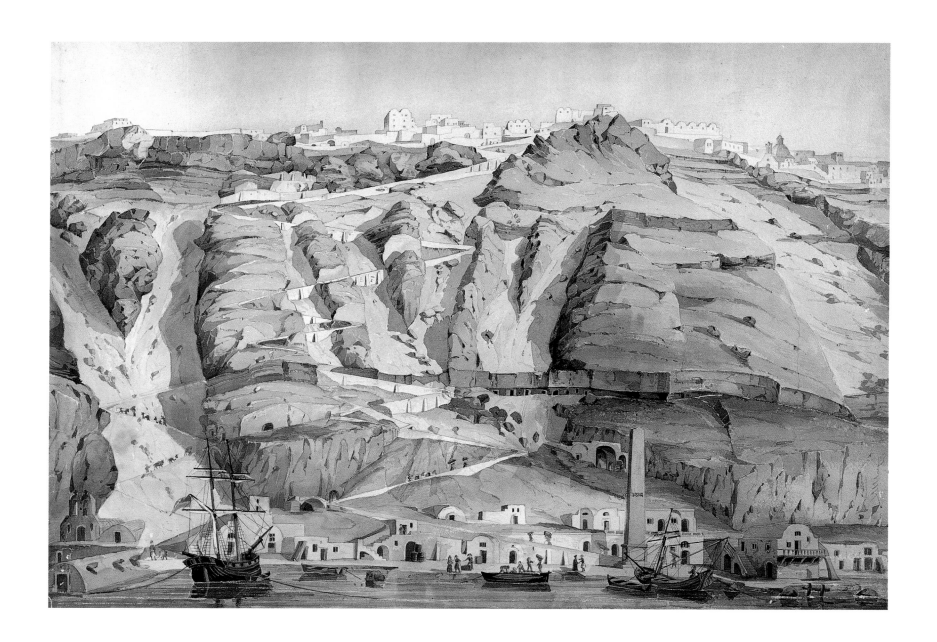

Anonymous
Santorin, View of Phera
1838
Watercolor, 49 x 70 cm (19¼ x 27½ in.)
Athens, National Historical Museum

The spectacular island of Santorin, with its cliffs (actually the walls of the crater of a still-live volcano) rising from immense depths of sea, is one of the most striking natural formations of the Aegean. This painting, by an unidentified artist, portrays the sheer walls of the caldera, with their varied hues, and the zigzag path that ascends the cliff, still navigable only on foot or by mule. The numerous boats moored at the quay suggest a rather lively life in both fishing and trading.

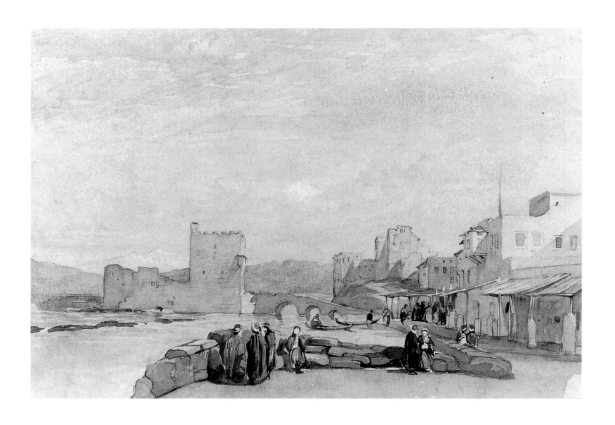

William James Muller (English, 1812–1845)

View of the Port of Rhodes

1838

Watercolor, 25 x 35 cm (9⅞ x 13¾)

Museum of the City of Athens, inv. 101

Maritime life is again to the fore in this picturesque view of a corner of the Port of Rhodes, which eschews the conventional sites of Mandraki Harbor to focus on a scene of daily life. Muller, like many of the artists of this period, was but a temporary visitor to Greece, spending only two months there in September and October of 1838.

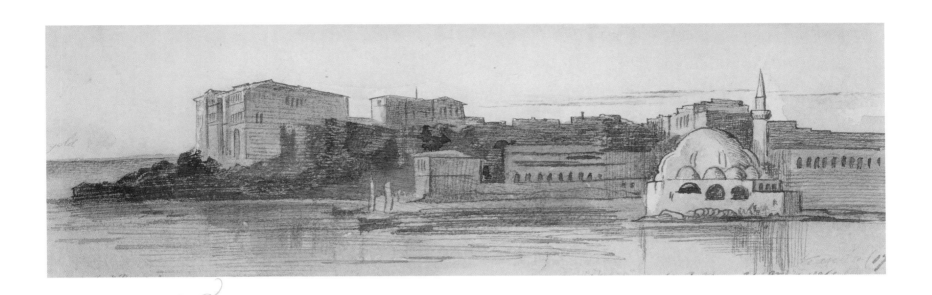

98

Edward Lear (English, 1812–1888)

Chania. 27 May 1864

Watercolor

Athens, Gennadius Library, no. 25

Lear made this sketch at the conclusion of his stay in Crete. He returned often to this view of the Chania waterfront, with its interestingly contrasting shapes of mosque and mansion. "When the morning sun shines on it the upper part — all white — and the Blacks' village by the shore look exactly like Syrian palaces; the long red line of wall between the two" (*Edward Lear: The Cretan Journal*, ed. Rowena Fowler, p. 31).

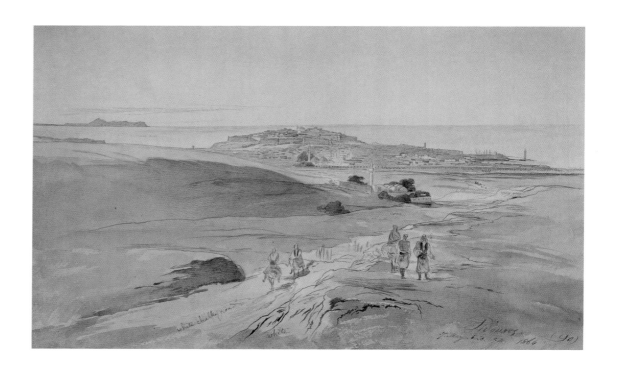

Edward Lear (English, 1812–1888)
Rethymno. 7 May 1864, 6.30 P.M.
Watercolor
Athens, Gennadius Library, no. 77

Lear was badly lodged in Rethymnon, with a drunken bore called George Kalokairinos; the other guests had bad manners, his room was hot and uncomfortable, Kalokairinos took him on disagreeable walks, and Lear was in a bad mood: "altogether Rethymnon is a bore." Lear appears to have been unable to respond to the charming mixture of Venetian and Islamic detail in the buildings of the city, the grandeur of the Fortezza or the pleasure of the water-front. Yet one would never guess it from the tranquil evening beauty of this scene, with its picturesque values intact and its topographical detail also in fairly good order. According to his diary:

Certainly a most meagre place is Rethymnon, and what to do tomorrow I know not. Anatolian sheep. Went up the hill we partly ascended last night, and drew till six: and now I have exhausted all the feeble resources of this place, the which is a bore. We returned slowly and by the filthy lanes; got home by 6.30. (Edward Lear: The Cretan Journal, ed. Rowena Fowler, pp. 59, 61.)

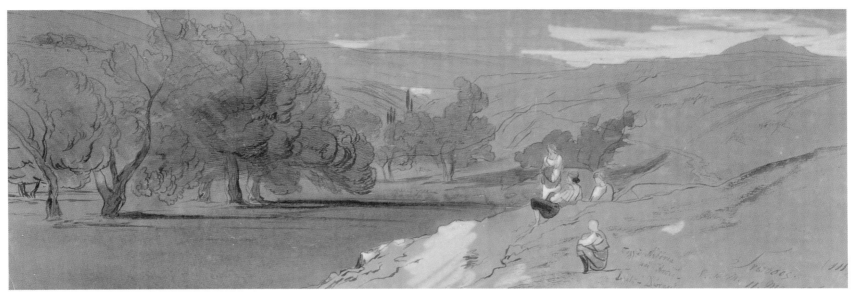

100

Edward Lear (English, 1812–1888)
Knossos. 11 May 1864, 8 A.M.
Watercolor
Athens, Gennadius Library, no. 57

The site of Knossos possesses water and trees and plenty of aïdhonia [nightingales], but except scattered masses of brickwork, little remains. The place however with its green hillside slopes and corn has a pretty aspic [a joke for "aspect"]. . . . It was near nine before we saw the lumpy shell of a tomb, called "of Caiaphas," and past nine when we got up to Fortetsa where there are lots of middle-aged walls — or Byzantine — and many old stones (the village was half deserted) and I don't doubt it was the acropolis of Knossos once upon a time. (Edward Lear: The Cretan Journal, ed. Rowena Fowler, p. 66.)

Biographical Sketches of Artists

Babin, J. P. (d. 1699)
FIGURE 5

A Jesuit priest, one of the fairly numerous members of various Catholic missions in Athens in the seventeenth century. He prepared the first pictorial map of contemporary Athens, which was published in his *Relation de l'état présent de la ville d'Athènes* (Account of the present state of the town of Athens) (Lyon, 1674). His work and his personal assistance were of great value to Jacob Spon in the preparation of his own map, which in turn became the basis for other early maps, including the anonymous one reproduced in Chapter I (FIGURE 10).

Barskii, Vasilii Grigorovich (1701/1702–1747)
FIGURE 80

A Russian monk who visited Meteora in 1745 in the course of his pilgrimage to the Holy Land, an account of which he published as *Stranstvovaniia Vasil'ia Grigorovicha Barskago po sviatym miestam Vostoka s 1723 po 1747* (Travels in the holy places of the East, 1723–1747) (St. Petersburg, 1887; in Russian). His publication was illustrated with a number of naive but charming drawings of the various monasteries on their precipitous rocks—the first visual record of the settlements.

Breydenbach, Bernhard von (ca. 1440–1497)
FIGURE 86

A German lawyer and divine who traveled on pilgrimage to Jerusalem and Sinai between April 25, 1483, and February 2, 1484. His travels were published as *Peregrinatio in terram sanctam* (Pilgrimage to the Holy Land) in 1486 and later translated into Dutch. Subsequent editions were adorned with maps and panoramic views by the printer and engraver Erhard Reuwich.

Carrey, Jacques, of Troyes (1649–1726)
FIGURE 6

A Flemish painter employed by the Marquis de Nointel, French ambassador to Constantinople, who visited Athens in autumn 1674. Carrey made an important panoramic view of contemporary Athens with Nointel and his party in the foreground. It appears that Carrey was also responsible for the detailed drawings of the Parthenon pediments, which are now in the Bibliothèque Nationale in Paris, although Nointel's biographer Albert Vandal maintains that these were by another Flemish painter, Rombault Faidherbe. These drawings are of unique importance as a record of the appearance of the pediments before the bombardment of 1687.

Cartwright, Joseph (1789–1829)
FIGURE 78

Cartwright was paymaster-general to the British garrison at Corfu from 1816 to 1820. A prolific artist in watercolor, he published his *Views in the Ionian Islands* in 1821 and his *Selections of the Costume of Albania and Greece* in 1822.

Cockerell, Charles Robert (1788–1863)
FIGURES 18, 44, 69

Cockerell was an architect, son of the architect Samuel Pepys Cockerell. In 1809 he began work in the office of Robert Smirke. He traveled in Greece and Italy from 1810 to 1814 to study architecture; his father clearly anticipated that he might thus return to England as a leader of the coming architectural fashion, the Greek Revival. With two different groups of friends, he was involved in two important archaeological discoveries: the pedimental sculptures of the Temple of Aphaia on Aegina (which were acquired by King Ludwig of Bavaria for the Glyptothek in Munich) and the frieze of the Temple of Apollo Epicurius at Bassae (which went to the British Museum). One of his most important achievements was the discovery of the *entasis*, or curvature of the horizontal and vertical lines, of the Parthenon and other Greek temples, which he described in a letter to Robert Smirke dated December 23, 1814. The effect of *entasis* was to lighten the appearance of the massive Doric columns and give them their airy quality. On his return to England, Cockerell was responsible for a number of important buildings, including the Ashmolean Museum in Oxford. His reconstruction drawings of parts of ancient Athens are of major importance and rarely seen. His account of his travels was edited by his son, Samuel Pepys Cockerell: *Travels in Southern Europe and the Levant, 1810–1817* (London, 1903). He published various papers on his architectural and archaeological discoveries in Greece, but, disappointed by the failure to secure the

Aegina marbles for Britain, he did not publish *The Temples of Jupiter Panhellenius at Aegina, and of Apollo Epicurius at Bassae, near Phigaleia in Arcadia*, until 1860.

Constant-Dufeux, Simon Claude (1801–1871)

FIGURE 17

The French architect Constant-Dufeux studied at the Ecole des Beaux-Arts in Paris from 1819 to 1827, and in 1829 was awarded the Grand Prix de Rome, which enabled him to travel to Rome and study there until 1835. While in Italy he visited Segesta in Sicily (1831), making studies of the temple there. There is no evidence that he ever visited Greece, and his architectural drawing of the Choragic Monument of Lysicrates (FIGURE 17) was perhaps derived from the drawings of others.

Constant-Dufeux, like other architects, was an enthusiast in the 1830s for the newly discovered "polychromy" of Greek architecture. Having discovered that Greek buildings were not, as had been thought, pure white, but had been painted bright colors, these architects introduced a similar style into their own works. In 1841 Constant-Dufeux became the chief architect of the Ecole de Dessin in Paris, and in 1845 he became Professor of Perspective at the Ecole des Beaux-Arts. His most famous building is the Pantheon in Paris, but he also designed the facade of the church of St.-Laurent in Paris, and was responsible for the restoration of the Roman Temple of Augustus and Livia at Vienne.

Coronelli, Vincenzo Marco (1650–1718)

FIGURE 43

Coronelli was a professional geographer who first made his name by the preparation of two globes for Louis XIV of France. He became the official geographer to the Venetian republic in the days of its ascendancy in Greek waters, and while in Greece in 1684 to 1685 he composed his *Memorie istoriografiche del Regno di Morea e di Negroponte* (Historiographical memoir of the Kingdom of the Morea and Negroponte) (1685; French edition 1686). In 1688 he published a general study of the Mediterranean as well as a further work on the maritime parts of Greece: *Arcipelago: Isola di Rodi e Regno di Negroponte*. He later published the *Venetian Atlas* and some other encyclopedic works. His books on Greece were illustrated with vignettes of the major cities and ports discussed.

Deering, John Peter Gandy (1787–1850)

FIGURE 37

Deering (formerly Gandy) was the younger brother of J. M. Gandy. Deering was a brilliant architect and draftsman who became a Royal Academician at the age of eighteen. From 1812 to 1813 Deering was in Greece as a member of the expedition of the Society of Dilettanti that resulted in the publication the *Unedited Antiquities of Attica* in 1817. At this time he acquired a few antiquities, including a torso from Rhamnus, which he later presented to the British Museum. In Greece he met Lord Elgin, who had recently removed the Parthenon sculptures to his home

in Fife. He was the latest of fourteen architects whom Elgin invited during the years 1799 to 1826 to provide designs for the north front and wings of his newly built home, Broomhall, in Fife. The facades were completed—by another firm of architects—in 1865–1868.

Deering's drawing of the Mystic Temple of Ceres at Eleusis (FIGURE 37) was exhibited at the Royal Academy in 1814. From 1817 to 1819 he worked with Sir William Gell on his *Pompeiana*. He erected several buildings in London, being joint architect with William Wilkins of University College London.

In 1827 he acquired by bequest of his friend Henry Deering the estate of The Lee near Great Missenden, Bucks. He adopted the Deering name and embarked on a political career in which he ceased to practice architecture.

Dodwell, Edward (1767–1832)

FIGURES 3, 36, 48

Dodwell had private means, and in 1801 he chose to travel in Greece; he visited Greece again in 1805 to 1806, part of the time in company with William Gell. Thereafter, he lived chiefly in Italy. In Greece he conducted archaeological investigations and collected a number of important vases and other objects. His observations on Greek antiquities are of some archaeological value and also an important document in the history of taste, displaying a predilection for sites, like Mycenae, with romantic appeal and the majesty of prehistoric antiquity as against the classical remains favored by previous generations. He made more

than four hundred drawings in Greece, some of which were published in 1821 as engravings in his *Views in Greece*, following the appearance of his large two-volume work in 1819, *A Classical and Topographical Tour through Greece, during the Years 1801, 1805, and 1806.*

Dupré, Louis (1789–1837)
FIGURE 15

Dupré was a pupil of Napoleon's court painter, a post he attained himself in 1802. From 1814 to 1819 he studied in Rome, and in 1819 traveled with three English companions via Corfu (where he enjoyed the hospitality of Sir Thomas Maitland) to Greece. In the course of his journey to Athens he made sure to meet and obtain the support of two important political figures, Ali Pasha, the ruler of Epirus, and Ali's younger son Veli Pasha, the governor of the Morea, who was at that time in Trikala. Arriving in Athens on April 15, he stayed there until July 9. He was acquainted with the leading foreigners in Athens, including the French consul Louis Fauvel, as well as the Macri household. The drawings and paintings he made at that time were reproduced in 1825 as hand-colored lithographs in his *Voyage à Athènes et à Constantinople* (Journey to Athens and Constantinople).

Eastlake, Charles Lock (1793–1865)
FIGURE 21

Born at Plymouth and educated at Charterhouse and the Royal Academy, of which he rose to be president, Eastlake learned from his master, Benjamin Robert Haydon, to specialize in historical paintings in the grand manner. In 1816 he went to Rome, where he was to live for the next fourteen years, and where he met many of the European travelers to Greece, such as Charles Robert Cockerell. In March 1818 he set off for Greece, stopping at the Ionian Islands of Corfu and then Zante. He then

traveled via Corinth to Athens, where he spent three-and-a-half months, during which time he became acquainted with Lord Byron, as well as the French consul Louis Fauvel, the Austrian consul Georg Christian Gropius, and the Italian painter Giovanni Battista Lusieri. He made a portrait of Teresa Macri, whom Byron immortalized in verse as the "Maid of Athens" (FIGURE 21). He made few views of Greece apart from the imaginary scene of *Lord Byron's Dream*. However, he incorporated what he had seen in pictures of the 1830s portraying scenes from the Greek War of Independence. By 1840 Eastlake was one of the leading authorities in the English art world. In 1850 he became president of the Royal Academy and was knighted. His distinguished professional career culminated in 1855, when he was appointed the first Director of the National Gallery.

Fischer von Erlach, Johann Bernard (1656–1723)
FIGURE 89

Fischer von Erlach was an Austrian architect whose *Entwurf einer historischen Architektur* (Outline of an historical architecture), published in 1721, was an illustrated history of architecture from its beginnings. It contained engravings of the supposed appearance of many of the monuments of antiquity, including the Temple of Solomon, the Hanging Gardens of Babylon, the Seven (classical) Wonders of the World (such as the Statue of Zeus at Olympia, the Temple of Artemis at Ephesus, and the Colossus of Rhodes), as well as more accurate views of Palmyra, Mecca, and contemporary Roman churches. He was responsible for many important buildings in Vienna, Salzburg, and elsewhere.

Gandy, Joseph Michael (1771–1843)
FIGURES 2, 47

J. M. Gandy was a pupil of the architect James Wyatt. He traveled to Rome in 1794 but never visited Greece. He worked with Sir John Soane from 1811, and many of his drawings, including a large number of unexecuted architectural designs and imaginary views of Greece, survive in the Soane Museum in London. According to the *Dictionary of National Biography*, Gandy was "too odd and impracticable a nature to insure prosperity." In *The Greek Revival* (p. 115), J. Mordaunt Crook speaks of his "pathological imagination."

Gärtner, Friedrich von (1792–1847)
FIGURE 61

The Bavarian architect Gärtner studied at the Munich Academy and in Paris, and became a professor at the Munich Academy in 1820. Despite constant rivalry with Leo von Klenze, Gärtner was responsible for the layout and the buildings of the Ludwigstrasse in Munich. Gärtner accompanied King Ludwig on his 1835 visit to Greece and obtained the commission to design the Royal Palace in Athens, for which Otto had invited designs in 1834, in preference to the proposals of Klenze. The long and demanding labor of building the palace brought Gärtner back to Athens for a second visit from November 1840 to March 1841; his pupil Eduard Riedel remained in Athens to oversee the completion of the building, which was at last finished in 1843. Gärtner's taste and genius were not exclusively classical (witness the Gothic Ludwigskirche in Munich), and he did not feel obliged to visit all the major Greek sites. He made day trips to a number of the nearer islands during ten days in February 1836, followed by a three-day tour of the Argolid and Corinth. The few watercolors he painted during his visit nonetheless exhibit a sensitivity to the colors and tones of the Greek landscapes as well as the texture of its buildings.

Gell, William (1777–1836)
FIGURE 82

Gell studied at the Royal Academy but did not exhibit. In 1801 he traveled in Greece and Asia Minor, and in 1803 he was knighted, following the execution of a mission to the Ionian Islands. In 1806 he traveled in the Morea (the Peloponnese) and joined for a time with Edward Dodwell for a visit to Ithaca and elsewhere. His numerous books about Greece include his *Itinerary of Greece* (1810), *Itinerary of the Morea* (1817), and *Narrative of a Journey in the Morea* (1823). Gell took a sardonic view of Greece and its inhabitants and was skeptical of any possibility of a successful bid for independence by the Greek people. He did a little desultory digging in parts of Attica but was not a contributor to archaeology. His few watercolors exhibit a romantic feeling for landscape, and are now in the British Museum and in the Benaki Museum, Athens. From 1820 until his death, Gell lived in Italy, where he made an important study of the buildings and paintings of Pompeii. He was noted as a conversationalist and wit, and seems to have had some hand in the first boat cruise to Greece from Naples in 1833.

Giallinas, Angelos (1857–1939)
FIGURE 67

The Greek painter Giallinas was born in Corfu and studied in Italy, returning to his native island in 1878. He is one of the most faithful exponents of the style of the Posilipo School associated with the eighteenth-century Neapolitan painter Giacinto Gigante. He specialized in large-scale watercolors of the landscape of Corfu and of other parts of Greece, and became famous with several exhibitions in the Zappeion, followed by others abroad, including one in London. The detailed precision of his draftsmanship is married to a poetical sensitivity to Greek landscape, monuments, and vegetation.

Haubenschmid, Johann Nepomuk (1792–1858)
FIGURE 53

Haubenschmid entered the Bavarian army in 1814 and in 1832 was one of the officers in the brigade sent to Greece. Promoted to captain in 1833, he returned to Bavaria in May 1834. A small number of paintings preserved in the Bayerisches Armeemuseum in Ingolstadt are mementos of camp life in Greece.

Haygarth, William (1784–1825)
FIGURES 50, 81

Little is known of Haygarth. As a young man he traveled in Greece in 1811, and got to know Lord Byron while in Athens. He recorded his impressions of Greece both in a series of sketches in pencil and wash (mainly brown and sometimes blue), which are now in the Gennadius Library in Athens, and in a most accomplished poem, *Greece, A Poem, in Three Parts*, published in 1814. His poem, which became overshadowed by the work of Byron, is the work of a sensitive traveler who has breathed not just the spirit of the landscape but has at time, it seems, heard the gods themselves in their haunts at Bassae and elsewhere. His paintings do not match the accomplishment of his poem, but they provide an interesting record (most of the sheets are dated) of an itinerary from Ithaca via Epirus and Corinth to Athens.

Heideck (or Heydeck), Carl Wilhelm, Freiherr von (known as Heidegger) (1787–1861)
FIGURES 8, 52

Heideck studied art in Zurich and Munich, but spent his life as a soldier. In 1826 he led a troop of German volunteers dispatched by King Ludwig I of Bavaria to assist the Greeks in the War of Independence. He remained until 1828, returned in 1832 as one of the regents for King Otho, and left finally in 1835. Though his paintings

are the product of mere leisure hours, they are technically highly competent and exhibit real feeling for Greek landscape.

Herbert, Arthur James (dates unknown)
FIGURE 63

Herbert was an English deputy quartermaster-general of the Ionian Islands in 1861, and during his sojourn there made two beautifully detailed watercolor views of the town of Corfu, from north and south respectively.

Hess, Peter von (1792–1871)
FIGURE 51

Hess came from a Düsseldorf family of artists and craftsmen and studied with his father, who taught at the Düsseldorf and, later, Munich Academies. Hess specialized in genre and battle scenes, and his first notable paintings were of the French expedition under Count Wrede from 1813 to 1815. He accompanied Otho's army to Greece in 1833 and painted two important pictures of the king's first days: *Entry of King Otto of Greece into Nauplia, February 6th, 1833* (FIGURE 51) and *Reception of King Otto at the Theseion*. In both of these, particular attention is paid to the exact representation of each individual involved in the scene, and many of the figures can be identified. He also painted a series of forty *Scenes from the Liberation of Greece*, of which thirty-nine were copied as frescoes by Friedrich Christian Nilson and erected in the Hofgarten arcades in Munich. These were destroyed in the Second World War. Hess's original pencil sketches for them are in the Stadtmuseum in Munich, and his small oils are in the Prinzenzimmer at Schloss Hohenschwangau. There is a set of rather larger copies, by Ferekidis, in the head office of the National Bank of Greece in Athens, hung close to the ceiling above the colonnade of the main banking hall. The series was also published as a set of engravings.

Hess had no interest in landscape painting: he remarked to Rottmann that "there is nothing for a landscape painter to do in Greece" (letter of Carl Rottmann to Heideck, March 12, 1834; quoted from Erika Bierhaus-Rödiger, *Carl Rottmann: 1797–1850*, p. 358), but he did include some occasional pieces of identifiable scenery as background to the *Liberation* pictures. In 1839 Hess entered the service of Czar Nicholas I and painted a series of scenes from the Russian War. Though most of his Greek paintings are formal and political, he also (from 1838) painted some nonpolitical scenes, such as Greek peasants on the beach, smugglers on Mt. Taygetus, and the like.

Hilaire, Jean-Baptiste (1753–1822)
FIGURE 90

Hilaire traveled in Greece with Comte Choiseul-Gouffier as one of the count's extensive retinue of scholars, artists, and men of letters. A few of Hilaire's paintings are extant, and he provided the originals of many of the engravings in Choiseul-Gouffier's *Voyage pittoresque de la Grèce*, but the whereabouts of those originals is unknown.

Hone, Nathaniel, the younger (1831–1917)
FIGURE 31

Hone was the son of the equally celebrated Irish painter of the same name. Where the father concentrated on genre paintings in a style echoing Terbruggen and other Dutch masters, the son adopted a more impressionistic style and favored landscape scenes, often of his native Ireland. He visited Athens in 1891 to 1892 in the course of a tour that took him to several parts of Greece (including Corfu) and Egypt.

Hope, Thomas (1769–1831)
FIGURE 91

Thomas Hope inherited a fortune made by his father from business in the Netherlands, and used it to pursue a career as an author, collector, traveler, and painter. He traveled for some eight years (1787 to 1795) in Greece and the Levant, and acquired a substantial collection of antiquities. In 1795, the Hope family moved from Amsterdam to London, and Hope acquired his own London home in 1799. In this year Hope visited Greece again, and toured the Peloponnese in the company of Procopio Macrì, father of the "Maid of Athens," Teresa. He employed the French artist Michel Francois Préaulx to supplement his own compositions, in the interest of acquiring a portfolio of views that was as complete as possible. Some works in this collection seem also to be by Fauvel. The complete collection of drawings is now in the Benaki Museum in Athens. On his return to England, he acquired further collections of antiquities by purchase (including the Hamilton vases) and became a noted patron of other artists, including John Flaxman and Bertel Thorvaldsen.

Hope's most important scholarly contribution was his *Costume of the Ancients*, published in 1809, a collection of costume drawings that is now in the Gennadius Library in Athens. This led to numerous designs for furniture, fabrics, and wallpapers in a classical style, which gradually came to dominate the taste of Regency England. In 1819 he published a novel, *Anastasius*, which was a fictionalized account of his travels in the East. Commenting on *Anastasius*, Byron said that his only two regrets were that he had not written it, and that Hope had. His importance in the history of taste is fully equaled by his significance as a recorder, often in minute detail, of the Greek scene at the end of the eighteenth century.

Klenze, Leopold Frank Karl von (1784–1864)
FIGURE 22

The architect Leo von Klenze studied in Berlin and became acquainted with Crown Prince Ludwig of Bavaria in 1814. Klenze moved to Munich in 1816, won the competition for the designs for the Glyptothek (his approach to museum design, with its emphasis on the use of natural light, was revolutionary in its time), and became the architect, under Ludwig as king, of most of the fine Neoclassical center of Munich, from Königsplatz in the east to Ludwigstrasse in the west, and south to Odeonsplatz. In 1833 Ludwig sent Klenze to Greece to accompany his son Otho (they arrived in 1834). There Klenze collaborated with the archaeologist Ludwig Ross on the restoration of the Acropolis, though his rival, Friedrich von Gärtner, was responsible for the Royal Palace (both Klenze and Friedrich Schinkel had produced plans for a royal palace on the Acropolis itself). On his return to Munich, and especially after Gärtner's death in 1847, Klenze became the undisputed master of Bavarian architecture, erecting eighty-six buildings in Munich alone, as well as the Walhalla near Regensburg.

Koellnberger, Ludwig (1811–1892)
FIGURES 13, 54, 84, 94

Koellnberger was a member of the brigade of Bavarian auxiliaries that accompanied Otho to Greece in 1833. He then joined the Greek army, with an automatic promotion of one rank, and eventually became adjutant to his battalion. In 1838 he returned to Bavaria, and never rose higher than major. His paintings of Greece (more than one hundred survive) are the work of a good amateur, and they clearly fulfill the function for which a modern traveler

would use a camera: mementos of fine scenery, people observed, humorous incidents, and his own quarters on his travels. Like his contemporary and fellow soldier Adalbert Marc (FIGURE 76), he has a keen eye for telling human detail, though he lacks the humorous and satirical touch of Marc. The two albums of his paintings are in the Kriegsarchiv in Munich.

Lange, Ludwig (1806–1868)

FIGURES 4, 24, 25, 55, 73, 92

Lange first studied as an architect, but turned to painting under the tutelage of Carl Rottmann. He accompanied Rottmann on his visit to Greece in 1834. He stayed in Greece as a teacher of drawing at the Athens Gymnasium until 1838, and prepared architectural plans for the Church of the Redeemer (which were not completed) and for the archaeological museum (for which the plans are lost).

His style is close to that of Rottmann in its awareness of the effect of light on the Greek landscape, but he shows greater interest than his master in the people of contemporary Greece, and many of his small watercolors are sketches of individuals or types. In some cases he paints the same scenes as Rottmann (especially at Mycenae), but his views of Tenos (FIGURE 92) and Delphi (FIGURE 4), to take two examples, are unique and precious records of those places in his time.

Lear, Edward (1812–1888)

FIGURES 62, 65, 66, 68, 79, 85, 98–100

Though Lear is now best remembered for his nonsense verse, in his lifetime this was just a sideline as he worked to make a successful career for himself as a painter. In the late 1820s he began to earn a living by painting birds, notably parrots, and from 1832 to 1837 was employed as artist at the Knowsley Menagerie by Lord Stanley. In 1837 his health deteriorated and Lord Stanley (who by now

had become Earl of Derby) sent Lear to Italy to work on his painting. He stayed there with interruptions for eight years, but at the end of 1847 political conditions forced him to leave. He went to Corfu, a momentous step that transformed his artistic work. As an artist Lear is above all associated with the Ionian Islands and northern Greece, which he portrayed with an intense feeling for light and the sun-drenched landscape, as well as with the vivacity that also informs his nonsense poems and his merry letters. The merriment was an escape from a deep-seated melancholy, no doubt partly related to repressed homosexuality. He never married, and led a lonely and often difficult life, preparing sketches to attract patrons for the large-scale oil paintings through which money was to be made (though modern taste strongly favors the watercolors). He stayed in Corfu again from 1855 to 1857, as his dear friend Franklin Lushington had been appointed judge to the Supreme Court in the Ionian Islands. In the intervening period, and again afterward, he traveled almost constantly, in the Middle East and Egypt, in Italy and Switzerland, in Crete (1864) and in India (1874). Though his life was always a struggle for recognition, his posthumous reputation has ensured him a place among the foremost painters of the Greek landscape.

Lembessis, Polychronis (1848–1913)

FIGURE 28

Born in Salamis, Greece, Lembessis studied art in Munich under the Barbizon painter Wilhelm Lindenschmit, who influenced his response to the light of Greece and its effects on the landscape. He was also influenced by Nikolaos Gysis, the director of the Bavarian Academy. His paintings range from genre studies of Greek types (street vendors, family groups) to landscapes and views of Greek antiquities. He held a major exhibition at the Zappeion in Athens

in 1879, worked on a series of Greek landscapes in the 1880s, and exhibited again at the Zappeion in connection with the celebration of the Olympic Games in 1896. His work is characterized by clarity and precision, although a semi-impressionist feeling for the effects of light is a legacy of his period.

Lusieri, Giovanni Battista (1751–1821)

FIGURE 14

Lord Elgin engaged the Italian painter Lusieri in 1799 as part of his entourage when Elgin became ambassador in Constantinople. Elgin had been unsuccessful in recruiting J. M. W. Turner for the position, as Turner proved to be too expensive. Lusieri, with a team of architects and artists, had the job of making drawings of the marbles and antiquities of Athens. He specialized in large and meticulously detailed panoramas, seven or eight feet long, done in pencil and watercolor. Unfortunately, most of his Athenian drawings were subsequently destroyed. After the Elgin marbles had been shipped to England— and eventually acquired by the British Museum—Lusieri remained in Greece in Elgin's service. However, Elgin could no longer afford much support, half ruined as he was by the saga of the marbles, and Lusieri was increasingly upstaged by newer painters and became more and more inactive. In 1819 Elgin finally withdrew his salary; in 1821 Lusieri died. A rare example of his work, a painting of the Philopappus Monument (FIGURE 14), is in the possession of the Elgin family.

Marc, Adalbert (dates unknown)

FIGURE 76

A lieutenant in the Bavarian-Greek army in the 1830s, Marc was one of a number of officers who turned to watercolor sketching to enliven the routine of their days on garrison duty in Nauplia and elsewhere. Though his work

is not of high artistic quality and he has difficulties with the representation of buildings, he has an eye for comic detail and an almost cartoon-like way of drawing the human figure that make his watercolors a sympathetic record of his Greek stay.

Marilhat, Prosper (1811–1847)
FIGURE 9

Marilhat traveled in the East in the years 1831 to 1833. He devoted particular attention to Egypt and became known as "le Meissonier de l'Afrique." His work tends, however, to landscape rather than genre scenes.

Muller, William James (1812–1845)
FIGURE 97

Little is known of Muller. Born in Bristol, he visited Greece in 1838, when he painted a number of views ranging from Salamis to Rhodes. More than mere topographical paintings, they often take an unusual angle on a familiar scene and suffuse it with an atmosphere of quiet melancholy.

Page, William (1794–1872)
FIGURE 19

Page attended the Royal Academy Schools and first exhibited in 1816. He must have been in Greece and Asia Minor some time before 1822, and at least two of his paintings of Athens bear the date 1818. He next exhibited in London in 1824, a scene of Constantinople. Most of the works that he subsequently exhibited consisted of Greek and Turkish views (including eight large watercolors of Athenian monuments). He also provided thirty sketches to illustrate the three volumes of *Finden's Illustrations of the Life and Works of Lord Byron* (London, 1833). He presumably traveled in the East again, probably in 1827 to 1831 and 1835 to 1838, but all his scenes depict the country under Turkish rule.

Pars, William (1742–1782)
FIGURES 33, 34

A portrait painter and draftsman, Pars was selected in 1764 by the Society of Dilettanti to accompany the expedition led by Richard Chandler to Greece and Asia Minor, the results of which were published as *Ionian Antiquities* in 1769. His watercolors, the bulk of which are in the British Museum, have a touch of incipient Romanticism in their concentration on the picturesque aspects of a scene, and may be counted as among the early productions of the English school of watercolorists. Pars exhibited seven Greek scenes, among others, at the first exhibition of the Royal Academy in 1769. He also traveled in Switzerland and the Tyrol; a visit to Rome was cut short by his death from fever.

Prosalentis, Aimilios (1859–1926)
FIGURE 30

Born in Venice, the son of Paul Prosalentis, the important sculptor, he studied painting with his father, worked for a while in Paris, and returned to Greece in 1874 as a painter of maritime scenes. He exhibited in this genre many times in Athens. The clarity of image in his paintings is achieved by the use of myriad tiny brush strokes.

Purser, William (ca. 1790–1834)
FIGURE 75

Purser was a British architect who traveled in Greece from 1817 to 1820. Many of his paintings were engraved for travel volumes written by others.

Quatremère de Quincy, Antoine-Chrysostome (1755–1849)
FIGURE 46

Sculptor, connoisseur, and mentor of Jacques-Louis David, the French Neoclassical painter Quatremère de Quincy expressed indignation over Napoleon's carrying off classical monuments from Greece and Italy in his *Lettres sur l'enlèvement des ouvrages de l'art antique à Athènes et à Rome* (Letters on the removal of works of ancient art from Athens and Rome) (1796) — the first to denounce such cultural depredation. His major — and beautifully illustrated — work, *Le Jupiter olympien, ou, L'art de la sculpture antique . . . considéré sous un nouveau point de vue . . .* (Jupiter Olympius, or, The art of antique sculpture . . . considered from a new point of view), published in Paris in 1814, contained important reconstructions of the Athena Parthenos on the Acropolis and the statue of Zeus at Olympia.

Randolph, Bernard (1643–after 1689)
FIGURES 32, 42

Randolph was the younger brother of Edward Randolph, who was instrumental in the abrogation of the charter of the colony of Massachusetts. He spent much of his life engaged in commerce in the Levant, returned to England in 1680, visited his brother in Massachusetts, and then composed his two admirable little books, *The Present State of the Islands in the Archipelago* and *The Present State of the Morea*, in which he conveys much useful information and lore about the contemporary scene. Both books have been reprinted by Karavias in Athens. The few engravings that adorn the books, while not high art, represent an important stage in the development of the pictorial representation of Greece.

Revett, Nicholas (1720–1804)

FIGURE 7

Revett was an architect who became acquainted with James Stuart in Rome and was chosen with him by the Society of Dilettanti to travel to Athens to study and draw the monuments. Though the work was undertaken jointly, most of the credit for the first volume of the published work accrued to Stuart; Revett thereupon relinquished his rights in the work and, though he continued to be a member of the Society, took no part in the publication of the further volumes. His own drawings for the first volume show an accomplished artist, and he was as swift as Stuart to introduce the forms he had discovered in Athens to the English landscape, his first work being a small temple at West Wycombe, Buckinghamshire. His most important work was the church at Ayott St. Lawrence, Hertfordshire.

Rizos, Iakovos (1849–1916)

FIGURE 29

Born in Greece, Rizos studied painting in Paris and did not return to live in Greece, though he exhibited not only at international exhibitions in Paris and elsewhere but in Athens. His paintings are suffused with the atmosphere of the Belle Epoque and convey an unusual vision of contemporary Greece.

Rørbye, Martinus (1803–1848)

FIGURE 26

Rørbye was a Danish painter who traveled in Greece with the architect Gottlieb Bindesbøll from 1835 to 1836. Bindesbøll was one of a group of Danish Neoclassical architects, students of G. F. Hetsch, who were responsible for designing several important buildings in Athens (the University, the National Library, and the Observatory, among others) as well as for bringing the Neoclassical style to the fore in Denmark. Rørbye showed a particular interest in the excavations and restorations being conducted under the direction of the archaeologist Ludwig Ross; one of his paintings depicts the excavations on the Propylaea, while a better-known one shows the Tower of the Winds still half buried in the ground (FIGURE 26) and a focus for children at play in the market.

Rottmann, Carl (1797–1850)

FIGURES 38, 39, 45, 56–60, 95

Rottmann studied art in Munich and became known first as a painter of the spectacular scenery of the Bavarian Alps. From 1826 to 1827 he traveled in Italy and came to the attention of King Ludwig I of Bavaria, who commissioned him to carry out a series of frescoes of Italian landscapes for the Hofgarten arcades (they are now in the Residenz in Munich). When Ludwig's son Otto became king of Greece in 1833, Ludwig commissioned Rottmann to go to Greece and prepare a similar series of Greek landscapes for the same location. Rottmann executed more than two hundred sketches, watercolors, and drawings in Greece; when he returned home, he continued to work on many oils and frescoes based on the Greek sketches.

Rottmann was steeped in the classical past of Greece: when he visited Sicily in 1826, he took with him the then recently published edition and translation of Pindar by the Munich professor and philhellene Friedrich Thiersch. His paintings rarely show a contemporary Greek, though they do sometimes include ancient Greeks or modern Bavarian soldiers. In one memorable piece of invention (FIGURE 45), a painting of the plain of Sparta is adorned with a figure, supposedly Thiersch, lounging before an imaginary stone containing an inscription commemorating an athletic victory, of the kind celebrated by Pindar in his poems. Though he may be counted as perhaps the first European artist to celebrate Greek light, Rottmann also paints a fairy-tale vision of Greece. He returned to Bavaria in 1835 and executed twenty-three of the Hofgarten paintings as oils; they are now in the Neue Pinakothek. To most tastes, the watercolors (in the Graphische Sammlung in Munich) are much truer to the Greek scene; they are also much better preserved than the oils, whose varnish has discolored badly.

Schinkel, Karl Friedrich (1781–1841)

FIGURE 23

The German architect Karl Schinkel is mainly associated with Berlin, where many of his greatest Neoclassical buildings are located. Like other artists of his time, he was inspired by ancient Greece, for example in the now lost painting, *Blick in Griechenlands Blüte* (Glimpse of Greece in its heyday). In 1834 he was one of several architects to submit plans for a royal palace in Athens, which was to incorporate the existing buildings on the Acropolis into one grand new structure. Fortunately, the plan was never implemented.

Schranz, Josef (1803–after 1853)

FIGURE 64

Schranz was of Maltese origin. He visited Crete in 1834 with the topographer and scholar Robert Pashley and presumably his paintings of Athens and the Ionian islands date from the same period of his life. Many of his paintings are in the Benaki Museum in Athens and the Museum of the City of Athens; two are in the British Embassy in Athens.

Skene, James (1775–1864)

FIGURES 40, 41, 71, 72, 83

Skene inherited the estate of Rubislaw from his father in 1791. He was called to the Scottish bar in 1797 and became a friend of Walter Scott. From 1802 Skene traveled on the continent and did not return to Edinburgh until 1816. He was in Greece between 1838 and 1845, and was one of the first visitors to Greece to benefit from the new-found freedom of travel and the wider borders of the kingdom: few before him had done much painting in central and northern Greece. Skene was an amateur painter and was not especially skillful with the pen. The distortions of perspective in many of his paintings seem to betray the use of the camera obscura, an instrument for projecting an image of the scene on to a sheet of paper, which the user could then draw around. Walter Scott said of him, "For a gentleman, he is the best draftsman I ever saw." In 1829 he prepared a series of illustrations for the Waverley Novels. His paintings of Greece, as well as of France and Switzerland, emphasize romantic aspects of nature — knotted and gnarled tree trunks, beetling precipices — but they also betray an unusual interest in the ruins of the Greek Middle Ages, with views of monasteries, churches, and bridges taking their place alongside classical antiquities. His diaries, which have not been published, are held at the Academy of Athens.

Stackelberg, Otto Magnus, Freiherr von (1787–1837)

FIGURE 49

Stackelberg, who had begun a diplomatic career before deciding to go in for painting, visited Greece in 1809, and took part with Carl Haller von Hallerstein, Charles Robert Cockerell, and others in the discovery of the Bassae frieze. But his interests were not predominantly archaeological, and his work is among the first to display an interest in the contemporary people of Greece, particularly in their costumes. The beautiful colored engravings of his *Costumes et usages des peuples de la Grèce moderne* (Costumes and customs of the peoples of modern Greece) are a landmark and a treasure.

Struys, Jan Jansz. (d. 1694)

FIGURE 88

A seventeenth-century Dutch traveler.

Stuart, James (1713–1788)

FIGURES 11, 12, 16

Known as "Athenian Stuart" because of his work on *The Antiquities of Athens Measured and Delineated*, Stuart was sent to Athens with Nicholas Revett in 1751 by the Society of Dilettanti; they returned in 1753. This was the culmination of several years of training and artistic activity in Rome, and a long process of preparation of proposals to the Society for an expedition to Greece to study its architecture and thus "improve the arts of England." The first volume of *The Antiquities of Athens* was published in 1762, but in the meantime both architects had begun to make an impact on the English landscape with buildings modeled on those of Athens. Stuart erected a series of Athenian monuments at Shugborough in Staffordshire, as well as other Neoclassical buildings elsewhere, while Revett did buildings at West Wycombe in Buckinghamshire. In addition to the measured technical drawings, Stuart made a series of gouaches of views of Athens, some of which were engraved in subsequent volumes of *Antiquities*, the second of which appeared in 1789, after Stuart's death.

Thévet, André (ca. 1502–1590)

FIGURE 87

The French traveler and cartographer Thévet left Venice in 1549 for an extended journey to the East. He met Petrus Gyllius, the topographer of Constantinople, and visited Athens, Rhodes, and Alexandria. He resumed his pilgrimage to Palestine in 1551. In 1555 he visited Brazil. At this time he became historian and cosmographer to the king of France and in 1554 he published his *Cosmographie de Levant*, which was illustrated with numerous plates. Later works not relevant to Greece include his *Grand Insulaire* and *Cosmographie Universelle* (Paris, 1575).

Vryzakis, Theodoros (1814–1878)

FIGURE 74

Vryzakis was born in Thebes. His father was hanged by the Turks during the War of Independence and Vryzakis was brought up in the orphanage founded by President Capodistria on Aegina. Friedrich Thiersch, the philhellene and philologist from Munich, discovered Vryzakis and took him to Munich to study in 1832. There he attended the Hellenic High School founded by Thiersch and developed a style of history painting somewhat influenced by the French painters of the War of Independence. He painted a series of scenes from the Greek War of Independence and exhibited widely in central Europe. Many of his works were published as engravings. He did not return to live in Greece again, but in his will he bequeathed many of his paintings to the University of Athens.

Weiler, Wilhelm von (active 1830s–1840s)

FIGURE 93

A German architect.

Weston, Lambert (1804–1895)

FIGURE 27

An English painter of the Romantic school.

Williams, Hugh William (1773–1829)

FIGURES 35, 70

Williams's first visit abroad was to Italy and Greece (after 1812). He traveled with William Douglas of Orchardton, who paid his expenses in exchange for the drawings that Williams was to make. Their acquaintance with Thomas Maitland, governor of the Ionian Islands, smoothed their path in Greece. Williams was in Greece until 1818 and also spent some time in Rome, where he mingled with other artists and Grand Tourists. A two-volume publication of his travels, with engravings from his own drawings, *Travels in Italy, Greece and the Ionian Islands* (1820), won him the sobriquet of "Grecian Williams." In 1822 he exhibited the watercolors made during his travels, and from 1827 to 1829 his *Select Views in Greece* was published in serial form. The whereabouts of the drawings he must have made for Douglas is not known. His paintings of Greece do not differ greatly in their tones and colors from those he made of Scotland, but great attention is paid to atmospheric effects — the influence of Turner — in views such as the storm at Sunium (FIGURE 35), the clouds and sunbeams that dapple the plain of Chaeronea, or the purple sunset hills of Marathon. An accomplished artist, he was the teacher of George Basevi, and also played an important part in the design of the monuments on Calton Hill in Edinburgh. Most of his paintings are in the National Gallery of Scotland.

Zográfos, Panagiotis (late 1700s–mid-1800s)

FIGURE 77

Zográfos, who came from the Sparta region, was engaged by General Makriyannis to prepare a series of paintings illustrating the progress of a number of battles in the War of Independence, which would act as illustrations of the written accounts given by Makriyannis in his *Memoirs* (themselves a modern Greek classic). The paintings were made between 1836 and 1839. They concentrate on portraying the successive stages of the battles they depict, in schematic form; no pretense is made at naturalistic landscape, and in some ways these naive works look back to the topographical drawings of the seventeenth century.

Bibliography

AICHNER, ERNST.

 Bayerische Militärmaler: von Beich bis Thöny. Exh. cat. Ingolstadt, 1982.

ATHANASSOGLOU-KALLMYER, NINA M.

 French Images from the Greek War of Independence, 1821–1830: Art and Politics under the Restoration. New Haven and London, 1989.

AUGUSTINOS, OLGA.

 French Odysseys: Greece in French Travel Literature from the Renaissance to the Romantic Era. Baltimore, 1994.

BIERHAUS-RÖDIGER, ERIKA.

 Carl Rottmann: 1797–1850. Munich, 1978.

BOLTON, ARTHUR T.

 The Portrait of Sir John Soane, R. A. London, 1927.

BURTON, ROBERT.

 The Anatomy of Melancholy. 3 vols. 1684. Reprint. New York, 1948–1961.

BYRON, GEORGE GORDON, LORD.

 Lord Byron: Selected Letters and Journals. Edited by Leslie A. Marchand. Cambridge, Mass., 1982.

CARNE, JOHN.

 Syria, the Holy Land, Asia Minor &c, Illustrated in a Series of Views Drawn from Nature by W. H. Bartlett, William Purser etc. London, 1836–1838.

CARTWRIGHT, JOSEPH.

 Views in the Ionian Islands. London, 1821.

CHANDLER, RICHARD.

 Travels in Asia Minor, 1764–1765. 1825. Edited and abridged by Edith Clay. London, 1971.

 Travels in Asia Minor and Greece. 2 vols. London, 1817.

 Travels in Greece. Oxford, 1776.

CHARLEMONT, LORD (JAMES CAULFEILD).

 The Travels of Lord Charlemont in Greece and Turkey. 1749. Edited by W. B. Stanford and E. J. Finopoulos. London, 1984.

CHOISEUL-GOUFFIER, MARIE-GABRIEL-AUGUSTE-FLORENT, COMTE DE.

 Voyage pittoresque de la Grèce. 2 vols. Paris, 1782; 1809.

CLARKE, EDWARD DANIELL.

 Travels in Various Countries of Europe, Asia and Africa. 6 vols. 4th edition. London, 1818.

COCKERELL, C[HARLES] R[OBERT].

 The Temples of Jupiter Panhellenius at Aegina, and of Apollo Epicurius at Bassae, near Phigaleia in Arcadia. London, 1860.

 Travels in Southern Europe and the Levant, 1810–1817. Edited by Samuel Pepys Cockerell. London, 1903.

CONSTANTINE, DAVID.

 Early Greek Travellers and the Hellenic Ideal. Cambridge, 1984.

CROOK, J. MORDAUNT.

 The Greek Revival: Neo-Classical Attitudes in British Architecture, 1760–1870. London, 1972.

DECKER, HUGO.

 Carl Rottmann. Berlin, 1957.

DEUTSCHES MUSEUM.

 100 Jahre deutsche Ausgrabung in Olympia. Exh. cat. Munich, 1972.

DODWELL, EDWARD.

 A Classical and Topographical Tour through Greece, during the Years 1801, 1805, and 1806. 2 vols. London, 1819.

 Views in Greece. London, 1821.

DUPRÉ, LOUIS.

 Voyage à Athènes et à Constantinople. Paris, 1825.

EASTLAKE, LADY (ELIZABETH RIGBY).

 A Memoir of Charles Lock Eastlake. 1869.

EISNER, ROBERT.

 Traveler to an Antique Land: The History and Literature of Travel to Greece. Ann Arbor, Michigan, 1991.

FERMOR, PATRICK LEIGH.

Mani: Travels in the Southern Peloponnese.
London, 1958.

FINE ART SOCIETY.

The Travels of Edward Lear. Exh. cat. London, 1983.

GELL, WILLIAM.

The Itinerary of Greece. London, 1810.

Narrative of a Journey in the Morea. London, 1823.

HAYGARTH, WILLIAM.

Greece, A Poem, in Three Parts, with Notes, Classical
Illustrations and Sketches of the Scenery. London, 1814.

HELLENIKE HETAIREIA CHARTOGRAPHIAS.

Cartography of the Shores and Islands of Greece. 2 vols.
Exh. cat. Seventh International Symposium of the
Society for Hellenic Cartography. Athens, 1989.

HEYDENREUTER, REINHARD, JAN MURKEN, AND
RAIMUND WÜNSCHE.

Die erträumte Nation: Griechenlands Wiedergeburt im
19. Jahrhundert. Munich, 1995.

HISTORICAL AND ETHNOLOGICAL SOCIETY OF GREECE.

James Skene: Monuments and Views of Greece,
1838–1845. With an introduction by Fani-Maria
Tsigakou. Athens, 1985.

HOGARTH, PAUL.

The Mediterranean Shore: Travels in Lawrence Durrell
Country. London, 1988.

HUGHES, THOMAS SMART.

Travels in Sicily, Greece and Albania. 2 vols.
London, 1820.

INTERNATIONAL EXHIBITIONS FOUNDATION, 1971–1972.

Edward Lear in Greece: A Loan Exhibition from
the Gennadius Library, Athens. Exh. cat. Meriden,
Connecticut, 1971.

JENKYNS, RICHARD.

Dignity and Decadence. London, 1991.

KALLIGAS, MARINOS.

Greek Landscapes after the War of Independence.
Athens, 1978.

KOSTER, DANIEL.

Naar 't heerlijk Griekenland, Verbeelding! voer mij heen:
Reizen naar Griekenland 1488–1843. Groningen,
1993.

LANGE, LUDWIG.

Die griechischen Landschaftsgemälde von Karl
Rottmann in der königlichen Pinakothek zu München.
Munich, 1854.

Reiseberichte aus Griechenland in Auszügen aus den
Briefen des Architekten Ludwig Lange. Darmstadt, 1835.

LEAR, EDWARD.

Edward Lear: The Corfu Years. Edited by Philip
Sherrard. Athens, 1988.

Edward Lear: The Cretan Journal. Edited by Rowena
Fowler. Athens, 1984.

Edward Lear: Selected Letters. Edited by Vivien
Noakes. Oxford, 1988.

Views in the Seven Ionian Islands. London, 1863.

LIEB, NORBERT, AND FLORIAN HUFNAGL.

Leo von Klenze: Gemälde und Zeichnungen.
Munich, 1979.

MAKRIYANNIS, IAONNES.

The Memoirs of General Makriyannis, 1797–1864.
Edited and translated by H. A. Lidderdale.
Oxford, 1966.

MARCHAND, LESLIE.

Byron: A Portrait. London, 1971.

MICHALOPOULOS, DIMITRIS.

Views of Athens before and after 1821. Athens, 1990.

MILLINGEN, JULIUS.

Memoirs of the Affairs of Greece. London, 1831.

MISIRLI, NELLI.

Ελληνική Ζωγραφική: 18ος 19ος αιώνας
(Greek painting: 18th–19th century). Athens, 1993.

NATIONAL GALLERY OF SCOTLAND.

Watercolours by Edward Lear from the Collection of the
Hon. Sir Steven Runciman. Exh. cat. Edinburgh, 1991.

NOAKES, VIVIEN.

Edward Lear. London, 1968.

PASHLEY, ROBERT.

Travels in Crete. 2 vols. London, 1837.

RANDOLPH, BERNARD.

The Present State of the Islands in the Archipelago.
Oxford, 1687. Reprint. Athens, 1983.

The Present State of the Morea. 3rd edition. Oxford,
1689. Reprint. Athens, 1966.

REINHARDT, BRIGITTE.

"Der Schlachten- und Genremaler Peter von Hess."
Oberbayerisches Archiv 102. Munich, 1977.

RODENWALD, G.

Otto Magnus von Stackelberg: Der Entdecker der
griechischen Landschaft, 1786–1837. Munich, 1957.

RUSKIN, JOHN.

Lectures on Art. Oxford, 1870.

ST. CLAIR, WILLIAM.

Lord Elgin and the Marbles. Oxford, 1983.

SANDWICH, JOHN MONTAGU, EARL OF.

A Voyage Performed by the Late Earl of Sandwich Round
the Mediterranean in the Years 1738 and 1739.
London, 1799.

SEIDL, WOLF.

Bayern in Griechenland: Die Geburt des griechischen
Nationalstaats und die Regierung König Ottos.
Munich, 1981.

SHERER, JOHN.

The Classic Lands of Europe, with Engravings by Allom,
Bartlett, Leitch, etc. London, 1879–1881.

SPON, JACOB.

Voyage d'Italie, de Dalmatie, de Grèce et du Levant
fait aux annees 1675 et 1676 par Jacob Spon et George
Wheler. Amsterdam, 1679.

SPRATT, T[HOMAS] A[BEL] B[RIMAGE].

Travels and Researches in Crete. 2 vols. London, 1865.

STACKELBERG, OTTO MAGNUS, FREIHERR VON.

Costumes et usages des peuples de la Grèce moderne.
Rome, 1825.

STONEMAN, RICHARD.

Land of Lost Gods: The Search for Classical Greece.
London and Norman, Oklahoma, 1987.

A Literary Companion to Travel in Greece. Malibu, 1994.

STUART, JAMES, AND NICHOLAS REVETT.

Antiquities of Athens Measured and Delineated. 2 vols.
London, 1762; 1789.

TREGASKIS, HUGH.

Beyond the Grand Tour: The Levant Lunatics.
London, 1979.

TSIGAKOU, FANI-MARIA.

Lord Byron in Greece. Exh. cat. Greek Ministry of
Culture/British Council. Athens, 1987.

The Rediscovery of Greece: Travellers and Painters of the
Romantic Era. London, 1981

Thomas Hope: Pictures from 18th Century Greece. Athens:
Benaki Museum/British Council/Melissa, 1985.

Through Romantic Eyes: European Images of Nineteenth
Century Greece from the Benaki Museum, Athens.
Alexandria, Virginia, 1991.

VOGT, ADOLF MAX.

K. F. Schinkel: Blick in Griechenlands Blüte.
Frankfurt, 1985.

WATKIN, DAVID.

Athenian Stuart. London, 1982.

The Life and Work of C. R. Cockerell. London, 1974.

Thomas Hope 1769–1831 and the Neo-Classical Idea.
London, 1968.

WHELER, GEORGE.

A Journey into Greece in the Company of Dr. Spon of
Lyons. London, 1682.

WILLIAMS, H[UGH] W[ILLIAM].

Select Views in Greece. 2 vols. London, 1829.

WÜNSCH, RAIMUND, FRIEDRICH HAMDORF, ADRIAN
BUTTLAR, AND MICHAEL TIEDE.

Ein Griechischer Traum: Leo von Klenze: der Archäologe.
Munich, 1985.

ZOGRÁFOS, PANAGIOTIS.

Freiheit oder Tod: Bilder des Panagiotis Zografos über den
Kampf der Griechen gegen die türkische Fremdherrschaft
1821–1830. Leipzig, 1982.

Index

Acknowledgments

I have been favored with the assistance and cooperation of an unusually large number of people in the researching of this book. I would like to express my gratitude to all of the following for their friendly contributions to my project and their help in making this book possible.

Dr. Ernst Aichner, Director, Bayerisches Armeemuseum, Ingolstadt; Dr. Polymnia Athanassiadi, University of Athens; Dr. Kai Brodersen, University of Munich; Professor John Camp, American School of Classical Studies, Athens; Mr. Mungo Campbell, National Gallery of Scotland; Ms. Magda Dimoudi, Corfu Tourist Office; Dr. Duvigneau, Director, Stadtmuseum, Munich; The Earl of Elgin; Mr. Stathis Finopoulos; Dr. Achim Fuchs, Director, Kriegsarchiv, Munich; Dr. Elizabeth French, Director, the British School at Athens; Ms. Antonia Havani, art dealer, Corfu; Dr. Christoph Heilmann, Neue Pinakothek, Munich; Dr. David Jordan, former Director, The Gennadius Library, Athens; Dr. Haris Kalligas, Monemvasia Society and Director, The Gennadius Library, Athens; Dr. Marilena Karabatea, Curator, the Goulandris Museum, Athens; Ms. Margaret Kelly, National Gallery of Scotland, Edinburgh; Professor Richard McNeal, Franklin and Marshall College, Lancaster, Pennsylvania; Professor Olga Palagia, University of Athens; Mr. Joe Rock, University of Edinburgh; the Hon. Sir Steven Runciman; Dr. Dimitris Michalopoulos,

Director, Museum of the City of Athens; His Excellency Oliver Miles and the staff of the British Embassy at Athens; Andreas Papadatos, the Corfu Reading Society; Frau Tomaschek, Staatliche Graphische Sammlung, Munich; Dr. Angela Tamvaki, Director, The National Gallery, Athens; Dr. Fani-Maria Tsigakou, the Benaki Museum, Athens; as well as the staffs of the following institutions: the King Otto Museum in Ottobrunn, Munich; the Royal Institute of British Architects in London; Sir John Soane's Museum in London; and the Department of Manuscripts of the Bavarian State Library; and to all those who made my visits to Greece to work on this book a delight, as always.

I would also like to thank those who helped realize this book: At the Getty Museum, the Publisher, Christopher Hudson, supported this book since its inception, and Benedicte Gilman, the Editor, managed the project. At Getty Trust Publication Services, Pamela Patrusky Mass designed the book and Elizabeth Burke Kahn coordinated the production. Tobi Levenberg Kaplan, a consultant to the Getty Museum, edited the manuscript.

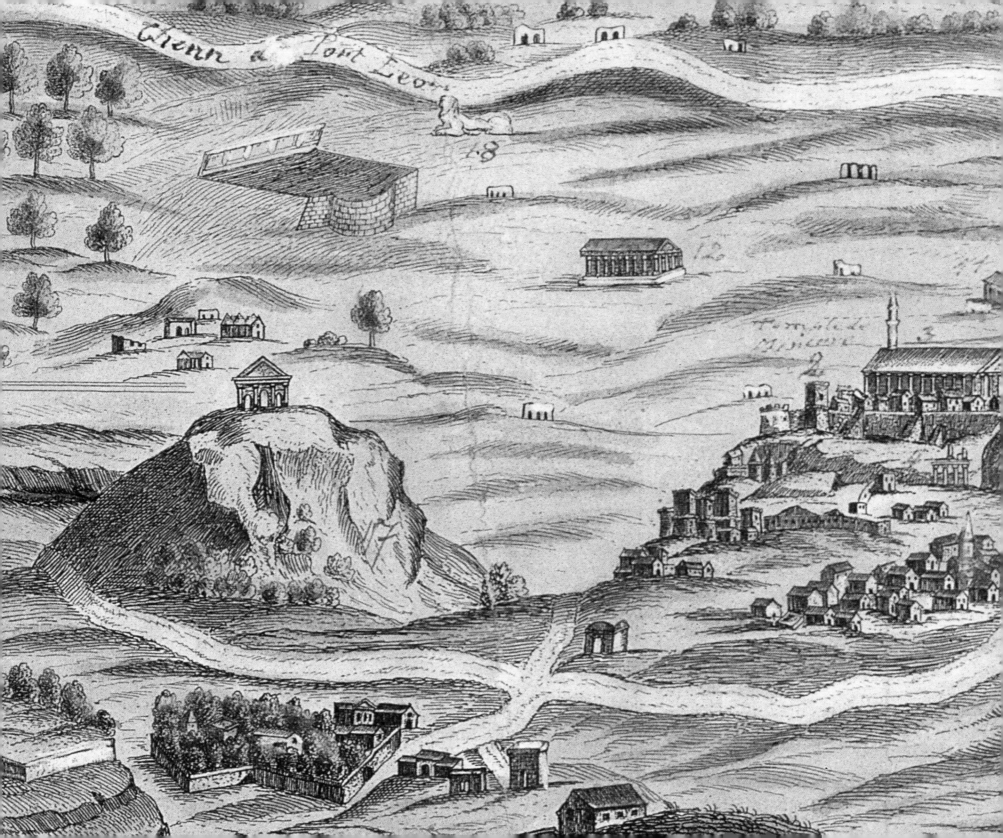

Glenn a Port Leon